ART OF
MEMORIES

ART OF MEMORIES

CURATING AT THE HERMITAGE

VINCENT ANTONIN LÉPINAY

Columbia University Press
New York

COLUMBIA
UNIVERSITY
PRESS

Columbia University Press gratefully acknowledges the generous support for this book provided by Publisher's Circle member Harriet Zuckerman.

Columbia University Press
Publishers Since 1893
New York Chichester, West Sussex
cup.columbia.edu

Library of Congress Cataloging-in-Publication Data
Names: Lépinay, Vincent Antonin, author.
Title: Art of memories : curating at the Hermitage / Vincent Lépinay.
Description: New York : Columbia University Press, [2019] | Includes bibliographical references and index.
Identifiers: LCCN 2018042780 (print) | LCCN 2018042870 (e-book) | ISBN 9780231549561 (e-book) | ISBN 9780231191883 (cloth : alk. paper) | ISBN 9780231191890 (pbk. : alk. paper)
Subjects: LCSH: Gosudarstvennyi Ermitazh (Russia)—Officials and employees. | Art museums—Social aspects—Russia (Federation)— Saint Petersburg. | Corporate culture—Russia (Federation)— Saint Petersburg.
Classification: LCC N3350 (e-book) | LCC N3350 .L47 2019 (print) | DDC 708.947086—dc23
LC record available at https://lccn.loc.gov/2018042780

Columbia University Press books are printed on permanent and durable acid-free paper.

Printed in the United States of America

Cover design: Julia Kushnirsky
Cover photo: Courtesy of The State Hermitage Museum, St. Petersburg

For Niloé and Eliot.
Secret lives of Saint Petersburg revealed.

CONTENTS

PREFACE

Experimenting with the Hermitage

This book results from a series of experiments. The first and foremost of these experiments is the collaboration between a scholar, foreign to Russia until 2012, and the director of a tight and proud community—the "Hermitagers"—solidly attached to their institution. Feeling a foreigner to Russia during the period 2012–2015 came easily. Nationalist sentiment spared no quarter of the country. Russian academia was trapped in the absurd choices required by the growing tensions following the escalation of the feud between the West and Moscow in the wake of the Ukrainian operations. I was a strange foreigner: a caricature of a foreigner because I started this project with a limited command of Russian, and because I was coming with the mixed aura of a few years as an assistant professor at MIT and the much greater aura of the "French social scientist." The aura was different than what Anglo-American scholars have discerned in French social scientists. It was colored by the idea that Saint Petersburg was once closer to Paris than to Moscow and that many French (or French speaking and writing) philosophers traveled to the Winter Palace to advise its residents. In the eighteenth century, Denis Diderot and Joseph

de Maistre both cemented close intellectual relations through grand principles and lofty generalizations—as Diderot himself recognized, when he famously wrote that the first time he had felt a free man was in Russia, a country where men are called slaves.

In the face of self-assured and self-confident employees of a Russian institution, my combined professional and personal identities were slippery enough that I surprised my interlocutors. Why would a foreigner, unable to express himself and his most basic research needs, come to a closed institution with the claim to study it in original ways? Others before me had tried and failed to penetrate Russia. Most recently, French architect Dominique Perrault had won—and then lost—the competition for the new Marinskii Theater in a turn of events that had left both sides bitter and in conflict. And the conversation leading to this study started in September 2012, exactly two hundred years after Napoleon's disaster at Berezina. So, the prospect of a French scholar exploring Russia and being either overwhelmed or routed out did not escape my interlocutors. Nevertheless, being French was also an immense asset when I started interviewing Hermitagers in the museum: one of their claims is to be both the guardians of the treasures of Russia, with its many complex layers, and to be its most European avant-garde. Conducting this study as a French social scientist eased my conversations with older employees, who likely would have found it degrading to be questioned by an American scholar, let alone a "technologist" from Massachusetts. I noted their impeccable command of the French language and their reminiscences of famous French novels: a Frenchman, they seemed to believe, was likely to possess a similar understanding of the sophistication of Russia. Younger employees were less charmed by French etiquette than they were curious about the trajectory of a Parisian, once stranded on the American East Coast for a decade, traveling back too far east in Old Europe. These probes and assessments went on for the duration of the project, but the Hermitagers' claim for the uniqueness of the museum never disappeared, and as that claim persisted, so too did my experience of being a foreigner. That experience was shared by even my

most staunchly Russian colleague, who insisted that the museum was impenetrable for everyone, let alone an outsider.

I had not at first relocated to Saint Petersburg to study the museum. I had come by invitation of the rector of the European University at Saint Petersburg. Oleg Kharkhordin had launched a new Center for Science and Technology Studies in 2011, and he was looking for a director. After a week in Saint Petersburg, I met with Mikhail Borisovich Piotrovsky, the director of the State Museum Hermitage, who was visiting the university in his capacity as head of its board of trustees and instructor in art history. The conversation was as brief as it was consequential: being asked what I studied, I decided to cover my growing sense of hesitation in the face of many possible projects in my new home: "I study objects" was my strategically vague reply. Firm and decisive, the director of the museum determined that only the most improbable choice—an inadequate and illiterate scholar—held out the possibility of mining insights from his institution. This decision, sealed during the cocktail hour opening the joint Hermitage–National Gallery exhibition of medals depicting Napoleon, would lead to this book. It was to be neither a journalistic piece in search of juicy little stories of the Hermitagers nor a consultant's report on the museum's own efficiency.

ART OF MEMORIES

INTRODUCTION

The Hermitage, a Cultural Laboratory

his book is about an exception; it is about the unique way that one of the world's major cultural institutions—the State Hermitage Museum, in Saint Petersburg, Russia— thinks about museums and their mission. This institution occupies a position that makes it a case in point for social scientists interested in studying the specifics of art history in Russia as well as the morphology of the city of Saint Petersburg, largely animated by the flow of tourists eager to visit the museum during the summer months. Nowhere can one find a museum that encapsulates so many paradoxes: while the Hermitage is a museum of global scope—if one contemplates the span and breadth of the collections assembled therein—it has largely grown in isolation since the Russian Revolution of 1917. And while it seriously cultivates the art sciences—with more scholars employed in furthering art history by means of investigating the treasures of the museum than can be found anywhere else—its scholars have, to a large extent, resisted the new art-historical trends adopted in other museums and art institutes both in the USSR and abroad. Consider also that while the Hermitage is committed to its city's identity and proud

of maintaining a (conservative) standard of culture, one that has been dictated by a long tradition of families belonging to the city's intelligentsia, it nonetheless promoted professional mobility during the Cold War and invented its own standard of professionalism. Widely considered the gem of Russia, and allegedly one of the most generously endowed cultural institutions in the country, the Hermitage promotes national patrimony and maintains the treasures of more than three centuries of state splendor; however, it also houses one of the world's most richly endowed collections of Dutch, French, Italian, and Spanish paintings. As such, it partakes in the conversation and scholarship of global art history, at times straining the limits of its identity as a national museum cultivating domestic memory.

In addition to these fundamental paradoxes, one should note that the State Hermitage Museum is also among the world's most active museums, based on the number of exhibitions curated each year. Since the end of the Soviet era in the early 1990s, the museum has opened up to the rest of world. Once a sealed enclave, its glories glowing and radiating only within its limited geographic territory and even, at times, only within the walls of the museum itself, the Hermitage has jumped onto the world scene and become more active than most other museums of its size. In its attempt to catch up with the rest of the museum world—while remaining committed to its identity, forged in troubled political times—the Hermitage has changed, and these changes have taken place in a space that itself deserves close scrutiny. This space features the complex coexistence of objects and people in a building that is both an architectural work of art and a layering of people—those who lived there and who first started the collections and those who inhabited the museum and kept it alive and vibrant through the vicissitudes that were to come. This coexistence is problematic because of the sheer accumulation of things and, notably, of employees who were given the privilege of never having to retire: in the early 1990s, Mikhail Borisovich Piotrovsky, the freshly appointed director of the museum, decided to protect "Hermitagers" from the vagaries of the chaotically liberalized

Soviet economy and allow them to stay on the museum payroll *ad vitam aeternam.*[1] In so doing, he engaged in a social experiment whereby the museum collected and preserved things *and* persons in equal measure. Although the decision to turn the museum into an enclave of seasoned curators is still debated among employees, it was not entirely revolutionary. The Hermitage has been a haven for its employees since the turmoil of the late 1930s as well as during the Cold War, when the political climate was not always favorable to keeping and curating the collection that it boasts today. To a greater extent than at other museums of similar caliber, the Hermitage is an institution where one makes a career and spends one's entire professional life. Seen from the outside as a world-class museum, on the inside it is experienced as a large and distinguished family.

Other museums share these features to varying degrees, but the Hermitage is among the most important advocates for and exemplars of these conservation practices, which encompass both artifacts and Hermitagers themselves. This fixation stems from equating the Hermitage with a national treasury. The tension created by this equation is acute because, even though the treasure may be "national," it contains many items that are of foreign origin, such as the renowned collections of French impressionist works and Dutch engravings. Therefore, the "national" pride attached to the museum is of a complex nature.[2] The fascinating aspect of these collections comes from the forms of attachments that they trigger and the ethos that they generate among the Hermitage's employees. Put simply, these employees are experts of extraterritorial collections but they have developed this expertise in relative isolation and confinement, and the transformations experienced in Russia since the late 1980s only exacerbated and dramatized the conflicts that such forms of expertise create. The Hermitagers' expertise was formed during a period when scientific correspondence with other specialists was rare (if it existed at all), and the museum's employees and most treasured pieces were based in Leningrad. In sum, the Hermitage demands that we question how a distinctive form of art expertise developed within an enclave that was experienced as a family

and was largely unable to participate in the rituals of the broader museum world.

APPROACHING THE HERMITAGE

Although the project began as an ethnographic study, the subject matter directed me deeper into the history of the museum. Asked about their daily activities, employees immediately brought a long history into the discussions, often by invoking characters—some still alive, others long dead but whose memory was clearly an important factor in their experiences. As a consequence, this book belongs to many literary genres and borrows from different analytic methodologies. Begun with an eye on the organization of work around material both secret (because it is kept behind closed doors) and highly publicized, the study of the museum took the path of media studies to make space for the centrality of infrastructures of memory. The subject of the study was a population cultivating simultaneously a treasure and a systematic discourse about that treasure, and the initial design for a study of a rare institution that spanned the imperial, Soviet, and post-Soviet periods had also to confront the local theories of art history deployed by these subjects within the building. Had I wanted to study the museum as just an organization—in the tradition of organization studies interested in the interplay of rules and discretion, abstract codes of conduct, and charismatic leaders guiding collectives down new paths (DiMaggio 1978, 1982, 1983; Heinich and Pollack 1989)—I would indeed have had to deal with a large residue in these Hermitagers' grammar of action, more occupied by the ghosts of legendary keepers[3] and the proper behaviors demanded by the collections than by the rules animating the museum.

The museum spoke directly to the theory of organization and to the field's recently renewed attention to "project organizations." Since the 1990s, the rapid opening of the Hermitage to the rest of the museum world has taken the shape of a rise in exhibition activities.

Locally and on the foreign museums' scenes, Hermitage employees have had to devote more of their time to organizing exhibitions and to making their collections accessible to foreign curators seeking to borrow the Hermitage's exhibits. This new emphasis on temporary activities not directly related to the documentation of Hermitage treasure has stood in conflict with the Soviet-era ethos whereby the museum's activities were less in conversation with the rest of the museum world. An entire generation of keepers had learned to define themselves in relatively confined terms and without reference to other museums or collections. Their presentation of self and their strategies within the museum constantly mobilized their legendary keepers and art pieces, whose enduring influence compelled my interlocutors to act in specific ways. These legends did more to polarize the behaviors of keepers than the explicit and formal rules setting the legitimate field of action in the museum, and could be described as their magnetic fields. How to talk about the collections, how to write about art pieces, and how to open up the treasures of the Hermitage were questions that constantly referred back to these great figures. However, conflicts and tensions were not absent from these accounts; the museum was not presented as a form of Eden, and my interlocutors did not present themselves as sainted employees. Yet their great predecessors and the museum's outstanding collections demanded their respect. Passions on this subject ran very high; such affects gestured toward a history of Russia, the USSR, and post-Soviet Russia that set this organization apart as a special candidate for study. At first sight, this passion was seemingly driven by proximity to the pieces accumulated in the museum over a long period of time. This proximity at times turned into appropriation, feelings of a seamless continuity between the keeper and his holdings. The cases of appropriation were numerous and were defended on many grounds; some of these defenses clearly drew on the language of the organization: as keepers are legally responsible for their collections, many of them insisted that they should have control over their pieces and decide who could come close and inspect or study them. A strong motive, however, stood between passion

and an unmitigated sense of full and unchecked private appropriation: the need to do scholarship.

This motive was usually attached to the vivid memory of a legend, a predecessor whose mark on generations of Hermitagers was evidenced by their remarkably sharp eyes and ability to "read" works of art. "Being scientific"—in Russian, научный, which carries the meaning of systematic rather than experimental knowledge—in the wake of such legends required another form of passion. Scholarship would not necessarily stand in the way of passion but rather transform it through verbal articulations (Hennion 2015). Being a scholar in the museum required one to produce something beyond the simple appropriation of and fusion with one's collection, and yet the exact nature of such a production is highly debated among Hermitagers. For example, some of these legends were writers who left a rich opus still viewed as canonic by current keepers, while others—among them the most revered keepers of all—had written little, preferring instead to transmit knowledge orally and in person, at the site of the treasure or artwork under scrutiny.[4] This oral method constituted a form of science unable to endure in the manner of documents. The forms of knowledge produced by the museum keepers and scholars are a central feature of *Art of Memories*. They direct the book towards the genre of media studies (Kittler 2009, 2014) by paying attention to the material manifestations of conflicts between the oral tradition and the requirement of scientific documentation in the museum. Looking at a cultural organization that aims to produce science entailed surveying materials that have not thus far found favor with art historians: scientific documentation as proto-art history. This book has found inspiration in the media studies of the past three decades, with its attention to the invisible infrastructure of knowledge (Ernst 2012; Kafka 2012). As a discipline, art history itself has a history that is sequenced by renowned art historians who have suggested both a creed and a toolbox. From Heinrich Wölfflin to Didi-Huberman, art history as a unique and specific discipline has borrowed from many disciplinary currents. In *Art of Memories*, the needle points toward the Palace Square to

understand how the supposedly mundane and trivial practices of documentation and cataloging in the museum contain insights for the art of describing art pieces: art history from the bottom up and documentation as proto-scientific monograph.

Michael Baxandall's (1972) concept of the "Quattrocento eye," introduced in his book *Painting and Experience in Fifteenth-Century Italy*, ushered in a form of art history concerned with the social and material conditions of art appreciation, specifically the appreciation of paintings. For Baxandall, understanding of the artistic object was not, in this period, formed within museums (in the sense familiar to us since the nineteenth century); instead, it was in shops and workshops alongside noble courts that taste was produced. Patrons, workshops, artisans, and artists were the coordinates and forces moving the production of a taste not yet unified and under the control of a single group strong enough to dictate a canon. The virtue of Baxandall's work is to point to the distribution and flux of that canon. Although very different from the institutions of Baxandall's Quattrocento, the Hermitage during the twentieth century also offers a microcosm of employees and collections to which boundaries (spatial, political, professional, and disciplinary) were both present and surprisingly absent. Similar to those studied by Baxandall, this configuration produced a lasting museum taste and culture, premised on the proximity between collections and curators and on the confinement of both. In *Art of Memories*, we offer a "museum's eye"—and more precisely "the Hermitage's eye"—in an effort to do justice to the exceptional conditions in which the infrastructure of knowledge in the museum was established and how that infrastructure inflected the institution's professional culture. The two perspectives of organization and media cross-fertilize. One of the virtues of the new perspective on media launched by Harold Innis (1950) and Marshall McLuhan ([1962] 2011, 1964) has been to document the role of infrastructures of knowledge on the organization of labor. The division of labor inside the museum and its scientific communication with the rest of the world, two of the most perplexing issues in the museum, are only understood if one accounts

for the role that scientific documentation has played in articulating both a large body of things and a growing body of employees. The contribution that this traversing of Hermitage territories aims to make is a reading of an organization through its technologies of memory. It brings together questions of documentation (Gitelman 2014; Riles 2006) as a new way to understand an institution that produces art history in a confined environment where sensibilities are cultivated through a proximity to collections. The result is a study of the tensions between sensibilities celebrated to the point of anti-intellectualism and documentation as symptomatic of the conflicts that shook the museum during the twentieth century.

There is no shortage of books about the State Hermitage Museum. Searching for these books, in all possible languages, housed in public libraries, I found that more than three thousand had been published since the late eighteenth century. Some of them center on the collections, and usually refer to their contents as "treasures." Others focus on the building itself, while still others capture the extraordinary lives of museum employees. A special "curator" series published by the museum press is dedicated to these legends of the state museum (Nikulin 2010; Izergina 2009; Spassky 2013). More than employees, the curators see themselves as the ancestors of a dynasty that harks back to the beginning of the museum—specifically, the museum as a "collection in a building." These books tell the story of a museum and its collection and single out the building, the treasures nested therein, as well as its star keepers and scientists. Strangely and sadly, none of these books have ever shed light on the museum beyond the picturesque images of the building overlooking the Neva River or of the collections neatly promoted in catalogues. The silence surrounding the museum's daily activities is all the more troubling when one considers its bustling curatorial activities. Each year the museum hosts dozens of exhibitions. Some will circulate abroad; others will only display pieces owned by the museum but kept in storage areas. Much public exposure is given to the exhibitions and the building. All year long, the city is draped in images of the museum and posters of its exhibitions. Small and large

souvenirs of the museum can be found throughout the city, from the palace itself to Pulkovo, Saint Petersburg's international airport. Visitors also capture thousands of images of the museum, so that its presence on the Web offers a mix of the monumental—in keeping with the imagery promoted by the museum itself—and the intimate, with ubiquitous selfies shot in front of the most iconic pieces on display. What else is there to document when promotion, occurring simultaneously from the top and the bottom, shines so much light on the museum? All these images have one thing in common: they are part of the myth-making of an institution—a unique myth built around a building, a large palace that has been transformed since the eighteenth century, with new wings added to its initial city footprint. The myth both gives shape to the building and keeps it at bay, de-realizing it. The mythic shape created through all the images of the building has made it a familiar feature of the city of Saint Petersburg, even for those who have not set foot in the city (perhaps even more so for them than for anyone else). The repetitive media representations of the building have simultaneously virtualized its presence and flattened it to the point where we may be led to think of it as nothing more than a series of images. But, for those who have come close to it, there can be no doubt that the building is decidedly more voluminous than an image.

A BOX OR AN ENCLAVE?

The myths surrounding the Hermitage have a quasi-magical ability to both dramatize the building and render it shallow—that is to say, to turn it into a "box" containing few narratives.[5] A cursory conversation with the people of Saint Petersburg would easily convince us that the city is full of stories about the museum; it has been a witness to some of the most dramatic events of the czarist, Soviet, and post-Soviet periods. *Art of Memories* is about a dramatic box, monumental and frequently tested by a tragic succession of events that left their mark on the city of Saint Petersburg and the world at large. If we

posit that we start with a box and end with the world, this must, indeed, be a box worthy of careful scrutiny: it contains treasures that have engendered the relentless envy of the world. However, it is not a box that simply offers us a diffracted history of czarist and Soviet regimes, a miniature merely encapsulating and exacerbating all their features. It is a central character in the story of Russia, now and then, an actor in Russian art history and in the economy of Saint Petersburg. So why would one want to think of the Hermitage as a box in the first place? What sort of provocation is this, and does the topic merit yet another provocation at a time when Western scholarship on Russia is too easily disregarded for lack of respectful engagement with its subject matter? Engaging a rich and layered institution such as the Hermitage by means of the notion of the box is, however, not meant to reduce or limit it to moments within the history of imperial Russia or the USSR. Boxes are not trivial, and in the case of the long twentieth century of the Hermitage, they are also not simply a tenuous metaphor for the museum. Both as a container, in the form of the building, and as content, in the form of the pieces circulating within and across the walls of the palace, the Hermitage has had a long dialogue with boxes. Yet this would be no more than a metaphorical means of moving into the life and history of the museum if the boxes were to reveal only their seemingly simple format. *Art of Memories* claims otherwise: we cannot understand the Hermitage as a place where things and people are kept and where knowledge is produced and spread if we do not study the paradox of its spatiality as both a center of curation and a haven of protection for generations of intellectuals in Leningrad and now Saint Petersburg.

As historians of global trade (Innis 1995; Levinson 2010) have shown, boxes and packages are no trivial matter; on the contrary, they played a central role in the increased circulation of commodities and goods throughout the twentieth century. As infrastructures of communication, they explain both the types and the quantities of goods that have been boxed up, while simultaneously showing us that packaging has consequences for the modes in which nations

and continents are bridged. Global communication and trade can only be understood if we pay close attention to the role of the multiple envelopes that channel goods across borders. These insights are useful as we consider the various situations of the Hermitage since the Revolution of 1917 and as a way of understanding the relations cultivated between the building(s) and the collections. Unlike museums intentionally designed and constructed to host art collections on display, the Hermitage did not begin as a gallery. While displays and personal performances of courtiers were not out of the question, the Winter Palace—the initial building, designed by Bartolomeo Francesco Rastrelli—did not have the collection and its presentation as its goal. Neither were the subsequent palace extensions commissioned by Catherine the Great and executed by the architects Yuri Felten and Jean Baptiste Vallin de la Motte initially intended to host visitors. Rather, they were meant to extend the grandiose, rococo architectural style of the palace while housing Catherine's growing art collection. From the very beginning of its construction and the acquisition of many of the collections now on public display, the building has been thought of as a magnificent box conveying the glory of Russia. With Catherine collecting at a pace unmatched by other empresses (or emperors, for that matter) and with the opening of the collection to the public in 1854, the building was soon challenged by its contents, as the spatial expansion of a set of intended new buildings lagged behind the pace of new acquisitions. With the rapid intake of new art pieces after 1917 and then again after 1945, the tension between the architectural monuments and the collection took a more dramatic turn. The relations between these two gems of the Hermitage museum—the building(s) and the collections—have not previously been analyzed and constructed as the relations of containers to contents.

The initial architecture of the museum would be of no concern if the building remained a private space, as it was for Catherine and her close network of friends and relatives, who enjoyed the collection behind closed doors. Turned into a public space, however, the container was itself suddenly seen from within, and its accumulation

of paintings and sculptures was shown to the public. These treasures were, indeed, specimens of long-distance trade: purchased in Prussia, England, and France, they immediately opened the box to the rest of the world. If containers, boxes, and packages allowed goods to travel near and far, the box of the Hermitage brought distant treasures to the banks of the Neva, to the very heart of Saint Petersburg. Unlike containers that have been vectors for the standardization and uniformity of goods, the Hermitage snuck into Russia and then the USSR a variety of unique and exotic art pieces from faraway lands. Whereas these treasures were proudly displayed up until the Russian Revolution—and then, to a more limited extent, until the 1930s—the building itself switched from being a display case to an opaque container, limiting the circulation of its treasures within Soviet society. Once a type of window display, it later became something akin to a safe: the box was now seen as a vector of cosmopolitanism, within which its employees found respite from the rigid cultural policies enacted during the Stalinist era. In this space, employees entertained and cultivated complex relations to their surroundings and to their past. However, there was never a perfect match between the building, the contents, and the curators. The people of the museum were infused by the extraterritoriality of the box that sat in the midst of the city: they lived with the treasures of the past as much as they lived with their contemporary city dwellers. One might say, therefore, that the Hermitage has been a time capsule steering us deep into the past and to the edge of the present. The images and books published by the Hermitage Press may arrest the story of the museum and freeze it around certain moments in time, but the conversation taking place inside the museum never stops and exhibits an intense level of engagement with the collections, the public, and the various missions of the museum. The Hermitage may well be one of the most prolific manufacturers of the Russian past, in conversation with some of the richest collections of world art. It is a strange box indeed, documented lavishly but concealing more than 90 percent of its treasure, and turning out exhibitions at a rate that outpaces museums of comparable size.

In a famous text, Svetlana Alpers (1984) characterizes Dutch paintings from the seventeenth century as belonging to and partaking in a visual culture. She goes to great lengths to define just what that visual culture was like, referencing Baxandall's (1972) original perspective on social art history. Images proliferated in all circles of life, beyond the sphere of art narrowly defined: they abounded in maps, atlases, and so forth. I suggest that the Hermitage is defined by an enclave culture. The oft-used notion of "treasure" in the titles of books published about the museum makes sense within this context. In other words, from the start the museum was the site of treasure and the gem of the royal family; it became another type of enclave when the czar was ousted and the aristocracy demoted. In this new enclave, employees were allowed to maintain the old and suspicious treasure. It became a haven in the face of often brutal and unexpected events occurring outside of its walls. Promoted as a place of peace and respect, where one might find a proper education throughout the vicissitudes of the period following 1917, the museum was surrounded by actions and events that engulfed people who were not in line with or in admiration of the regime. The protection granted to museum staff by the directors is, to this day, hailed as the defining feature of an employee's experience. But the museum, while acting as protector against arbitrary arrests and other threats that colored life outside of its perimeter, was not an empty shell within. Inside, one found species as fragile as and often less naturally resilient than the Russian art lovers who worked there. People who lived and worked in the museum were not just attending to their own safety and seeking shelter. While doing that—or maybe in order to do that—they would attend to collections in need of maintenance. The relations between these two activities—seeking protection and maintaining art—deserve close attention because they always interact in the narratives offered by employees. Caring for things and the imperative of keeping the treasure that had been accumulated over a long period of time literally animates employees when they vividly recount and relive what is now presented as the quasi theft of the 1930s, when Soviet

authorities sold off some of the paintings in order to solve a bud-getary crisis.

In the history of containers told by historians of science and technology, boxes are vectors of standardization. In keeping with the motto that the interactions of content and containers are not neutral—"the medium is the message" being the media's version of this insight—the idea has been primarily one of codetermination and porosity. The bottom line of these studies has embraced the Deleuzian motto of a new topography revisiting the inside/outside divide and replacing it with networks and lines of influence. In pro-saic terms, these studies insist that containers and boxes never hide and never protect content; instead, they transform it and its envi-ronment along the way. In this book, I use these insights but also point to the other side of the coin and to the dialectic of porosity and insulation. Containers protect and allow different milieus to seemingly coexist as long as their envelopes keep them separate. In this dynamic, boxes not only breed the counterintuitive conver-gence of inside and outside but also—much more mundanely, one might say—prevent two milieus from merging. They hide as much as they make visible; they create secrets as much as they reveal treasures. But this trivial element of the box, which we exploit in an effort to understand the role of the building throughout the twen-tieth century and even to the present day, has a nontrivial conse-quence that may also explain why life on the museum premises has not stopped for lack of fresh air breathing through its doors and windows. By insulating collections and people in a confined space, the building has become a vector of surprises through a complex form of collective forgetfulness. The organization of the museum is better understood as a series of nested boxes than as a cube that accommodates transparent activities. This analogy should not be likened to the Russian *matryoshka* dolls, where the envelope tells all about the content, which is itself an envelope, and so on and so forth. In the case of the Hermitage, the large box of the building and the smaller boxes of the departments and subdepartments are architectures of secrecy and byzantine politics, but they are not a

collective zero-sum game. What one forgets is not necessarily infor-
mation intended for another, and what one hides is not necessar-
ily information kept for oneself; the museum constitutes, rather, an
architecture that fosters collective losses of memory and individual
discoveries. The forgetfulness and surprises made possible by the
nested and convoluted architecture of the museum organization
has injected a form of drama into living in a box that would not oth-
erwise be guaranteed.

THE HERMITAGE AS A LABORATORY

Art of Memories documents the unique tension of an enclave talk-
ing to the rest of the art world about Russia, French impressionists,
Dutch engravings, and all of the museum's various collections. This
enclave has produced art history from behind thick walls, at times
appearing to have more in common with the Russian science cit-
ies (Josephson 1997; Brown 2013) of the Cold War era than muse-
ums of similar caliber in terms of its relation to its own collections.
What I have previously termed a box—within the context of media
studies—I understand as a cultural laboratory within another aca-
demic tradition, initiated this time by historians and sociologists
of science who have redirected the attention of epistemologists of
science toward the actual sites of scientific knowledge production
(Latour and Woolgar 1979; Lynch 1985; Shapin and Schaffer 1985).
What kind of laboratory is the Hermitage, and why would borrow-
ing this landmark feature of modern science help us understand
a cultural institution nearly as old as laboratories themselves?
The answer to this question is that the Hermitage is both a literal
scientific laboratory and a cultural laboratory—that is, a center of
curation, wherein a unique ethos was formed during the twentieth
century that survives to this day. "Center of curation" is a varia-
tion on the notion of "center of calculation," first devised by Bruno
Latour (1983) in his work on the paradoxes of laboratories in his
study of Pasteur. The puzzle that animated Latour's inquiry stemmed

from the apparent tension between the confinement of experimental sciences happening in laboratories and the transformative effects that these sciences have had on the outside world. Another manifestation of that paradox, once formulated by Steven Shapin and Simon Schaffer in their study of the first experimental laboratories in England, in the sixteenth century, came from the tension between the secrecy and closure entailed by laboratories and a scientific ethos privileging openness and public contestation. There are notable differences between centers of curation and calculation which *Art of Memories* elaborates further in the coming chapters, but of relevance here is one common feature animating the lives of scholars and curators. The envelopes of laboratories and museums are designed to control their porosity. Like a laboratory, a museum takes from the world and gives back knowledge about the specimens it has accumulated. The Hermitage, represented by its director, a vocal advocate of the museum's research traditions, has long insisted that the institution is primarily a place of scholarship. To a greater extent than in other museums, its keepers are scholars. They write, they design exhibitions themselves, and they talk about their collections. It is also a literal laboratory, with a restoration department that keeps its objects intact, has a complex relation to its past and its future, and is charged with displaying objects outside of the clean and protected environment of the storage area. So, within the context of laboratory studies—an academic discipline that has changed our perception and understanding of scientific activities as social scientists began to study the apparently mundane and routine activities taking place within scientific institutions—a museum such as the Hermitage is a form of demarcation that produces both a form of knowledge and an experience that is not possible anywhere else. The purified atmosphere of a laboratory is not just a technical characterization of an environment created by confinement. In this case, it is also the experience of a way of life that museum employees adamantly consider unique to the Hermitage. During the twentieth century, the museum underwent a series of changes in the wake of the Bolshevik Revolution of 1917 and the subsequent waves of new

political and social trajectories inside Russia. These changes continue into the twenty-first century as the Hermitage experiments with new ventures in the world of contemporary art, at times creating outrage at the most conservative fringes of the Russian population. For all the wonders housed in the palace and its storage areas, the enclave of the museum was also a source of embarrassment for the Communist Party. Contrary to the socialist realism that was asserted in the early 1930s and pursued again during the Khrushchev thaw of the late 1950s, the treasures of the museum remained as traces of the tastes of an aristocratic past and represented bourgeois accumulation of wealth, neither of which was to be celebrated. Rather than promoting Canova and Monnet, a state institution was to provide instruction in the proper socialist tastes of proletarian artists. The walls of the museum became a convenient means of retaining treasure that should not be sold—as was the case in the early 1930s, when the USSR faced a scorching fiscal crisis and rushed art pieces to Western markets, where many masterpieces were eagerly acquired at prices below their actual value. The museum became a magnificent storage area for items that had to be retained for a variety of reasons, but not out of ideological purity. Party leaders knew that they possessed a treasure and thus had leverage in secretive conversations with Western leaders. This geopolitical compromise entailed allowing a population of keepers to maintain the collection, but behind high walls. For the regime, the impure and improper was inside, not outside. This confinement created a sense of belonging. Being a Hermitager meant more than working in a state museum. It characterized a stance toward the rest of Russia, the rest of Europe, and the history of Saint Petersburg as home to a longstanding avant-garde of intelligentsia oriented to Europe.

Saint Petersburg's glorious past as the cultural capital of Russia and the Soviet Union circulates among Hermitagers and animates their understanding of their mission. This culture of intellectuals in conversation with the West, marked by major cultural interactions, was nourished during the Soviet era, when few other exchanges of this kind were permitted (Kozlov and Gilburd 2014; Gilburd 2014).

Speaking languages, reading books, and writing about artworks owned by the museum were the forms of virtual cosmopolitanism that most Hermitagers could enjoy as members of the creative and scientific elites. These were modalities of resistance against forms of oppression that tried to enforce cultural homogeneity and a culture that would communicate to the masses the immense emancipatory effort initiated by Soviet leaders. The Cold War era turned the museum into a confined space: few scientists from outside the Hermitage stepped into the storage rooms, and visits from foreign scholars were scarce. Thus, museum employees were cursed with life on a quasi island, protected and monitored from a distance. However, this existence was not met with resentment because the island of the Hermitage was also, in many ways, a kind of heaven.[6] Many Soviet policies ceased to take effect at the front door of the museum, and the people working there understood the sorts of privileges they enjoyed. Within these walls a unique conversation with the collected treasures was possible, one that could not occur anywhere else. Just as the foreign treasures that had once been housed in Moscow were transferred and now confined within a physical periphery, a historico-cultural periphery was also instituted—that is to say, the glorious past of decadent czarist Russia now harbored both the intelligentsia that had always shown reservations vis-à-vis Moscow's power, and the pieces themselves, which served as reminders of the Stalinist era and the ultimate survival of decadent art.

DOMESTIC ART HISTORIANS

Classical museums have been analyzed in various ways by people intrigued by their strange nature: they host populations obsessed with relics of the past, are sites of objects so valuable that their destruction would damage the economy of their host countries, and are vectors of an economy of tourism that exploits national heritage and features museums engaged in global looting. As such, these institutions have much to say about the culture of conservation.

This interest in museum studies has never been as timely as it is today, with the number of museums on the rise despite the series of crises that have hit the economies of the world. Despite these crises, however, the art market has become a refuge for very wealthy individuals in search of financial vehicles that function below regulatory radars. Faced with institutions that are small worlds unto themselves, a recent trend in museum studies has been to approach them from a host of perspectives (notably, the perspective of high culture is often omitted). Museums have thus been considered from a quasi-ethnographic angle, opening up discussion of the functional hierarchies that exist in these peculiar little worlds that generate so much attention, drawing tourists and donors alike. Documentary films have deployed this perspective. *La Ville Louvre*, by Nicolas Philibert (1990), and, more recently, *The National Gallery*, by Frederik Wiseman (2015), are two examples of this trend. From this perspective, no function or activity should prevail over any other in the description of the museum. Flattening the cast of characters and setting them on par with one another allows these documentaries to treat the museum's front and back stages in equal measure. Employees in charge of the maintenance of storage areas, old ladies looking after the rooms, and the museum's keepers all partake in the same function of keeping the institution going. This much broader lens has been refreshing to the extent that it has classified as relevant those activities that were previously edited out by museum history, obsessed with the circulation and trade of a few grand masterpieces. In a way, museums easily lent themselves to this form of analysis, as the time-honored, default ethos of museum employees has itself encompassed attention to the materiality of objects: issues such as the organization of collections on display and approaches to the circulation of visitors designed to minimize the damage to artworks are natural concerns for museum managers and a daily worry for their employees.

While welcoming this broader lens, I have nonetheless privileged a particular perspective when setting my own analytic feet upon the grounds of the Hermitage. The claim of science trumpeted

throughout the museum prompts us to focus on the group of employees who contribute directly to its scholarly output: these include the keepers in charge of individual collections; research scientists without collections of their own; restorers; "methodologists," who script the work of guides and translate the work of keepers and scientists for the visitors; and finally, the guides working in the museum. All these characters frame in their own way Hermitage scholarship for an audience ranging from the Hermitagers themselves to foreign colleagues with expertise in a given collection. Research focused primarily on "scientists" is unlike the literature dedicated to the legends of the museum, which is a form of organizational hagiography produced to remind employees of the ascetic values of great keepers who devoted their lives to the good of the collection. The production of knowledge by these scholars takes place within the museum enclave, and is informed by an infrastructure that would delight any documentarian who, with lens wide open, dared hypothesize that what held a museum together was not necessarily its experts or its paintings but, just possibly, its janitors. This infrastructure, however, is both invisible to the eye of the documentarian and central to our understanding of the kind of scholarship invented in the museum. Against this (admittedly welcome) analytical provocation that sees museums as small worlds whose denizens are equals, and against the rote presentation of the legends of an organization, *Art of Memories* documents how the material organization of the museum itself produces art history.

The State Hermitage Museum is a place of sciences, from that word's most literal meaning, in the case of restorers, to its broader connotation of systematic scholarship, as cultivated by the keepers. This is one of the missions set by its director, and it has been a claim fiercely defended against attempts to separate museums from research institutions. There is certainly a great deal of science produced at the Hermitage, but it is also a museum with characteristics so unique that what "doing science" means in this context must be specified. Given the grandness both of its collections and its reputation among art historians, one may wonder whether the Hermitage

was a player among other Soviet and Russian institutions and actors only or whether it indeed shaped a more global definition of "doing science" in art history during the twentieth century. Once the museum stabilized after World War II, and once the wounds of the Nazi blockade had begun to heal, Hermitage scientists did not have long to enjoy the luxury of joining the global art history scene and engaging in conversation about their new collections. Very quickly, the curtain of the Cold War descended, separating Hermitage scholars from their colleagues in Western institutions. For scholars who had only rare opportunities to visit other museums and collections outside the USSR and its allied countries, the museum and its collections came to encompass, de facto, the entire world of art. This long episode, which marked nearly four decades of Hermitage scholars' professional history, has defined an ethos held by these art historians that we do not find in other museums. Other Soviet institutions were equally controlled and monitored in their relations with their Western counterparts, but none had collections that compared to those of the Hermitage.[7] This ecosystem, which mingled an impressive collection (which was not yet systematically organized) with a profession not yet abiding by a disciplinary standard, is what I study in this book.

Today, we observe the Hermitage at a time when a new generation of art historians, trained in the discipline's various traditions, is emerging from academic institutions both in Russia and abroad. These differences between this generation and their predecessors are noticeable not only when young graduates of prestigious doctoral programs in England or the United States return to do scholarship in Russia and meet with colleagues at the Hermitage; they are also manifest when Russian PhD students discover both the varying worlds of scholarship produced by senior scientists (who have been working at the museum all their lives) and scholarship produced by art historians trained in the traditions of German, French, and American art history. This heated encounter among different paradigms within a discipline such as art history, with its own long history of feuding orthodoxies and schools, is not itself new. Perhaps

more than other disciplines, however, art history can be recounted as the history of a series of back-and-forth encounters between different views, always entrenched and often attached to adjacent disciplines (primarily history)—or, as a discipline that to varying degrees moves in opposition to the scientific imperative grounded in formal methods and in various ways defines itself as a formulation of taste and a testimony of unique personal encounters with discrete works of art. Torn between these imperatives—generalization and the scientification of the language of art, on the one hand, and the conveyance of a unique experiential encounter with artwork, on the other—the historical account of art history intersects with the history of the Hermitage.

Buoyed by the authority and autonomy it enjoyed within the world of Soviet and Russian museums, the Hermitage set many of its own standards for the practice of art history. One such standard is the absence of what might be considered recognizable world standards. The museum lived itself as a miniature or model art world unto itself; everything was there, setting it apart from most museums, whose specialized collections lack the breadth and depth of those at the Hermitage. This autonomy also dictated unique trajectories within the museum: simply put, one would enter the museum and train oneself therein, indicating that what mattered at the Hermitage was one's unique proximity to its collection. This mode of training meant that professional codes of conduct did not apply so much as local rules of excellence. Attaching the exercise of art history to the intimate exploration of collections had two consequences that set the Hermitage at odds with the discipline of art history at large. Other institutions posited, in the first place, that for the sake of general expertise and scholarship, the general public should partake in (or at least have access to) art-historical discussions. At the same time, a hierarchy must be established between individuals with training and those without, so that access to the works of art could be prioritized accordingly. The Hermitage disrupted these rules and invented a way of doing art history that was premised on proximity to a treasure, with the consequence that anyone could be

an art historian so long as he or she was close enough to the art-work. In this context of an autonomous discipline, how are forms of legitimate expertise asserted within the organization? If certification by an external authority is not needed, if proximity is key to becoming an expert, who will settle challenges of expertise between different bodies all equally close to the works of art? Guides, keepers, security guards—any of them might claim to be the closest and most proficient experts. Few of them ever do.

OUTLINE OF THE BOOK

Art of Memories is a social history of an enclave in the whirlwind of an imperial, Soviet and post-Soviet history. The eye (à la Baxandall), the taste, and the theories of the museum are understood by making a series of stops throughout its premises. Instead of visiting each and every department or unit of the Hermitage with the imperative of exhausting the population working there, I am traveling the museum to cast light on the complex of Hermitagers and collections, to understand how they define each other and to examine how the scholarship produced inside the museum is shaped by its organizational structure. The museum is a magnificent container of artworks. That container is visited as a work of art in its own right. The treasure accumulated therein is usually presented to the visitor as eternal and eternally there, with minimal mention of the acquisition process that builds the collection. The treasure is often presented without a history, in static classifications of collections. But how do new objects come to the museum, and what are the selection principles guiding their acquisition? In chapter 1, I document the transformation of items as they enter the museum and examine the "curse" of a museum called upon to serve as a storage site for personal artifacts. Entering the museum is a difficult moment that speaks to the larger issue of the mobility of the Hermitage treasure and the sense of property and appropriation that the confined history of the Hermitagers has created.

The great number of objects kept in the museum and the rapid increase of its activities— both in house, with more exhibitions held now than ever before, as well as abroad—demands that actual collections be replicated in an information infrastructure. The information needed to know what is in storage, on display, and traveling to an exhibition in London belongs to the art of description. This is not a trivial, let alone an innocuous, activity in the museum. What may at a distance appear to be a mundane series of tasks turns out to be the germ of art history as a discipline. Although a given mode of description may be meant to simply categorize an item for functional purposes, it immediately invokes principles of aesthetics and forces decisions that resonate deeply with the Russian trajectory of art history as a discipline. In chapter 2, I revisit the territorial and professional conflicts created by the imperative of classification.

The Hermitage has a unique character: it does research and claims this activity as one of its priorities. This, in turn, informs its identity as a research institution—a very large art history department, with the objects of study within reach of the scientists working therein. A few meters away from their offices, Hermitage employees enjoy the luxury of intimate interaction with pieces that slowly become "theirs." This configuration of a largely domestic science of art took shape during the Cold War, at a time of considerable confinement. The relative lack of circulation by Hermitage scientists had consequences for the kind of art history produced in the museum. Chapter 3 documents how a culture of amateurism and deprofessionalization emerged from the museum's isolation within the Soviet Union and in relation to other research institutions abroad.

To grasp the history of the museum, one must understand the ways in which its collections have made their way into the confines of the palace. Initially comprising monarchs' diplomatic treasures, the collections came slowly to draw on a wider variety of sources. During the twentieth century, the circulation of the collections picked up speed. Under these challenging circumstances, keeping the objects of the museum in good shape and standing became a priority, and

restorers were featured as the most prominent employees, fulfilling the task of conservation for a treasure in need of constant care. In chapter 4, I analyze how restorers negotiate their duties to the treasure (by hiding it) and their responsibilities to the keepers, who seek to promote the artwork by displaying it for the public.

I go on to address issues related to the observation that most visitors experience the museum by way of a tour. If we exclude those already living in Saint Petersburg and art lovers ready to fly there to experience Canova et al. directly, a tour is often the first and last contact that tourists will have with the Hermitage. In the process, they are told what to watch and how to watch it; they are invited to experience the building and enjoy the pieces on display. But for many of these tourists, the museum is only one of several other stops in the city. How does one speak of the museum to tourists coming for a city tour rather than for a specific artist abundantly displayed in the Hermitage? This question has gained importance as people visit the museum in ever-increasing numbers. What may have been a question primarily directed at pedagogues—the "methodologists" in the Hermitage—is largely a problem of crowd management. In chapter 5, I look at the organizational problems of guiding these crowds through the museum.

I return to the space of the museum itself in chapter 6 to tie the issue of memory to technologies of documentation within the context of the Hermitage's large-scale collections. Scrutiny of the buildings and their architecture directs the reader back to the importance of the collection's topography and the important role it plays in the science produced on the premises. The argument made here is that the technologies of vision deployed to deal with a massive collection generate a form of partial memory that runs against the forgetfulness produced by the accumulation of vast quantities of artworks— if the vision is too distant, only attributes are visible; if too dense, the artworks hide themselves from the keeper.

In the conclusion, the tension between documenting the Hermitagers and maintaining the enclosure and protection of their community is revisited. The conditions under which art history

was practiced during the long twentieth century turned documents into "levers" wielded to various effects. Tools of memory for the museum keepers, documents also served as levers for outside and enemy forces seeking to pry open the box Hermitagers had so cautiously cultivated.

1

MOVING OBJECTS

etween 1930 and 1936, the Hermitage sold a number of paintings. Pressured by the economic crisis of the late 1920s, Communist Party authorities decided to cash in on the West's fetishistic attraction to these artworks, which had ambiguous value for the Party leadership itself. The money of capitalists represented a short-term fix: there were few doubts that the proletarian movement had succeeded and the revolution would continue to spread, so the treasures of the Hermitage would, in any case, soon become the people's treasure. For dignitaries outside the museum, often suspicious of museum employees spending their days dusting off capitalist memorabilia, the sell-off was not a compromise of the Soviet experiment. In fact, the czarist treasures, which had cost many lives, could now be put to good use in helping to overcome some of the natural roadblocks standing in the way of the revolution.

This episode has been recounted many times (Serapina 1999; Semenova and Iljine 2000; Odom and Salmond 2009) and in many

With Andrey Vozyanov. Vozyanov is a lecturer at the European Humanities University in Vilnius, Lithuania.

languages, but it also passed to posterity through generations of museum employees, who may not have hoped for successful world revolution as intensely as Party officials did. Instead, they saw the sale as the real and irreversible loss of some of the finest pieces accumulated by the museum in the eighteenth and nineteenth centuries. Interestingly, a recent Russian-language publication by the Hermitage Press (State Hermitage 2016) still lists these lost treasures as part of the museum's collection, as if artifacts once stationed in the Hermitage are forever meant to belong there. In many ways, and for many of the museum's employees, these estranged pieces are still part of the museum, and they feel this loss—where "they" refers both to the keepers and to the objects themselves, as if the latter still yearn for their natural site, the Imperial Palace. This discourse on the proper location and natural ownership and stewardship of artworks is not unlike that of empires in decline still listing as territories provinces that have long since been lost. What elements in the relationship between employees and the things they keep and maintain manifest such a sense of loss? Sometimes these things were not even visible, meaning that employees did not have them in their line of sight on a daily basis; however, the pieces that were sold in the 1930s were indeed in the limelight at the Hermitage and were subsequently exhibited by the institutions that bought them. It is good to remember that most of these masterpieces were not created by Russian artists or artisans: primarily the work of foreign masters, they had themselves been acquired by the Hermitage from abroad. In other words, they were imported belongings, not naturally and locally grown treasures.

Still, it is important to note that the Hermitagers' sense of loss and ensuing outrage should not be compared to the growing number of repatriation claims made by tribes and countries for archeological objects taken from their lands (Jenkins 2016; Felch and Frammolino 2011; Turnbull and Pickering 2010; Grimsted, Hoogewoud, and Ketelaar 2007). Whether in regard to bones or stone arches, museums have been dealing with an increasing number of requests for either repatriation (when possible) or reparation. These demands are usually grounded in a discourse that pits museums—as enactors

of violent deprivation—against previously colonized countries. Nothing of this kind occurred in relation to the paintings that were sold in the 1930s—no force, no looting was used in their removal; instead, a series of merchants worked as go-betweens to strike a price for perfectly legal transactions. However, ultimate sale prices were subsequently criticized for undervaluing the items, and blame was laid all around: on Party leaders for failing to understand the art market and on shady networks of merchants for setting prices too low. Despite the unease these criticisms bring to light, the transactions were completely legal. And yet, more than eighty years after the fact, the wound is still painful, and the body of the museum is missing some of its features. The strong feelings in today's Hermitage for these ghosts of previous holdings, now stranded in American museums, manifest a feature of the Hermitagers that I will document throughout the book: a general attachment to the museum as a *territory* marked by its subjects, the masterpieces maintained therein. This attachment is marked by a general interest for everything that concerns the museum—as opposed to what could be a functional and efficient division of labor assigning specialists to a particular area of expertise—and also entails a particular interest for *what is kept*. The perimeter of what is kept is not limited in scope to the place of storage or work; instead, it encloses a space that might be likened to a factory in which employees' identity as people of the Hermitage is crafted. This identity is worth studying because it is both territorial and composite. It has relatively clear delineations in the space of the city, but it is also composed of a series of collections, each of them operating as little kingdoms. Solidly attached to the territory of the museum, locked in the storage areas or in the galleries, these collections also point to worlds beyond the walls of the museum: works by Rubens and Rembrandt, coins, archeological treasures, and so forth all point to other parts of the world. This is, of course, the case for most museums comparable in size to the Hermitage—all are torn between their local footprint and their multiple world collections. But the Hermitage has a different sort of porosity, and even the term "porosity" fails to capture the specific tension of its particular embedding.

Today, a sale of pieces such as the one that occurred in the 1930s would not be possible. In 1996, a law was passed that designated all belongings of the Hermitage as inalienable, national property: "Museum items and museum collections within the state part of the Museum Fund of the Russian Federation are not eligible to disposition except in the cases of destruction or exchange for other museum items and museum collections. The decision on disposition . . . is made by federal executive authority."[1] Yet even while the museum's treasures are now solidly secured in place at the Hermitage, the acquisition department continues to bring in new pieces. Rarely are these new gems for the collections; more often they will go directly into storage and escape visitors' attention. Still, the addition of artworks to the museum creates a conversation between the existing and the incoming and gives rise to a situation of negotiation around the perimeter and the identity of the museum.

SELECTION

New items constantly enter the State Hermitage Museum, in groups and as single items. More than ninety thousand items were acquired between 1997 and 2014.[2] Groups of new items sometimes compose distinct collections; in other cases they are merely heaps of objects. People and even entire departments have as their sole responsibility the orchestration of this endless flow of new arrivals. Historically, the composition of the Hermitage was such that the things came first—before it was a museum it was a collection that mirrored the personal curiosity and political engagements of members of the imperial dynasty. As Geraldine Norman (1998) writes, imperial romances, marriages, and murders all had an impact on the collection, as did the byzantine bartering of international politics. Two of the present-day museum's principal missions—the display of art for the public and, importantly, the scientifically based study of new items—both came much later. Hence, choosing new things

frequently means dealing with old things—to the extent that new arrivals are always successors to the items already located in the museum. The difficulty is that the initial choices were made using other criteria than the ones animating today's departments and employees. In this sense, the people in charge of the contemporary selection process are, whether they wish it or not, also engaged with a succession of previous choices. Furthermore, it is not only members of the acquisition department who live with this vast treasure and make sense of its meaning on a daily basis—this is an activity in which all Hermitagers are engaged. They are the people caring for objects, who are literally "thinking objects" as a living, just as legal professionals think laws and rules. How does this coexistence influence the selection process undertaken by Hermitage employees?

To understand the selection of items for and within the Hermitage, we should depart from the stereotype that likens this process to an omnivore eager to acquire as much as possible. In a recent documentary, *Hermitage Revealed* (Kinmonth 2014), the Dutch architect Rem Koolhaas makes a challenging statement: that the uniqueness of the Hermitage lies in the fact that it is not essentially characterized by the activity of collection or selection, but by accumulation. From this vantage point, any limitation experienced by the museum as it seeks to multiply its possessions would clearly be understood as negative. This would equate the Hermitage with small museums wherein quantity is considered an uncomplicated virtue: the more the better. However, one should note that, contrary to Koolhaas's "accumulation" claim, the Hermitage is now in a much more complex position: that is to say, it expands its collections in a more focused and qualified manner, and even deaccessioning (removing objects from the collection) can be understood as an activity that adds a new dimension to the museum's purpose. Susan Pearce (1994) formulates a useful, though tentative, difference between (one-directional, plain, utilitarian) accumulation and (analytical, formally complicated) collection. However, in this regard the case of the Hermitage seems to be quite unique:

the options for acquisition are many, yet the vast majority of the items presented as candidates for acquisition are refused; that is, Hermitage employees strike a balance between selecting what is offered and searching for what is needed. This functional combination represents a much more complicated effort at *harmonizing* the distribution of things between places. It is, in fact, a harmonization of multiplicity inherited from previous epochs. Czars and emperors contributed to the treasures of the Hermitage without following any criteria that would today be recognized as professional. They took whatever items were accessible to them from wherever they could be found, and their options were virtually unlimited.

> In 1766, the natural history cabinet of the then well-known numismatist I. F. Brain was bought in Danzig; in 1771, the Münzkabinett of the Horse Guards' Captain M. K. Bremse followed. In 1775, "various medallions and ancient coins in the amount of 474" came from Livorno with antiques; in 1786, the cabinet of natural history and numismatics of academician P. Pallas [arrived]. In 1784, coins and medals that remained after the death of a favorite of Catherine II, A. D. Lansky, were added to the Hermitage collection. (Potin and Shchukin 1990)

Here and there, fashions and tastes, personal sympathies, and political relations came into play; similarly unpredictable (though undertaken, of course, under far different circumstances) was the sampling of Western art by Soviet armies during World War II. The practice of "scientifically conscious collecting" appears, then, to be a relatively recent phenomenon in the Hermitage, dating back only to the late twentieth century. Until the recent past, the people who had been bringing things to the Hermitage—be they emperors, foreign diplomats, or soldiers—had unconsciously set the museum's (quite broad) scope. The peculiarity of their position was that they could be quite independent in deciding what to add to the already existing accumulation of items. Moreover, during this period of "spontaneous" accumulation, decisions could be made

singlehandedly. Nowadays, by contrast, the Hermitage has to keep the range of its collection in mind, given its established reputation in particular spheres of specialization (though the strength of its reputation varies from specialty to specialty).

> The Hermitage's level is very high, so it needs the opportunity to select things from everywhere. (Keeper, Menshikov Palace)

And within a process of reflexive selection it becomes possible for keepers to talk not only about what they have but also about what is lacking in order to complete this or that part of their collections.

> Lacuna should be filled. If something by Juta Paas-Aleksandrova, our well-known jeweler from the 1950s to the 1970s, was brought to us, I would demand to the Committee that we purchase it. . . . This is the history of Soviet jewelry. (Member of the Russian Jewelry Department)

The Hermitage now has many such "histories of" within its scope, and each is potentially worthy of an effort toward greater completion and fuller composition. Yet, a large museum needs a clear set of priorities when it goes out and tries to expand its histories. Describing the process of collection-making, museum studies often refers to the metaphor of speech and the classical linguistic distinction introduced by Ferdinand de Saussure, which implies that the single verbal act (speech) obtains its significance only within a stabilized system of language. If the word stands for a particular artifact, then it is necessary to be aware of cultural and historical grammars for connecting several items into the "sentence" of a collection or exhibition.

> We have available to us in the social structure the langue, a body of objects, material culture, with which to produce our social lives. In order to create social sense, these are structured according to generally understood categories, and give rise to the parole,

the actual objects in daily circulation doing their social jobs. Because objects (like everything else) are only meaningful in relation to each other, these social objects work in groups or sets. (Pearce 1994, 2)

In other words, before accepting a new object one must know the *langue* of what one owns very well; more than that, one must have some general familiarity with closely related languages. One of our interviewees, from the Department of Scientific Expertise, shared such a proposal: "It would be great to have such a person, who could be aware of the whole picture of . . . let us say, Western culture."

Yet this comment reflects a dream rather than a realistic expectation at the Hermitage. A lively discussion exists on the relative virtues of lacking narrow specializations, pitting older Hermitagers against new keepers trained along more typically Anglo-Saxon principles of management. As it turns out, even the museum's subfields turn out to be too broad to be overseen by a single expert. To make matters worse, the subfields are gradually expanding. Hence, keepers discuss contradictions between at least two different strategies of acquisition. One is to purchase more pieces by a single artist in an effort to complete a given set; the other is to include more artists, even if each one is represented by only one painting.

> There are permanent arguments, discussions; the keeper must ground why he wants this or that. Why he needs the second painting by some artist—whether the artist is important, or whether we are closing some lacuna. . . . We have a lack of understanding with the keeper from the Russian Department. He wants to buy everything, and I say there's no need to, even with Fabergé. For instance, some brooch, one of many of similar kind. Without proof of its origin. He says that a similar piece was on auction, but there were a lot of similar pieces . . . including beetles and butterflies by Fabergé. Well you know, Fabergé was living not on Easter eggs and expensive snuffboxes with diamonds, but on mass production. (Keeper of Russian jewelry)

ACQUISITION AS RISK

Risk is an essential element of both the acceptance of gifts and the purchase of objects for the Hermitage. In fact, risk was the reason behind the creation of the Purchasing Committee, a complicated constellation of varied expertise—so complicated, in fact, that the committee convenes only three or four times a year, keeping queues of objects waiting at the museum's doorstep. The Purchasing Committee is composed of keepers from all departments and is designed to assess the relevance of new additions to the collection. Its discussions feature facts and hypotheses, the recognized reputation of the object, and the intuition of inspired researchers.

One of the risks that arises from accepting an item is the responsibility that the Hermitage irreversibly takes upon itself for the object's condition. By law, objects in the collection do not leave the museum once they have entered it. One could posit situations in which de-accessioning represents part of a museum's mission—arguing, for example, that items should be passed along to an institution that "fits" them better and provides the best conditions for their storage and display. In the context of the Hermitage, giving things away is not discussed because it is legally impossible. There are notable exceptions, such as the Pushkin sofa, which is located outside the Hermitage but is nevertheless cared for by Hermitagers. And some objects arrive at the museum for restoration, for which the Hermitage is well known worldwide. Hence, the decision to accept an item has long-lasting effects. Taken together, the risks involved in and limitations on purchasing objects point us to the reasons that make collecting a collegial activity at the Hermitage: it is necessary to both distribute the risk and share expertise. The risk immanent to all items has organized people of widely varying backgrounds into an authoritative body within the museum: the Sector of Acquisitions, where the negotiation, balancing, and distribution of risk takes place. People who work in the Sector of Acquisitions combine quite a broad range of competencies.

We are already [required to act as] lawyers, art historians, financiers, and customs brokers—[the range of roles] is broader every year. (Specialist from the Sector of Acquisitions)

In essence, the sector has to be aware of the *languages* of numerous Hermitage departments. This is necessary in order to define the correspondence of an item to the Hermitage's sphere of interest, to identify keepers potentially interested in specific items, to make sense of pricing on the market of museum items, and to keep in mind the quite sophisticated legal issues as well as the danger of fraud. Irreversibility dramatizes the acquisition stage. What we can glean from observing the sophisticated, multistage process of acquisition is that the necessity to select produces a number of effects. It provokes a debate by colliding classification principles; it incentivizes people to find intersections of their private spheres of interest and calls upon them to define priorities and create prognoses about artists and artistic schools. The very necessity of selection is both a constraint and an important unifying and intersubjective force in the acquisition process.

The Hermitage is always hard at work selecting items, gathering opinions, monitoring ongoing auctions, checking the availability of must-haves, and filtering out the less valuable items. The Sector of Acquisitions monitors two basic sources for new acquisitions: the first is requests made by employees of the Hermitage who find out about interesting things currently for sale; the second is offers made by people from outside the Hermitage. The selecting process is informed by two related considerations: the acquisitions budget is limited and, therefore, the Hermitage is unable to buy everything that its experts would wish to have. More interesting, the budgetary limitation creates a specific and productive constraint forcing the museum to reflect about its identity and mission. The Hermitage—with its broad and heterogeneous sphere of competence in different periods, artistic schools, and forms of art—has an indefinite potential for accepting new objects. In a sense, then, the

limitations of money and access give shape, dynamic, and direction to the museum's development. The Hermitage has to define what it is and what it is not (for example, "not Russian art," "not technical objects"). In this regard, the need to become acquainted with other museum experts and keep abreast of news in the world of museology becomes crucial.

The division of labor in the process of looking for new pieces is somewhat flexible: in some cases the keeper finds an item, while in others the Sector of New Arrivals initiates the process. An acquisition can be occasioned by collaboration or contestation among several keepers and/or departments; this is especially so in the case of composite collections. In conversation, the subject of acquisitions at auctions elicits mixed views from Hermitagers:

> Sometimes we buy items at auctions. They are very rare but important. (Young specialist from the Sector of New Arrivals)
>
> I have bought a British item from the eighteenth century from an online antiquarian resource. But I seldom do it. (Keeper of Russian jewelry)

While auction acquisition is not routine for specialists—since this method is based upon financial competition—the memories one hears about auctions are generally long narratives (not quoted in full here) that vividly illustrate the trickiness of the job, which sometimes demands of museum workers that they get the best possible object within a given budget.

> One of them, [a descendant] stricken by the crisis of 2008, had to sell [the collection], and he called us and suggested that we buy it, but we were not able to buy even one or two things from it, because prices were [over our] limit. I showed the catalogue, which was covered with yellow stickers from colleagues who wanted this or that item, to Mikhail Borisovich. The catalogue was in two volumes; both were like a hedgehog [with yellow notes sticking out everywhere]. So Mikhail

Borisovich looked disgustedly and said: well, buy two. (Member of
the Sector of Acquisitions)

This anecdote was followed by a narrative tracing the pricing
process, the long negotiations between the seller and the agitated
art historian, and the attempt to persuade the former to decrease
the price.

A second hurdle in the acquisition process is the fact that the
Hermitage has limited storage space and therefore cannot accept
everything presented to its open doors. That is to say, offers exceed
the museum's demand, both in terms of collection-building ambi-
tions and available storage space.

There are a lot of items. Items are waiting in queue for a long time
because of that large number. And storage [spaces] are full, and
there are a lot of potential gift givers/sellers, and the problem
is that there are so many good items. (Member of the Sector of
Acquisitions)

Though stories about lucky acquisitions at auction are beloved
and recalled in significant detail, the standard acquisition process
at the Hermitage is a different one. Contrary to auctions, which are
thrilling but rare, the open-door event on Thursdays is regular and,
as a rule, less exciting. Each Thursday, the Hermitage systematically
considers the items of potential cultural or historical value that are
brought by people directly to the museum. In practice, this often
means communicating with people who have little or no knowledge
in art history. As a result, museum workers take a pedagogical or
informational approach to these interactions.

They may explain: yes, you have brought a very nice coin from
the Ekaterina epoch, but, unfortunately, we have a full collection
of Russian coins. So we won't buy it. But we can explain to you
where it was made and how we see it. (Member of the Flemish Art
Department)

The prestige associated with the Hermitage as a place—and placement venue—makes these situations even more complicated. Some owners eagerly come to open-door Thursdays sincerely believing that their item has a substantive reason for being in the Hermitage (based on qualitative and formal criteria). However, the motives that draw individuals to the back of the museum—where pieces come and go—as opposed to the public entrance, are varied. Acquisition department employees clearly express their feelings about being "used" as a certification authority and cultural guarantor. At times, a visit to the open-door Thursday is simply a way of having personal belongings—long held at home but also long forgotten and of uncertain origin—named, identified, and sometimes appraised for their monetary value:

> Some just want to find out what the thing they have is. . . . They brought a tremendous miniature from 1792, by Isabey, who was a court master of Napoleon. . . and they asked for like one million dollars . . . we showed them the Artnet resource to prove that the price [could not be] more than [a certain amount], that [the miniature was] malformed, devoid of setting. . . . Finally we agreed on a price and purchased it. (Member of the Sector of Acquisitions)

Such volatility in contemporary art appraisal should be considered in light of the fact that private art collectors were prohibited from operating in the Soviet Union (Burrus 1994). State monopolies were in effect, and private belongings could neither circulate nor be sold on an open market. This ban did not help cultivate a sense of art's fair market value; rather, when artworks were transferred from one individual to another, compensation often took the form of gifts or exchanges for comparable items. This history helps explain the sometimes ludicrous and always disproportionate expectations of people seeking appraisals on Thursdays. Nonetheless, an item's price is not necessarily the primary concern of the visitor to open-door Thursday. If one considers the prestige associated with visiting the museum and, for locals, the possibility of participation in the

official Friends of the Museum program—both of which allow people to partake in the cultural significance of the museum—then one understands how an even greater prestige could be linked to contributing to the museum's collection. More than extracting a large amount of money from the museum, the point of approaching the acquisition department is to join one's belongings to a community of objects that stands for a glorious past. Donations and inexpensive offers are not rare, but they are usually reciprocated by displays of the donor's or seller's ties to the Hermitage.

> For antiquarians it is prestigious to sell something to the Hermitage. Once a good local painter presented his still-life for the kitchen in our office. Soon I read in his catalogue that his works are stored in the Hermitage. I returned his still-life to him immediately. Same story with the man who gifted two of his cameos to the Hermitage (via Yulia Kagan), and Mikhail Borisovich had signed a usual note of thanks. Soon after I saw a catalogue where the letter of Mikhail Borisovich was used as frontispiece. And formally it was not a subject for reclamation, but we would not have accepted that gift if we knew it would be publicized this way. (Specialist from the Sector of Acquisitions)

The success and prestige of the Hermitage have other unexpected consequences. Nobody wants clutter in the museum, and the relationship that donors or sellers and the Hermitage cultivate is deeply asymmetric from at least one point of view. For a variety of reasons, having one's piece enter the museum is a sign of success, either personal or institutional. For the outside party, the end result of getting a piece into the museum is that the object is now bestowed with "belonging." But for museum employees, the arrival of such an object is the beginning of what is sometimes a long trajectory for the acquired piece—an object's career that will most likely create frictions between different groups within the museum. It is also the beginning of a series of surprises. The piece is now owned

by the museum, and its employees need to care for it and make sure it is in the right place and bears the right name.

Employees who joined the Hermitage after the czarist era's major waves of acquisition never had to deal with the constitution of the collections. That is to say, the collections were already in place and had been produced either by princely tastes or by nobles and merchants who had collected privately—for example, the Morozov collection of impressionists, one of the gems of nineteenth-century painting collections owned by the museum. After World War II and the stabilization of the largest collections following the return of war treasures repatriated from occupied Germany, acquiring new items became a much more mundane activity. The actual question of the collection—that is, the entire holding of the museum—changed from tragic bonanza to a weekly routine of screening pieces that might possibly complement patchy series or missing collections. In a certain sense, lamenting the departure of great pieces during the 1930s is much easier than figuring out how best to move forward with new acquisitions.

ACQUISITIONS BETWEEN DESTINY AND CAREER

Over the past several decades, a series of related concepts has emerged as part of an effort to understand the individual trajectory of things. *Career* is a notion used by Arjun Appadurai to analyze the trajectories of an artifact's presence in the global world. Appadurai is interested in understanding how artifacts are ascribed trade value—that is to say, the process of commoditization (Appadurai 1986). Igor Kopytoff (1986) introduced the word "biography" to analyze the role of things in culture—drawing parallels with the biographical approach to the trajectories of human lives—an approach that is now widely used to understand cultures. In *Art of Memories*, the concepts of *destiny* and *career* as applied to the lives of things will follow a distinction that lies between *emic* and *etic*. *Destiny* is the

word used by our interlocutors to characterize a different approach to the agency of things in the museum. We introduce the latter not in an effort to oppose the term *career*, but rather to describe the specific role of the museum in the careers of objects: *destiny* is the stage of a biography that is imagined by museum experts and mobilized as justification to acquire things for the museum. Unlike many cases where objects undergo a series of transformations and changes of ownership but where none of these stations produce their own narrative of the trajectories leading up to them, museums only accumulate because of the relevant story they can produce about their acquisitions. The most basic elements of an acquisition's destiny are: the circumstances and personalities related to its creation; the circumstances by which its owner is found and changed; and the periods and forms of use it has undergone. An object's destiny is what a museum needs to know—or, often, figure out before it can formally own it. In a less dramatic formulation, museums talk about the provenance of an object. The object's career embraces all the above-mentioned elements of destiny but also includes being found and accepted by the museum, the changes in its condition, the mobilization of museum resources to produce the relevant kind of knowledge for visitors, its exhibition, and all other forms of exploitation and use. A thing's destiny is, of course, a key factor during the Acquisition Committee's "application review":

> There are things [that take on specific meaning upon entering the] museum meaning. [They have] potential for [different] exhibitions. When [the object] comes to the museum, but before its formal assignment to a collection, it becomes a museum item. When it comes to a particular keeper it becomes a "museum item, part of a holding." (Member of the Russian History Department)

One might say, therefore, that destiny is the set of events that occurred prior to the thing entering the museum, and its career also includes what occurs thereafter. The notion of *career* of an object points to its participation in the processes of knowledge production

and education. An object starts its career after getting into the routines of a particular museum. It can be thoroughly studied and involved in the process of historical interpretation. The object may be reascribed and placed into another classification category. It might be built into an analytical scheme or exhibition concept (each time with different objects). The career of the thing is a museum production. During its career, the perception and value of the object may change. An extreme example of this is when a fake is revealed after years of misconstrual. In such cases, a successful career is an unwanted destiny. A keeper of Flemish art shared his frustration after finding out that half (sixteen out of thirty-two) of the Rembrandt paintings stored in the Hermitage were copies. However, he admitted that real science is not safeguarded against sudden disclosures.

> Once a colleague came to me and showed the vase "Free Love" from the Russian Museum; it was registered as French porcelain of the eighteenth century and was identical to the one we have. I was astonished and upset. But then we just turned it over and saw the signature in Russian: "Subbotin, year 1802." And in theory I might make similar mistakes. In such cases we proceed to reattribution; it is fixed in inventory, and we consider the question of transferring the item to the place that is proper for it. (Keeper of Russian porcelain)

A range of actions toward objects in museums can be distributed between the modes of career and destiny. In fact, some actions—including restoration, inclusion in catalogues, and participation in exhibitions—might even take on contradictory meanings when seen from a career or destiny perspective. For example, a catalogue made by specialists from an auction house before the sale triggers the transfer of the thing to a private collection. A catalogue usually includes an introductory text (or several texts) with general information about a set of items presented and is followed by images with descriptions. But the value of the catalogue is not only illustrative but also documentary. A keeper tells us about his frustration at

seeing a painting of high value to (completing) his collection being acquired by an anonymous collector:

> It has gone, it is not here. Some lord looks at it in his castle. Private collector won't show it to me. But there's an image in the card-index of the auction house. (Keeper of Flemish art)

Though the thing was lost to the museum because of the bend in its destiny (moving to a private collection), its career potential was, in fact, created by the effort of the very people who wanted this bend to happen (that is to say, by the staff at the auction house). The consideration of the provenance information of the painting made public by the auction house started an assessment of the existing stock of similar and related pieces in the museum. It invited, even so briefly, keepers to imagine how their potential new acquisition would shake the collection. The conversations mobilizing the destiny of a potential acquisition resort often to historical figures: dates, names, conditions of production. Less often do they summon exclusively aesthetic considerations

When we speak about the relation between art and cultural value, it becomes clearer why Hermitage researchers prefer to classify themselves as historians rather than art scientists: while tastes change over time and differ between places, historical value is somewhat different in this respect, and unearthing this value requires other forms of labor. Even if the aesthetic value of a thing declines, the historical knowledge attached to it remains. Historical descriptions serve as part of museum things; without the descriptions they are incomplete. In the following example, the historical description of the collection's biography is presented before its phenomenological description.

> Now we are about to purchase one of the most exciting pieces in my career. It is a tea service by the Imperial Porcelain Factory, which was gifted to Dr. Dimzdarev (he was titled as duke) by Ekaterina in 1768 as a reward for the smallpox vaccination. If [I were] to recall the

most tremendous purchase, it [would be] Gallery Popov. In the years 2009–2010 we acquired the most significant collection of Russian art abroad. A. A. Popov founded the collection in 1919. He was a Russian officer and stayed in France before the revolution. So he gathered two collections: Russian porcelain of the eighteenth century and Russian watercolors of the first half of nineteenth century; both were unrivaled. (Member of the Sector of New Arrivals)

Such a premuseum trajectory for an object is often made public, while items of significant art value might be described in a more laconic fashion and without the need for historical narration when showcased. Most of the museum's possessions combine both kinds of value, but the two require different degrees of museum participation: with the artistic value, the narrative comes down to crediting the creator; with the historical value, it must be completed (or, better, continued) by the museum's scientific staff. Sometimes the presentation of objects—paintings, for example—includes their elements of origin. We are presented with the who, where, and when of the object: "Canova, Paris, 1815, marble statue." Sometimes we are also given information about the path that led the thing to the museum: "Belonged first to the Barefoot Contessa, then to X, Y, and Z, and was acquired by the Hermitage in 1978." The descriptive difference originates from how much the museum knows at the moment of acquisition and how much it discovers subsequently. Artistic and historical descriptions of the object leave some room to maneuver. Frequently, the museum might have an interest in concealing the path that led the object onto its premises; some biographies are not beautiful, and some are simply boring; speculation and aesthetics are able to fill this space. When a museum does not have certain knowledge of or the desire to speak about a thing's destiny, historical details might be dominated by artistic characteristics. Supplying facts that are inaccessible to the untrained eye is a type of professional test for museum workers. The eye's judgment is openly subjective, and art descriptions do not pretend to be the only or final truth; instead,

they belong to a genre that allows the narrator to say a wide range of things. Historical data about the art object expand the narration beyond the narrator's perception and also impact the gaze of the next generation of spectators, who will not only observe the thing but also read about what they see. The Hermitage community actively takes on this responsibility, hinting to us about the changeability of aesthetic fashion, as opposed to the steadfastness of historical groundwork.

Destiny can be tragic—consider the prerevolutionary Russian bells that were melted into weapons—or it can be peaceful, such as the aristocratic portraits that migrated from one monarch's palace to another. But in both cases destiny points to a given understanding on the part of the museum: whatever has happened to the object prior to joining the museum is beyond the museum world's responsibility. The dialectic between destiny and career is the tension between a museum collecting pieces of the past and a research institution figuring out what is the past, present and future of its collection. To focus exclusively on an object's career—that is, to equate the kind of events happening before acquisition with those happening once the museum gains possession—would flatten the object's trajectory and detract from the drama of the moment of appropriation. This tension between the destiny of the object and its museum-made career is all the more central to us because it pits against each other at least two groups of Hermitage employees who care for the objects. We will elaborate more on the different forms of attention to objects in chapter 4 but they play a crucial role in the acquisition process. Keepers and employees of the acquisition department, who are in charge of selecting new pieces for the collection, refer primarily to the destiny of the prospective new property. In their regular narratives of acquisition, these sought-after objects have definite properties (year of creation, identity of the first owner, etc.), and the art of buying for the Hermitage is the art of matching these new characteristics to existing ones within the rich pool of objects already in possession of the museum. As we saw earlier,

there are at least two modalities in which such matching takes place: strengthening an already present specialty or shoring up an ever-expanding pool of objects to live up to the museum's reputation for generalist ambitions in acquisition. This embrace of destiny defines the museum as a site of conservation of known elements. In opposition to this closed perspective, keepers and restorers are often led to question the finite list of characteristics of objects acquired and to reopen and produce destiny from inside the museum workshop, in a gesture that points to the open-ended notion of destiny. This second view insists that the museum does not only produce a list of exhibitions through which the objects travel. It also produces, perhaps, new insights into the origins of an object. To formulate the opposition in question as simply as possible: Keepers, in their role as acquisition advisers, present new objects as known and as investments for the sake of future exhibitions. Restorers and keepers-as-scholars of the collection, on the other hand, explore the objects, which may, to date, be largely unknown to scholarship. So destiny has a function for keepers making a case to acquire a new piece: it tells of the area of specialization and the strength of the museum. In the contentious meetings of the Purchasing Committee, when keepers all articulate the worthiness of their proposals to the museum, objects need to have a solid destiny, one that leaves no doubt as to their scope and pedigree. The bottom line is that the museum knows what it buys.

Hermitage built its collections at varying speeds. Sometimes large amounts of new materials arrived; other times they slowly trickled in to eventually form a collection. Museums are temporary way stations for paintings and statues and whatever else museums collect, but we collectively delude ourselves into thinking that these objects "belong" there and the acquisition ritual is this very moment where what had been outside for decades or centuries becomes museum material. Being the natural site of a piece produced years before and miles away is never easy. Less so when this space has been reclusive and protective of its collections like Hermitage.

OBJECTS AS CONNECTORS

Simply acquiring new items is not the Hermitage's aim. People in the museum serve, care about, or exploit objects in a number of ways. Some try to get at the core ideas behind images, some bear these images in their hands and hang them on the wall, some talk about them, some assess the damage incurred during exhibitions, some make photos of these images and edit them. But directly or indirectly, all of these individuals have an impact on the object by way of placing it, producing knowledge about it, transmitting that knowledge, recovering the original material structure of the object after it has been damaged, or preventively creating good conditions for preservation. In turn, these individuals are influenced by the objects in varying ways. Although their experiences are so varied that one could think they are dealing with different objects altogether, in fact they deal with the same physical objects. It is by now an old truism of science and technology studies to point to the role of objects in mediating and choreographing the coexistence of collectives with otherwise irreconcilable perspectives. "Boundary objects" (Star and Griesemer 1989), as they have come to be called, have indeed enriched the repertoire of collective actions and made space for a variety of things in human affairs. One of the concept's key insights is the possibility of peace in the absence of consensus and the diffracting role of objects that lend themselves to a series of incompatible interpretations, each appealing to a different public in a different world. Although the notion was coined to describe the coexistence of different experts in a museum, the Hermitage's acquisition process offers a slightly different case study. Rather than stressing the multiplicity of understandings afforded by the objects in the museum, we read in the moment of acquisition a ritual that brings together different bodies of experts. This summoning happens around the new items under consideration. The object may come with a variety of documents that appeal and talk to different constituencies in the museum, but the item also produces an

intense moment of gathering, during which irreversible decisions are made. The drama of the acquisition, couched in the legal terms of the museum law passed in 1996, means that a new piece can only be kept or transferred to another state museum. No secondary market will be able to alleviate the burden of a foolish and hasty decision made without proper consideration.

There is a second consideration that may help explain the social effervescence created by an acquisition and how this differs from the case of the natural history museum studied by Star and Griesemer in the late 1980s. The specimens they studied in the Berkeley Museum of Vertebrate Zoology are only important as carriers of attributes. Their disappearance would make no difference as long as these attributes were properly recorded in databases. In other words, the specimens are interchangeable. Scientific museums are less obsessed with—and sometimes, in their more modern and disembodied iterations, have even forgotten about—the aura of the items they collect and display. By contrast, while the Hermitage collects all manner of things (not exclusively works of the masters), the museum perpetually stages their aura. Even teaspoons or coins are always signs of cultural glories, as are the past glories of archeological findings or (a more recent fetish) collections that were the property of famous families. These kinds of artifacts are not valued as sets of attributes only; their presence is dramatized throughout the museum, still intent on displaying its treasures. In other words, the museum does not only contain information conveniently collected in one site, a one-stop shop for hungry visitors. More than this, it offers the presence of a series of historical artifacts that show in their turn the presence of czars and czarinas, noted families, or famous artists. These manifest as elements straight from a unique past, as opposed to elements from a generic nature.[3] This difference between museums as information and museums as presence explains why the facets of the objects under consideration for acquisition do not exhaust the engagement that various communities cultivate. When this happens, they have to find a lingua franca, negotiating about the object, each from their

personal expert perspective, but always focused on the object present during the negotiation. Examples of such situations go beyond acquisition proper: for example, when the physical transportation of items occurs, it sometimes produces new descriptions, as exhibitions represent moments when the object may polarize communities. These communities may have different interests and see the candidate (object) at hand from different and perhaps irreconcilable perspectives. Nonetheless, they come together to inspect the objects themselves, beyond the document trail that will quickly follow every piece after its acquisition. Prospective objects, bound for the collection, may be used by different groups for different reasons: one keeper could easily make a case for an item that will feature centrally in an upcoming exhibition, while another keeper may suggest the acquisition is needed on the basis of a "completion of the collection" argument. In that sense, these items could be quite mundane boundary objects, but their use and necessity would still need to be articulated during the Purchase Committee meeting, and as such they would have to be discussed "publicly." During these moments, the various domains and departments of the museum emerge. Instead of creating an artificial common world for parties who otherwise disagree by exploding objects into facets and attributes, the objects under consideration for acquisition force upon the many parties and constituents a consideration of the museum's perimeter and direction.

The cohesive effect of the gathering around objects has produced a distinct genre of acquisition narrative wherein the variety of expertise mobilized to decide on a new purchase is erased. Many jobs in the museum, including the work of research, entail a form of self-detachment and effacement, as they remain unseen to the ordinary spectator. In Viktor Faibisovitch's (2010) article "Dari Gnyezda Orlovih" (Gifts of the Orlov family nest), the history of the object fills the entire text, which only then concludes: "Well, the things were delivered to our museum in the spring of 2007. Five vases needed reconstruction. After this, in December 2007, they were presented to the public." The object receives its "true" and "full" meaning only after we get to know this history. The contribution

of Hermitage employees—be they representatives of the transportation company, lawyers, restorers, exhibition managers, historians such as Faibisovitch—is gently packed into one sentence. This case is only one of many self-effacement strategies adopted by museum employees in the face of the fetishization of incoming items. Despite the claim by its representatives that the Hermitage only works as an institution by being strongly hierarchical, on the personal level this claim proves to be invalid. Instead, the Hermitage is created at the intersection of multiple personal territories. The prevailing motive for the selection of objects at the Hermitage is not hedonism or personal aesthetic pleasure but rather an interpersonally shared interest and endeavor to inscribe new acquisitions into the existing collections. Rules of assemblage are formalized in a creative way that plays with classifications, scientific conceptions, and human curiosity. A continuous discussion about prospective objects takes place among different experts: some strive to make the thing time-resistant; others want to perpetuate it in the people's memory; and all of them have to pursue their respective ends in consideration of the others' declared interests, so they are forced to learn one another's languages. However, the effort and labor of harmonizing the worlds within the Hermitage is generally not seen. In fact, to the public at large the Hermitage is known for just the opposite: it is a "gathering of everything," "a universe," and is publicly positioned as a collection of things, not a collective of people who are, in fact, placed in the background of the picture.

LOSING PIECES (AGAIN) TO EXHIBITIONS

A significant part of the career of objects is their participation in exhibitions.[4] Upon entering the museum, objects are notified, the end of what may have been a tumultuous life of their own: created in a workshop, sold by a merchant, and then changing hands a dozen times following the vicissitudes of history, particularly the Russian and soviet history. The law of 1996 making all current properties of state museums inalienable possessions of the Russian

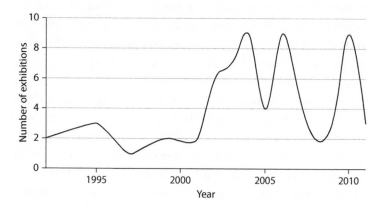

FIGURE 1.1 Exhibitions of the Hermitage's collections in Russian Federation cities, 1991–2011.

Federation dramatized even further the irreversible move entailed by an object joining the museum. So, from the distant point of view of property, the museum is an end point and a de facto removal from the marketplace. Still, museum pieces undergo circulation, just of another form, radiating from their new site of rest (storage room or permanent exhibition display) to temporary exhibitions within or (more often) outside the museum. It is not far-fetched to think of exhibitions—and the social tumult they beget—in relation to the rarer event of acquisition: exhibitions as mini-acquisitions or sell-offs. Once objects have been bought, they can circulate in and out of exhibitions and back to their site of storage or permanent display many times. For some masterpieces, this circulation can incur significant travel distances and regular visits to the restoration department. Although acquisitions are more dramatic than loans to partner museums or relocation within the museum, exhibitions also contain the same elements of social crisis as one-time acquisitions. In both cases, what is at stake points to the proper location of the objects, to the risk of displacing them, and to the perimeter of the museum.

Exhibitions are important because they force people who speak different languages to communicate about the objects. And these

people, forced to communicate, not only speak different languages but are "amateurs" of their field, meaning connoisseurs who have built their expertise by proximity to their collections rather than by formal academic training. Asking these experts to come together and to discuss their collections' items for future exhibitions brings a risk and a tension, as in these moments the bond between the keeper and his collections is questioned.

> If an exhibition of someone's personal collection is organized, people from different departments begin to aggregate all of it, but otherwise we just do not know anything; we may think some detail is missing, but it is kept by other keepers. (Specialist from the Russian History Department)

These language groups include engineers and keepers, artists and programmers, lawyers and finance staff. They might experience difficulties in their interaction: for instance, climatologists admit their astonishment when confronted with the "ambitions of exhibition designers," while art specialists find themselves debating with radiographers from the Scientific Expertise Department. Each time, the object under consideration unifies groups of Hermitagers into a collective, where professionals get to know about other disciplines. The compilation of items for an exhibition may, for example, demand a certain type of research. This work is analytical (the exhibition's initiator must devise a concept, present it to colleagues, and get the approval of the committee), but it will also include navigational and logistical work. In a way, exhibitions force otherwise rather autonomous and self-sufficient departments into a single whole.

> In order to attract the public you have to be broad. It's a headache—this invention of a concept for an exhibition. Each thing at the Hermitage is good . . . but what if [the exhibition is] "porcelain and just porcelain" . . . you choose an angle of view, intersection of East and West. With me it was the case of the nautilus exhibition. Was it difficult? Yes, very. I had to contact different departments. (Keeper of Russian jewelry)

The constellations of objects are interactive in relation to the exhibition space. All the curators spoke of how sensitive paintings are to temperature and light, and the constraints this places upon them when considering a particular item for one exhibition in relation to a tight schedule for displaying it again in others.

The [number] of items is matched with the size of the exhibition hall—it might be 100–120 or 200–250, depending on the format of the objects. For paintings one needs a large hall, for example, Nikolaevskiy Hall. Then, the humidity and temperature conditions for particular material [are significant]. Porcelain, say, might be anywhere, but graphics must not be placed under direct light. If the exhibition features heterogeneous items—say, glass, graphics, paintings, porcelain—a choice also has to be made.... My exhibition Antique Reminiscences needed to be in a traditional place, but [the most suitable space] was occupied with a temporary exhibition, which could not be demounted because they had already sold season tickets for the next year. So they gave me the fore-hall, which was perfect, and the Antique Reminiscences exhibition was resonating well with the decoration of the hall itself. (Keeper of Russian porcelain)

Organizing an exhibition also demands logistics in timing because the museum object is unique and cannot be in two places simultaneously.

It is not that they give out everything at once—the items may be already reserved for forthcoming exhibitions. So, compilation takes effort, though it is not visible at the exhibition. (Keeper of Russian porcelain)

Exhibitions are moments of aggregation and disaggregation, occurring much faster than in the case of permanent holdings. In this process it is possible not only to familiarize oneself with other holdings but also to see one of the many possible combinations

of the objects, which differs from the context of its own individual holding. Exhibitions are moments of new information. They may not disrupt the nearby objects from the museum's existing holdings. Exhibitions are increasingly manifestations of curators' search for a primary role and claim for creativity in the art world, but they do not force a change of categorization, a new thesaurus of descriptive terminology, or a new division of storage space. Still, despite the different logics of exhibitions and in-house description and storage, exhibitions become steps within an object's career, a piece of information mentioned in future resumes, as documentation and trajectory of a piece.

> Sometimes you need to indicate not only the year of acquisition but also [the object's associated] literature and [previous] exhibitions. (Keeper of Russian porcelain)

An exhibition means a new chapter in the life of a museum property. Its previous chapters included the object's provenance—at times a complex series of back-and-forth transfers among dukes, princesses, and merchants. Keepers, in their infinite task of recording and documenting the pedigree of their collections' pieces, see these additional layers, made up tours within and beyond museums, as so many pieces of information that need to be kept and updated. So, although it would be fair to question the casting of the exhibition ritual as a quasi acquisition in terms of transfer of property, from the point of view of the social drama that comes with the mobility of objects usually kept in one site (gallery or storage), exhibitions stir passions in ways that compare readily with the acquisition of new pieces. Museums like the Hermitage are peculiar organizations to the extent that they combine two missions: keeping objects as parts of collections and showing them in the context of exhibitions that sometimes cut across the boundaries created by the collections. Properly keeping and preserving the treasures assembled in the premises of the museum sets a series of constraints, but it comes with a clear mission: maintenance. Showing objects in exhibitions

sets another series of constraints that can collide with maintenance: mobility. The Hermitage belongs to a hybrid type of organization that one could call a "project organization." If we survey the daily activities of Hermitage researchers, we find a mix of long-term tasks meant to produce science for the museum and more short-term, exhibition-related activities. The long-term science tasks usually involve some form of *catalogue raisonné* or monograph. These activities deal with the stock of objects and document them in more or less public fashion, as some of these activities absorb researchers for long stretches of time before they produce results that can be published. The other kind of activity does not look at the eternal collection as such but focuses rather on short-term performance that can only disrupt the other process of maintenance and documentation of the treasure.

The temporality of the exhibition is of a much smaller magnitude than the permanent fund: once the decision is made and an opening date announced to the public, employees have to collaborate, sometimes disrupting the orderliness of their long-term occupations. Working on an exhibition entails moving things from either their safe storage location or their permanent display. The exhibition shakes both the internal world of the Hermitage and that of the partner museums contributing their pieces. In both settings, exhibitions stand in the way of rest for both exhibits and museum employees. The "project" form, if pushed to the limits, could jeopardize the organization. A new addition to the Hermitage, its contemporary art section "Hermitage 20–21," operates almost exclusively as a project section, its exhibitions bringing in items from outside collections. Art galleries without funds and (as is typical) with few artists may be considered projects. Unlike the Hermitage, they do not commit to artists beyond the prospect of selling their work. Should an artist fail to gain prominence despite the gallery's public relations efforts, he or she could disappear from the gallery's catalogue and the project could end.[5] This configuration puts a strain on the museum employees.

An example will illustrate the nature and extent of such strains: A Hermitage historian, Marina Lopato, suggests curating a daring exhibition, "Monologue in Praise of the Seashell," revisiting several Hermitage collections and compiling 150 objects from around the museum, including cowries that served as currency in traditional societies of Indochina, a Nepalese figurine of a lama, netsuke from Japan, a scallop-shaped snuffbox of seventeenth-century Saxon origin, and several cameos by Dutch and Russian masters from the nineteenth to the twenty-first century. This diverse sampling of items is not a far-fetched thought experiment; such exhibitions exploiting the variety of treasures hosted by the museum are a trademark of the Hermitage. For Lopato, the Hermitage collections were not complete and self-contained universes but rather data points that she forced to interact with one another around an innovative theme. Cutting through existing collections, domains, centuries, and regions, Lopato looked at the Hermitage from a different angle, one afforded by the attributes of its objects. This new angle raises a new type of justification for acquisition, thereby challenging the notion of completion. At the same time, it multiplies the possibilities of exhibitions: a piece is no longer just the work of an artist, genre, school, movement, or era. This new way of looking at the Hermitage's collections increases the potential mobility of objects also meant to remain in place, adorning the museum eternally.

CODA

In 1918, immediately following the seizure of power by the Soviets, Russian private art collections were nationalized. Among them were the modern art collections of prerevolutionary merchants Sergei Shchukin and Ivan Morozov. The collections consisted of the works of impressionists and postimpressionists—Cézanne, Renoir, Monet, Van Gogh, Gauguin, Matisse, Picasso, and others—a few

hundred paintings and drawings in total. In 1923, the Museum of New Western Art was created in Moscow on the basis of these collections. In 1948, Stalin closed the museum, and the items were divided between Moscow and Leningrad. The Pushkin State Museum of Fine Arts, in Moscow, received about three hundred paintings; the Hermitage, in Leningrad, was entrusted another three hundred. For both museums, these collections became the "crown jewels"—attractive collections for domestic visitors and foreign tourists—as the art of impressionists and postimpressionists has not come out of fashion ever since, and the museums have exploited these treasures by publishing about them extensively. In April 2013, Irina Antonova, the Pushkin Museum's director, used her annual live television call-in show to ask Vladimir Putin, president of the Russian Federation, to restore the State Museum of New Western Art in Moscow by reuniting the divided collection. It was not the first time Mrs. Antonova put forward the idea, but this appeal to the president came as a surprise to many. It triggered a public debate on the subject, which lasted until July 2013, when the Russian government decided against reuniting art collections. Instead, it was decided that a virtual museum of New Western Art would settle the issue, leaving the collections where they were but giving a second life to the once banned institution.

For Irina Antonova, an employee of the Pushkin Museum since 1945 and its director since 1961, the reunion of the modern art collections was a longtime dream. She had debated the topic regularly with Mikhail Borisovich Piotrovsky, the director of the Hermitage since 1990. But it had never attracted much attention outside the museum community. During the call-in show on April 25, 2013, Mrs. Antonova first outlined the history of these collections and underlined that the Museum of New Western Art was closed in 1948 by Stalin on the basis of a repressive ideology. She then pointed out that restoring the museum would be in line with Russia's de-Stalinization trend and would provide the country with an outstanding museum. After mentioning the necessary displacement of paintings from the Hermitage to Moscow as the "difficult point"

of this project, she asked President Putin if he would support the idea. The president answered that he would support the restoration project but that it first had to be discussed by the community of museum professionals. He then gave the floor to Mikhail Piotrovsky, who pointed out that there had already been an exchange of items between museums, and the Pushkin had got hundreds of paintings from the Hermitage in the 1920s, pointing to a "debt" that the Pushkin owed the Hermitage, as opposed to the purported joint debt that both museums owed the ghost of the Museum of New Western Art. Sharply but with emotional undertones, he concluded by saying that it was a shame that such museum issues were discussed in that manner—by appealing to the president. Concluding the discussion, President Putin repeated that the solution should and would be worked out by experts.

What qualifies one as an expert when it comes to deciding the legitimate ownership of an artistic piece? One could legitimately question the positions of Antonova and Piotrovsky by pointing to the irreducible convention of the appropriation of treasures, whether such acquisitions are archeological or more directly the product of artists celebrated as such. The Hermitage, with its broad collections spanning archeological treasures and artistic movements, is a place of a unique ritual, where the variety of these exhibits is both celebrated and collectively forgotten. The celebration happens both during the uncertain moments of acquisition, when the museum is continuously probed about its orientations, and when the strength and concentration of its existing collections are discussed to settle on a new piece that will complement, enrich, and strengthen the existing lot. This moment is uncertain and rife with risks to the extent that it operates as a mirror and an identity test whereby each existing exhibit can be mobilized to support a new one; but with the mobilization of the presence of preexisting collections, the histories of their acquisition resurface and the increased heterogeneity of the museum collection appears more imminent. In the course of a risky celebration of the multifaceted collection, each new piece is also simultaneously absorbed

and tagged as Hermitage property. The label is a way of asserting the perimeter of the museum against the dispersion of its exhibits. Be they archeological treasures or the works of postimpressionists, once in the museum, the objects are there to stay, and each attempt at tampering with the property of the museum is faced with a drama similar to the one triggered by Antonova.

INTERLUDE 1

Art History and the Hermitage Before World War II

I f the history of the Hermitage in the second half of the nineteenth century is one of enclave and confined development of scholarship for amateur art historians sitting atop global treasures, the story of the early twentieth century starts on a different note, one of opening and cosmopolitanism. Prior to 1917, the Hermitage had been recruiting outside expertise when local cadres were not available as was frequently the case. In the mid-1860s, when the first director of the Imperial Hermitage, Stepan Gedeonov, was hiring for the vacancy of Hermitage Gallery keeper/curator, he offered the position to Otto Mündler, a consultant at the National Gallery in London, and to a professor of art history in Zurich named Wilhelm Lübke. By that time, Ludolf Stephani, a Leipzig-educated historian of classical art, had been the curator of Greek and Roman collections since the early 1850s, while Bernhard von Koehne, a former *Privatdozent* at the University of Berlin,

With Nikita Balagurov and Evgeny Manzhurin. Nikita Balagurov is Senior Lecturer in the Department of History at the National Research University Higher School of Economics in Saint Petersburg, Russia. Evgeny Manzhurin is Junior Researcher in the Karelian Institute at the University of Eastern Finland, Finland.

had been the curator of the Hermitage coin collection since 1844. In the following decades the number of scholars working at the Hermitage was gradually increasing, and by the mid-1880s it had among its staff five chief keepers heading departments and seven other keepers, four of whom were employed in the Department of Painting. There were also three restorers and forty-seven attendants. In 1886, Andrei Somov was appointed chief keeper for the Department of Painting, a job he would keep for over twenty years; Somov tasked himself with a scientific inventory and cataloguing of the collection. Before taking up his position at the Hermitage, Somov, trained in physics and mathematics at Saint Petersburg University, taught physics and worked at the offices of the Academy of Sciences. Although Somov always worked in academia, he was a self-educated art historian who nonetheless received wide recognition in the field. In the 1870s he compiled catalogues for the art collection of the Imperial Art Academy and in 1883 became the editor of the *Vestnik iziaschnykh iskusstv* (Fine Art Herald), one of the first specialized publications dedicated to the arts. Somov published a new, three-volume catalogue for the Hermitage collection; the project involved many visits to museums abroad as well as collaborations with leading international experts, including Wilhelm von Bode and Abraham Bredius. Following Somov's tenure, the Hermitage Art Gallery was headed by James Alfred Schmidt and Ernst Friedrich von Liphart. Schmidt was a doctoral student of Alois Studnička and August Schmarsow in Leipzig, where he specialized in Italian art, while Liphart was a Florence-educated artist of Baltic German heritage who taught himself art history traveling around the major European museums.

Between its opening as a public museum and its nationalization by the Bolsheviks, the Hermitage established a level of art history that was on par with its European peers. Its catalogues, a genre that remains central to museum science up to the present day, were written in concert with international scholars of the first rank and were published in several languages. Its curators were trained in art history to the standards of the time and published in leading journals both in Russia and abroad. These publications

made the collection a visible part of the international landscape, made it accessible to the international scholarly community, and rendered it an object of study for scholars based both in Russia and elsewhere. Despite this achievement, however, training in art history remained unavailable in the Russian Empire. One could argue that the Hermitage itself was a place for training in European art history—indeed, the museum required and attracted knowledge in this field, and the collection itself could have helped one to become a connoisseur. Yet it was only so for the privileged few. For non-Hermitagers, the best option for training in art history was a history-based university education, in which visual arts were taught as part of the archeology curriculum to facilitate the classification of artifacts. Eventually, the gap in the Russian academic landscape was to be filled by the Hermitage museum, which quickly grew into a major educational and research center in the field of art history.

In the 1910s a new art history hub started to take shape at another Saint Petersburg institution nearby: Count Zubov's institute was the source from which nonmuseum (academic) art history would eventually develop, offering a focus on the history of styles rather than classification, attribution, and cataloguing. The Institute of Art History, at Saint Petersburg, was a private initiative of the wealthy aristocrat Count Valentin Zubov and his two associates, Mikhail Semionov and Trifon Trapeznikov. The institute was supported by Zubov's personal funds and was housed in his family mansion in Saint Isaac Square. Modelled after German institutes in Italy, it was originally conceived as a research library, and when Zubov decided it had to take on educational functions, his personal friendship with many of its future professors was key to the institute's success. Art history as a field was at the time still marginal both in Russian and European academia. In Europe, however, professorships in art history had already been established, and Zubov took classes with a number of these pioneering teachers during his studies in German universities. Zubov discovered to his astonishment that, unlike in Russia, art history was taken "seriously" in Germany, and was thus elevated from an auxiliary to the fields of history and archeology to

a discipline of its own. As a text produced for the opening of Zubov's institute put it:

> This science, developed in the West, was barely noticeable in Russian practice. For it truly was some sort of an auxiliary branch of archeology in both our research institutions and university practice; it was so even in our professors' heads. There are a few connoisseurs of the art of Antiquity but in this area art history bears a clear imprint of archeology. Art objects are used as sources to study religion and everyday life or to facilitate the interpretation of literary works. (Nekrylova 2012, 201)

Zubov's discovery that art history can indeed be "serious" science took him through a number of German universities in search of a supervisor. By the time he completed his doctoral thesis with Adolph Goldschmidt in Berlin in 1913, he had already established the Institute of Art History, its original conception based on that of the German Institute in Florence. It was to have two main functions, serving as a major library of Western art for researchers to work in and as a host institution for occasional seminars. In continuity with the original institution, the premises now host the State Institute of Art History (SIAH), and some of its traditions continue to this day. One of them is the strength of the formalist approach, advanced by Heinrich Wölfflin and still influential in the method of art history practiced at the SIAH and among Russian art historians in general. The root of this feature of the Russian art history landscape goes back to Zubov's student years. In Germany, Zubov studied with August Schmarsow and Heinrich Wölfflin, among others. The specific vision of the discipline that Zubov formally established in Russia was in tune with that of Wölfflin. In his 1913 lecture on the methodology of art history, Zubov proclaimed:

> The main objects of our study are not separate art pieces but the evolution of artistic forms. To make such study possible, one needs proper knowledge of separate pieces and relevant historical facts. . . .

Secondly, the study of art pieces also means a comparative observation of their characteristics, both formal and technical, or, in other words, formal or technical criticism. We understand comparative methods as critical methods or methods of analogies. All methods regarding procurement will be called archeological methods. All these approaches serve to study the laws of evolution of artistic forms. Thus, speculations concerning the latter question would be the culminating point of our science. (Nekrylova 2012, 202)

This was the beginning of art history outside the museum. Wölfflin's ideas, brought by Zubov, took root in Russian academia, but less so in the Hermitage museum. The Hermitage keepers, cohabitating with the formalists at the Zubov Institute, seemed to be indifferent to formalist innovations. The problems of style and artistic forms would become the key issues for the art historians associated with the Moscow State University and the art museum that was its offshoot, now known as the Pushkin State Museum of Fine Arts. Most of them, including leading scholars of Western European art such as Boris Vipper, Ievsei Rotenberg, and Marina Sviderskaya, spent some time working at the museum, which, in Rotenberg's words, was "as important for a true art historian as military service for a true man" (Chakovskaia 2013, 493). This connection between the Moscow State University and the Pushkin Museum was more in tune with European practices of doing art history, or to be precise, with the practice common among the representatives of the Vienna school of art history. Closely aligned to Wölfflin's ideas, they normally combined university careers with curatorial work in museums or in conservation.

During the 1920s the Zubov Institute was a relatively untroubled haven especially in comparison to universities that were being overhauled to make sure the youth was not misguided by dissenting faculty members and to bring up a new generation of socialist scientists. As a more research-oriented center, and thanks to Zubov's connections and unique position, the institute was spared many inspections. However, when Stalin launched the

general push for a uniform socialist realist art in the late 1920s, many of the faculty in the Literary Studies Sector were attacked for formalism. Some had to leave, while a few ended up in prison. The institute went through a series of reorganizations and in 1931 was absorbed into the newly created and short-lived State Academy of Art History. As a result of further reorganization, the Sector for Visual Arts was transferred to the Leningrad Academy of Arts and moved to the eighteenth-century building that formerly housed the Imperial Academy of Fine Arts. A preparatory division organized in 1936 was staffed with leading scholars from the State Institute of Art History. Alexander Guschin, the former head of the Visual Arts Sector at SIAH, became the first dean of the Department of History and Theory of Art. Guschin's wide range of research interests was common at that time. Specializing in prehistoric culture, he also published books and articles on crafts in medieval Russia, the origins of art and architecture, Western European art in the Middle Ages, eighteenth- and nineteenth-century French art, as well as contemporary Soviet art. He taught theory and sociology of art and Marxist methodology of art. One of his students, Tsetsiliya Nesselshtraus, recalls:

> Such a diverse range of activities was in tune with the time and responded to the strife to bring the discipline of art history closer to the problems of contemporary [Soviet] art. This was the mission set for the organizers of the Department of Theory and History of Art at the academy. (Nikulin and Pavlov 1998, 5)

2

DOCUMENTING THE MUSEUM

There is a trivial fact about the Hermitage: it contains an enormous number of items. It would take you *eight years* to go through the whole museum even if you spend only one minute per item.[1] This is just one of many astonishing figures having to do with the Hermitage. The number of items in the museum is itself an element of folklore, cultural capital, and expert knowledge. Quantities matter when we talk about the Hermitage and its mission, but they also matter qualitatively. The multiplicity of items that number in the millions supplies not only a cultural image of the Hermitage but requires that the museum account for and classify each and every one. Simply keeping the collections in the spaces of the building requires some classification so that storage does not devolve into the random act of stocking. If possessions are to become collections, the imperative of documenting along the lines of classification is even stronger. It is impossible to describe and manage the variety of objects kept in the museum

With Andrey Vozyanov and Ekaterina Dyachenko. Dyachenko is Research Fellow, Institute for Statistical Studies and Economics of Knowledge at the National Research University Higher School of Economics in Saint Petersburg, Russia.

without agreeing on common features. Is an item a painting or a sculpture? An Italian or a French sculpture? Without these common properties attached to objects, collections accumulated in storage would lapse into chaos. With large numbers come large and varied classification schemes, and these classification schemes can, in fact, collide: the Hermitage deals with different alphabets, enumeration principles, documentation forms, and approaches to what proper history of art and culture means for the daily activities of keepers. Faced with this tension, organizing and making an account of the collections is both a prerequisite for all further operations and a moment of potential crisis. So, as museums describe things in a way that relates them to others, this reduction of the collection happens simultaneously with another gesture, central to museums: the presentation of their objects as unique. First, this requires a relational evaluation in order to figure out the meaning of a particular item within its artistic context. Concomitant to this effort is the need to know a lot of things belonging to a given type, and to compare and evaluate them. This procedure requires the expertise of art historians or historians of material culture. Second, the museum needs to accumulate this expert knowledge in a form suitable to share so that a person providing commentary on an object held by the museum is not left as the sole owner of "information" pertaining to the object. What is known about the things held in a Hermitage department has to be connected to other sources, either from other departments or from outside. Employees need to design a mode of communication about their collections that allows them to speak about a treasure at a distance, without having to point to the object as guides do.

Moving beyond internal, domestic communication issues and with many pieces circulating beyond the confines of the museum, Hermitagers must put in place a common grammar so that the museum remains more than a mere enclave. The peculiar history of Hermitage scholarship, developed in relative isolation, has not helped the establishment of a common set of descriptors across departments, let alone in relation to other museums. The promiscuity of scholarship during the waves of acquisition and the organization of research did not create appropriate conditions

for "information" to be produced in a systematic manner. Rather, the appropriation of individual collections by their keepers and the low turnover among heads of collections were seeds for the production of deep personal knowledge, solidly attaching keepers to their treasures. This tension in the production of information animates the relations of the scientific community at and around the Hermitage in a fractal fashion. At each and every level of its organization, the museum oscillates between establishing its own language and following the existing vocabulary of art history. This tension also manifests different and divergent understandings of what counts as the proper role of a keeper. In all departments of the museum, a romantic view of the duty of the Hermitager still prevails, bordering at times on anti-intellectualism. This preference for personal and affective engagement with the collections is based on proximity. In fact, it predates the museum, as the figure of the connoisseur in most Western societies signaled aristocratic distaste for professionalism and the division of labor. In the case of the Hermitage, it has been exacerbated by the political situation of Leningrad since the 1930s and the rise of Moscow as the center of decision-making, which de facto provincialized the families of Saint Petersburg and relegated them to a toxic treasure. Under these conditions—with communications limited and the object of care and study disqualified nationally by Soviet guidelines while worshipped internationally—producing information about the collections was not a straightforward endeavor. Factors of competition played out both locally and internationally, and they framed a form of censorship at the level of the state inasmuch as some of the most famed pieces were no longer to be studied. Why write notices that circulate in the museum and expose the extent of my collection? Why not just enjoy the treasure in a selfish but deeply secure way? Any other approach would jeopardize a keeper's control over his collection. Records and their infrastructures of knowledge were problematic documents because they immediately engaged keepers with questions of expertise and territoriality.

We use the Hermitage and its unique history—shaken by the vicissitudes of the czarist, Soviet, and post-Soviet history of the

twentieth and twenty-first centuries—to think about the articulation of art history and technical practices of documentation. Museums have two kinds of collections: the objects (of which only a fraction are on display) and the records standing in for the objects (whether they are on display or kept far from the gaze of keepers and visitors). One must also consider that the impetus to count things and to account for differences between many things came from many different horizons. At this point in the discussion, my own analytical gaze is still directed within the museum, but we will soon move out of its walls when studying its scientists as they move outward and publish about their collections. However, we first want to pause and ask to what extent the quite specific history of art produced in the museum is a progeny of the notice-making activity that beset keepers from the very moment of acquisition: inscriptions, categorizations, and the like whose ambition was order in the wake of the chaos created by the influx and variety of new candidates to store or display.

From short and sketchy notices meant to keep track of pieces when they are no longer under the purview of keepers to standard forms of art history as we know it (which look for formulae and are uncertain as to the proper perimeter of the discourse on the works of art in question), we search for a continuity showcased within the Hermitage. The simplest way of visualizing this continuity is to characterize both the notices for internal and personal use and the grand theories for readers who are ready to take such interpretive leaps as attempts to "talk about" art objects. As a keeper, whether I search concise, qualificatory modalities in order to sort items in a catalogue or engage in larger and more abstract theories, I am always reacting to images or forms and looking for a proper place for them in a cosmology—at times, a very limited cosmology, merely that of a museum official in charge of a collection and looking to bring order to a few dozen pieces. At other times, the cosmologies invoked are very ambitious indeed. Documents produced about pieces in the collection can originate from within the museum but nowadays also originate from a great number of sources outside the

confines of the Hermitage. In their most domestic form, they help us understand the intimate conversation that keepers entertain with their funds. The audience of that first conversation is limited; at times it is purposefully contained so that the order created by the notes taken about the pieces remain exclusive and for personal use only. Questions related to sorting and storing predominate at this stage, and the Hermitage's limited space determines the types of classificatory questions that animate the writing about its collections. The other end of the spectrum of inscription decouples the writing from storage imperatives; however, the inscriptions remain vividly occupied by the imperative of categorization, one that simply exists within a different space, this time charted by art history. Historically—and this is a unique feature of the Hermitage within the galaxy of comparably sized institutions—the journey from domestic to deterritorialized along the spectrum of inscription has been made backwards, starting with outside connoisseurs writing about the collections only to go back to the documentation of the maintenance imperatives as produced by domestic keepers.

We look at the documents designed to stand for things because they tell us much about the proximity of employees and collections. They are also a form of proto–art history, with a specific imperative that animates the keepers and specialists working with the objects: the imperative to create annotations and descriptions that make sense of what is in their possessions, allowing discrete elements of the collection to be retrieved, if needed. Stretching art history "upstream" towards these practices of archiving and describing is not an academic caprice stemming from a desire to challenge art historians' sleek and satisfied discourse—a discourse that is, in any case, not as sleek and satisfied as one might posit because the discipline of art history is regularly shaken by inner crises that tear apart short-lived creeds and principles. The reason motivating this approach is the specific history of the Hermitage, which underwent its own series of crises, moving it in a direction of satisfied engagement with its own resources and domestic conversations.

ARCHEOLOGY OF DOCUMENTATION

The documents containing information about items held in the Hermitage's fund are as vital to the museum as the items themselves. Here we will briefly reconstruct the development of the museum's collection documentation. The very beginning of this history highlights how inseparable description and classification practices are.

> The Hermitage received its first documentation when it got its first structure—earlier, in the eighteenth century, it was just the private collection of Ekaterina; the keepers were painters, so it was just documents of the court. In the beginning of the nineteenth [century] the enlarged property of the museum was in need of structuring, so it was divided into four departments, each with its own keeper and chancellery. . . . This was the way documentation began to be accumulated. (Hermitage archivist)

The history of Hermitage documentation begins soon after the collection was started, more than two hundred years ago. However, in the eighteenth and nineteenth centuries the gallery was not involved in large-scale book publishing; the first publications associated with the Hermitage were the collection catalogues, which appeared many years before the gallery was opened to the public in 1852. Naturally, the catalogues were initially handwritten, but quite soon thereafter, in 1773, the first printed catalogue of the Hermitage collection appeared.[2] It was written by Count Joan Munnich in French, the language widely used by the Russian elite during the eighteenth and nineteenth centuries. The catalogue contained brief descriptions of more than two thousand paintings and was used as a guide by those who visited the gallery, as it was arranged according to the disposition of the paintings in the halls. Sixty copies were printed, and they soon became a bibliographic rarity.

The second publication about the Hermitage is of a different genre, one that was to gain prominence with the transformation of

ECOLE ITALIENNE.

ULISSE ET NAUSICAA

4e
Tableau de Salvator Rosa.

Peint sur toile; haut 5 pieds 3 pieds 11 lig.; large de 4 pieds 6 pouc. 4 lig.

Jetté nud par la tempête, dans l'isle des Phéaciens Ulysse vaincu de fatigue, goûtait un sommeil profond près d'un fleuve, sous des ombrages épais. Tout à coup des voix éclatantes le réveillent. La fille de Roi de l'Isle, la jeune *Nausicaa* venue en ce lieu solitaire pour purifier ses robes dans les eaux du fleuve, jouait sur le rivage avec ses compagnes. (*) ,,Ulysse rompt alors une branche ,,chargée de feuillage, s'en forme une ceinture, sort de sa ,,retraite et s'avance. A l'aspect imprévu de ce mortel ,,souillé du limon des mers, les jeunes Phéaciennes saisies ,,d'épouvante, fuyent et se dispersent. ,, C'est l'instant du tableau. La fille d'Alcinoüs ne prend point la fuite; elle écoute l'infortuné qui l'implore, et pénétrée de compassion lui présente un voile. Deux jeunes filles sont à ses pieds et cherchent à se cacher; une troisieme derrière elle, moins effrayée ou plus curieuse, élève la tête par dessus son épaule et regarde furtivement Ulysse. Les autres ont disparu. Ces femmes forment un groupe charmant; la fermeté décente, l'humanité de la Princesse, contrastent avec l'effroi de ses compagnes; et la jeune curieuse, dont on n'apperçoit que la

(*) V. Odyssée chant VI. trad. de Bitaubé.

FIGURE 2.1A Excerpts from Labenski (1805).

FIGURE 2.1B

the gallery into a public museum. In 1790, Johann Gottlieb Georgi, a naturalist and physician, was invited by the Academy of Sciences to write a guide to Saint Petersburg. *Experience of Describing the Russian Imperial Capital City of Saint Petersburg and Attractions in Its Surroundings* is written in German and contains four pages on the museum, approaching it primarily as an architectural structure. In 1794, the guide was translated into Russian as a tribute to Catherine the Great; in this version the descriptions of the city's cultural characteristics were expanded significantly. From the very beginning, the descriptions of the museum and its collections were written by foreigners in languages other than Russian. The first Russian catalogue appeared in 1797, under the guidance of Franz Labensky. It contained brief descriptions of about four thousand paintings. The catalogue remained in print and served as a basic inventory of the gallery until the mid-nineteenth century (Yefimova 2009). In 1805, Franz Labensky embarked on a publication of prints from the best Hermitage paintings, accompanied by texts in Russian and French (Figures 2.1A and 2.1B). Engravings of the Hermitage paintings had been published before, but this two-volume work can be considered the prototype of the modern museum catalogue, telling stories about the gallery and presenting reproductions of seventy-five of its chefs-d'oeuvre (Kagane and Kostyenevich 2008).

When in 1852 the newly completed New Hermitage was opened as a public museum, its collection was to be accounted for in inventories and catalogues. This gave the Hermitage collection a documentary representation that is now expected of any modern museum. The first inventory of paintings at the museum and in the Winter Palace in general was mostly finished by the late 1850s, and was to serve as the main inventory document until as late as 1924. The more analytical task that followed—the compilation of a catalogue for the New Hermitage Art Gallery—also required a more profound knowledge of art. The two artists responsible for the catalogue, Lukashevich and Simon, were, like most Hermitagers at the time, what Levinson-Lessing (1985) called "cultured and fairly knowledgeable *dilettanti*" (193). So it came as no surprise that the final version was

edited by an external expert. Gustav Waagen, the then director of the Berlin Museum Art Gallery, was one of the biggest connoisseurs of Western European art and a founding father of art history as a scientific discipline. Waagen was invited to raise the project to international standards. His sojourn in Russia and his work on the first scientific catalogue for the Hermitage is a moment of importance in the history of science at the museum. At this stage in the history of the field, when reproduction was difficult and expensive and the disciplinary infrastructure (journals and art-historical publications) did not yet exist, direct contact between the scholar and the piece was the sine qua non for the production of knowledge and the development of expertise. The scholar could, therefore, easily become the sole expert, and the proficiency of the *cognoscenti* was determined by the number of works they had seen. Waagen's cooperation with the Hermitage brought a major art historian to Russia for the first time. The compilation of the scientific catalogue, however, proved a daunting task, and Waagen was not the only international expert to have contributed to this magnum opus. Another Berliner, Bernhard von Koehne, completed the editing of the three-volume publication of 1863, and its second edition (1869–1871) was partly edited by the French art critic Théophile Thoré-Bürger. Waagen's visit led to another important development: his book on the Hermitage art collection was published in German in Munich in 1864. This was the first publication about the Hermitage to qualify as scientific by the standards of the time, and as such it made the collection part of the European art history landscape.

The second half of the nineteenth century marked the popularization of the guidebook genre and the separation of gallery guides from museum catalogues. Guides were characterized by a selective coverage of the collection, and by a less academic style. By this time, the collections of the Hermitage were famous far beyond the Russian Empire, and the gallery was mentioned in many contemporary travel guides. It was also in the second half of the nineteenth century that photographic reproductions of paintings and drawings prevailed over other reproductive methods, and the Hermitage was

not left behind in this process. Since the 1850s, French photographer Adolphe Braun and his company, Ad. Braun et Cie, had been engaged in the creation and circulation of photographic reproductions of artwork. In 1883, his company became the first official photographer of the Louvre. That same year, Ad. Braun et Cie, which worked with many famous European galleries, published a catalogue of photographs of Hermitage paintings (Hannavy 2008). While the publication of Hermitage catalogues was monopolized by the state through the Ministry of the Imperial Court, guidebooks were published mostly by private publishing houses. While the latter also proposed publishing the catalogues, the museum declined and kept the state monopoly in place. As for the guidebooks and albums of selected pieces, they were not supervised by the ministry, but some of them were created in cooperation with curators of the gallery (Yefimova 2009).

It is worthwhile to reiterate that at this initial stage the collection was sorted and classified by foreigners, experts brought in from countries (primarily Germany) considered to have exemplary expertise in art history. What we observe here is the authority assigned to cosmopolitan knowledge and connoisseurship was premised on the circulation (mostly in Europe up until the early twentieth century) of experts. A related tension will eventually appear regarding the sorting and documenting of objects owned by the museum: For whom is the classification intended—who is its public? Is it the connoisseurs who navigate from one world-class museum to the next? Or is it local administrators who are increasingly taking charge of a hidden treasure inasmuch as it materially cannot be visible in its entirety—turning inventory books rather than exhibition halls into the spaces that need to accommodate all the pieces? Or is the classification process intended, perhaps, for local intellectuals who will invest their efforts in the museum and its collections as a place rich in a form of knowledge that will soon thereafter be discredited by the Soviet regime, particularly during the first decade after the social and artistic experiments of the 1920s? After having exposed the Hermitage collection to the trends of German art history, a new

class of Russian intelligentsia would soon seek refuge within the walls of the museum and treat its objects the same way they were treating their own books—by annotating them.

GENERATIONS OF DATA IN THE HERMITAGE

When the collection was private and relatively small, there was no need for a complicated system of accounting. As the collection grew and became more heterogeneous and as areas of interest expanded and multiplied, new subdivisions appeared and with them new documents, as keepers invented differentiating criteria to sort their collections. As we know from anthropologists of early classification systems (Goody 1986), the introduction of tables was an important stage in the history of knowledge. More topical, the French philosopher Michel Foucault dramatized the role of classifications in the history of the social sciences: "The table of the signs will be the image of the things. Though the meaning itself is entirely on the side of the sign, its functioning is entirely on the side of that which is signified. . . . The taxonomies used, artificial though they may be, are always intended to unite with the natural order, or at least to dissociate it as little as possible" (Foucault 2002). Inventory books for the Hermitage take the form of tables, in which every column dictates which attributes things have in common while, most importantly, the relationship between items and the museum are standardized. The type of order used in these books is a mark of the history of the museum itself, which is not identical to the chronologies of the assembled objects. A question well worth asking when presented with the architecture of memory and knowledge of a museum like the Hermitage is one of property, properties, and appropriation. These notions share a Latin linguistic root—*proprius*—which we will use as a key for understanding how documents of representation have been designed over time to negotiate the interaction between the collected objects and the individuals in charge of them. In the early stages of documentation, foreign authors were brought to

the museum temporarily in order to produce forms of accounts. In terms that were not then relevant but might help us today to understand these authors' position, they were consultants and scientific advisors at a time when there was not yet a proper Hermitage payroll or employment system. With the Revolution of 1917 and the transformation of the museum from a private to a public entity, this state of affairs changed for the first time: experts working at the museum became employees. With the increasing pressure felt by the museum following the state control of cultural activities in the 1930s, the initial distance of experts brought from abroad to produce brochures first and internal records second is replaced by a much closer and enduring relationship of employees and collections. Less outward and less compelled to immediately produce images of the museum treasures, employees of the Hermitage were tasked to document for internal purposes, at work in an institution for which showing off the treasure was no longer a priority.

The appeal of documents standing for things in their absence comes from their ability to orchestrate the distance between things by declaring their relevant properties and by delineating the limits of property and its consequence, responsibility. Keepers are no longer charged merely with studying and annotating their collections; they are also their collections' legal stewards. But before this relation was formulated in legal terms, keepers had another form of stewardship, emerging from the nearly exclusive contact they enjoyed with their collections. In this context, what needs to be studied is the specific time period in which the documentation of objects was established: although we are dealing with documents that represent more and more objects, of which an increasing number are not visible, the unique circumstances of Soviet museography have not made these documents into de facto public records. Designed, produced, and updated locally, much of the artworks' documentation did not have a fully public life until well after World War II. Before, the documents were artistic exercises performed by keepers, often trained as artists themselves and bent upon expressing feelings about works of art rather than abstract and dispassionate

coordinates. The mediums of this documentation—the book and the card index—explain why records were for a long time an indefinite exercise: they were both personal and passionate, public and objective, but always manifesting the larger interests of other parties in relation to the treasures of the museum.

Even today, keepers must sometimes deal with prerevolutionary and pre–World War II inventories (the "black inventory" and the "red inventory," respectively) in order to recover information. These inventories were thought of and designed for objects that would come into the museum as permanent holdings. This differs greatly from technologies of memory currently found in museums, which see some objects coming in as new acquisitions, other objects coming in for temporary exhibitions, and still other objects going out, for varying lengths of time, as deposits or for exhibitions in other museums. The Hermitage's prerevolutionary inventories, progeny of early catalogs documenting the royal treasures, were stock inventories of nearly immobile artifacts. After the collection's items started to circulate, requiring new documents to track their passage among museums at home and abroad, the earlier "black" and "red" inventories were not discarded entirely. Nevertheless, the use of these historical inventories changed, and this change was driven by interests related to the museum's history and to the acquisition of new items vis-à-vis this history, not by the particular qualities of the thing itself. The card index, a technology invented after the introduction of inventory books, is essentially a description of an object. Cards can be moved and regrouped alongside other cards, as can the objects themselves when they are first placed in one storage area and subsequently clustered elsewhere and with other objects. Cards have another feature that distinguishes them from the inventory books: they have more space for descriptions, and the descriptions are now implicitly understood as a process, not a single moment. Describing can take a long time to complete, yet once acquired the object is understood to be sited securely within the museum, whether its description is complete or not. The card is filled out at the moment the object arrives in the museum, but

only with the information that is known at the time. Sometimes empty spaces are left so that they can be filled in at a later date, after the information is discovered and/or verified. Keepers often speak about the old inventories with both respect and satisfaction, commenting on a complicated path of descriptive work that bridges the prewar and postwar eras:

> Old keepers did a great job. . . . Our inventory was started by Baron Fölkersam. He was then the main keeper of jewelry and the emperor's silver department and what is called the green inventory: it was filled in with quite some detail after the revolution. In some cases there were even deciphered brands (расшифровки клейм), that is, attributions. . . . During World War II, keepers experienced evacuation. They had to pack thousands of things, and then after their return they created a typology and described also the things that were not [yet] described. (Keeper of jewelry)

Immediately after the war, people who had never dealt with art were bringing a plentitude of new items into the museum buildings:

> After the war, Tarneus was adding what came later, and she also had to describe the trophy art that came in large amounts. So I am still using her typology. She distributed the material, and I consider this correct, according to cultural centers: Nürnberg, Augsburg, Paris, and so on. (Keeper of jewelry)

The post–World War II period marks a crucial division between record and description keeping and the collection. A sizable number of items housed in the Hermitage today were appropriated during World War II. It is not the purpose of this discussion to determine a name for these acquisitions or what their future should be, as relevant as these issues may be. Instead, my interest is directed toward more technical matters. The intake of the postwar period had to be executed very quickly and occurred with a hustle and bustle that, in some cases, left little time and space for the development of content

proficiency. In her biography of the Hermitage, Geraldine Norman (1998) cites a report by Joseph Orbeli, the director of the museum during the period of the war:

> The unloading of the first special train arriving in Leningrad took place on the day when the work of unloading the returned valuables of the Hermitage was finished. . . . The unloading was very fast. . . . The crates transported to the Hermitage blocked all the portals and the nearest halls. . . . It was necessary to open the crates to under-stand to which department they belonged. . . . The codes in most cases gave no information about the contents of the crates. . . . Many had no numbers at all. (270)

But who was to produce the descriptions of these new arrivals? Two decades of repression of the intelligentsia, including well-educated historians and art lovers, was aggravated by the overall postwar shortage of personnel. Under these circumstances, items were sometimes received at the museum by people without sufficient knowledge. The postwar years were not simply a breaking point; rather, they were the culmination of several troublesome decades for the Hermitage under the Bolsheviks:

> In 1917, after the revolution, the goal was to gather things illustrat-ing the everyday life of the bourgeoisie, and the historical-everyday department (историко-бытовой отдел) was created in the Russian Museum, . . . [then] it moved to the Hermitage, then returned to the Russian Museum, then to the Ethnographic Museum, [then] back to us again. All these movements meant, in fact, that soldiers just took bunches of stuff and carried them over [to the new location]. Some things fell out, some things were broken, other things were lost. . . . That is it. Difficult to recover the information. The record might say, "It is the thing from the house of Yusupovy," but there are four such houses. (Member of the Russian History Department)

The nature of these acquisitions was different than in "peace-time"—the new items were not deliberately selected to advance and

complete existing collections. Often, they were random and frag-mented samplings. However, soon after World War II a rapid intru-sion of ideology into technical terminologies took place, a process that culminated on a grand scale with Khrushchev's decree on the "elimination of unnecessary extravagance in architecture" and the proliferation of *khrushchevki* mass housing (low-cost apartment buildings). The semantics of descriptors and the range of possible meanings attached to the elements of the museum's collections were suddenly inflected by a worldview informed by Marxist-Leninist principles. Details and differences that used to matter were declared irrelevant.

> When our living space has shrunk to communal apartments and *khrushchevki*, it is natural that [our records no longer had labels such as] "table for visit cards," "table for toiletries," "lectern," and so on; it was all just "table." (Member of the Russian History Department)

The confluence of an influx of many uncategorized items and the limitations put on descriptors had notable consequences: during this period, the main identifier became the sticker with an object's inventory number. Due to time constraints, items were sometimes assigned nothing more than a number and a very schematic, broad, and uneven designation. Although a number signifies nothing essential about the art object, it does allow for the identification of a unit of property, which ensures that nothing is left unnoticed in the museum. For devoted art historians, these curtailed designations were thought of as temporary, but in the absence of scholars, they sometimes remained for decades.

CONTRADICTIONS OF THE ACCOUNTING MISSION

The Hermitage's system of accounting (not to be confused here with mere financial record keeping) is not a single process but rather a combination of tasks. The present accounting convention was

more or less completed after the Soviet government nationalized the possessions of the Hermitage and keeping became part of the museum's responsibility toward the state. In the 1950s, with a growing number of employees working in the museum in close contact with the collections, the principle of their legal responsibility was established. Museum possessions were estranged from their keepers, thereby destroying the flair of ownership. The tension that we detected in the museum is a product of the collision of the different meanings of "proper"—and its derivatives—we encountered earlier. This collision—and at times, confusion—grew within the confined environment of the museum, where keepers and collections were in a sustained, intimate relation: neither keeper nor collection would leave the premises; both were "toxic" such that it was better for them to be cloistered for purposes of this long face-to-face exposure. The tension arises from the conflict between the formal property of the collections (property of the State, but a less-than-desired property if assessed on the basis of its aesthetic values) and the accounts of the properties of the collections (accounts that take the form of public documents but are in practice produced and read nearly exclusively by keepers). This tension is fueled by an awareness—held both by the party officials, in denial of the bourgeois and aristocratic treasures, and the keepers, largely kept mute by the official party line—that the treasure is indeed a treasure, praised, worshipped, and valued by everyone else in museums, abroad.

> The museum fulfills the keeping of state property. What would happen if all original owners were to reclaim their collections from the museum? The whole Hermitage collection consists of what used to be private collections. (Member of the Russian History Department)

The current legal definition of accounting for museum treasures is still found in the Instruction of the Ministry of Culture of the USSR: paragraph 81 defines it as the "identification and registration of the museum's collections, which are public property" (USSR Ministry of Culture 1985). Though identification is mentioned first, in

reality it might occur many years after an item is registered. While recording is a momentary action, identification might require a long research process, one in which the item is inscribed into the order of the Hermitage. The instruction mentions both forms of accounting:

a The primary recording and attribution of the items that came to the museum for the purpose of their documentary preservation (that is, the production of a written act [актирование] and the addition of a brief record of new items in a log); and

b Inventorization, that is, the scientific recording of museum items: classification according to source types and types of materials, art spheres, collections, etc.; creation of a more detailed and exact description; clarification of the attribution; and inscription in the scientific inventory. (USSR Ministry of Culture 1985)

After an object enters the museum, as part of the accounting procedure it is assigned to one of the holdings, where it is also assigned its physical location. However, the "correct" wardrobe, shelf, container, or box for storing the thing may have nothing in common with the correct class, school, category, or historical period that it belongs to. *Materials*, *art spheres*, and *collections* are officially mentioned as non-contradictory elements of classificatory work; however, they can in practice be mutually exclusive. Each of these attributes requires a unique way of assigning the object within the space of the museum. Items such as cultural objects (with descriptions) need to be related to other things of the same kind, whatever it is that we mean by "kind"—historical period, art school, former owner, author, etc. If they are allocated in space in just the same way that they are connected nominally into collections, thematically close sets, or exhibition topics, it is easier to retrieve them all at once for an exhibition, to study, or to classify them. The collection as an analytically constructed entity gains its tangibility via its presence in one physical place.

The thing as a physical object of a kind (where "kind" stands for material, size, color, etc.) needs particular conditions of preservation (humidity, temperature, light, etc.). Therefore, there is an inevitable

tension between the location of objects according to their classification and the order of descriptions. Things are related to one another by their composites, which are not cultural inventions (even though they are named by scientists as such). However, the most important factor from the point of view of the keeper-as-scholar—that is, the museum employee in his or her knowledge-producing capacity—is often the criteria of relatedness, its location in cultural terms. While historicocultural value is a social construction, fragility is not (at least not in the same sense). Which one should be prioritized: the necessity to preserve or the necessity to study and display? To date, the preservation of the thing has proven to be the primary criterion by which museum possessions are ordered.

> Our principle of storage is based on material. One person cannot be responsible for both paintings and porcelain, because the museum also has the function of preserving. It is easier to take care of objects of the same type. (Member of the Scientific Documents Department)

The principle of distributing things according to their material properties not only complicates preservation and display but also creates a distinction between *holding* (хранение) and *collection* (коллекция). Keepers in the Hermitage use two different categories to denote sets of things. They explicitly distinguish these categories as different types of multiplicities. *Хранение* is a multiplicity of things recorded in one inventory book and assigned to the oversight of a particular keeper. Individual objects do not become *museum items* as soon as they arrive physically in the museum; analogically, a set of things in storage does not become a museum holding. Until they are properly recorded, they are (as explained by interviewee "I.," from the Russian History Department) merely a "junk shop." The holding represents a sphere of responsibility, transferred from one keeper to another; in this sense, it is similar to an inheritance. Items within a holding may not be unified by any idea or concept before their arrival at the museum, but the contents of a holding trace back to the internal organizational history of the Hermitage: holdings are

divided as the museum grows, and division occurs more often than unification; the growing body of possessions tends to diverge rather than converge. Holdings are documented in the form of standardized lists, where each item is given a similar set of identifiers.

Not every holding becomes a *museum collection*. According to one member of the Russian History Department, a collection is equipped with something like "a super-idea, so that things together [amount to] more than just the sum of [the individual parts]." It implies both long-term relations and intellectual effort (accompanied by all the difficulties of gathering the objects together). Records per se are insufficient material for the composition of a collection; instead, the "idea" is what one finds somewhere in the descriptions:

> [Regarding the] collection, . . . suppose you are married. Your family is more than simply you plus your wife. The same with a collection. (Member of the Russian History Department)

While the composition of a holding reflects the structure of the museum and its storage spaces and procedures, the collection might be dispersed across several holdings. For this reason, individual initiative and motivation are crucial factors in determining whether a collection will be assembled. One crucial prerequisite for this is the ability of the keeper to engage in "social networking" within the museum, as a collection is often formed with the help of various keepers. Given that the Hermitage employs over two thousand people, however, it is obvious that not everyone can communicate directly with everyone else. Because objects must be stored under proper conditions, collections are dispersed among different locations and holdings. The atmospheric conditions of the Hermitage reflect the significant variations in humidity of a Nordic climate: humidity, then, is the atmospheric variable most difficult to control. Additionally, the Hermitage stores items for centuries, a period that is too long for climatologists to reasonably and confidently evaluate. So, while the effects of a microclimate may or may not be radical and rapid, the museum's aim is to arrange optimal conditions

for long-term preservation: photographs require a low temperature; paintings require protection from direct light; coins may suffer from corrosion; and wood appears to be the most capricious material, reacting to humidity, temperature, and other aspects of air composition. This sometimes requires the separation of objects that once shared a climate within a room or palace.

> Pretend it was a collector who collected chairs, books, as well as something else; this is formally recognized as a collection. And at the moment when such a collection gets into a museum, . . . chairs go to X, instruments for repairing the chairs go to Y, the dress hanging in the wardrobe goes to a third place. And keepers sometimes do not know about one another's holdings. (Member of the Russian History Department)

Although an object's physical welfare is declared to be the museum's guiding principle in matters of storage, this ambition is not completely realized. If we were to look through a list of holdings and the descriptions of their content, we would realize how complicated and diverse the distributive principles for objects are among the various parts of the Hermitage. We would see that distribution is neither an exclusively cultural construction, conducted with total disregard for physicality, nor the opposite, a procedure guided by strictly material concerns, but a combination of the two approaches. For example, the criteria used most frequently to shape departments are national-geographic (East, Orient, Netherlands, Russia, Egypt, etc.) and historical (according to century), but the holdings are also formed by categories such as porcelain, metals (for numismatics), and canvas. In addition, if we were to use a political map as a visual metaphor for the departments within the Hermitage, separated as they are by borders of expertise, we would see many individual enclaves represented.

> Say we receive from some Mr. X a watercolor of the Golden Drawing Room (which later became the Malachite Hall). It is by Grigorii Chernetsov and presents the interior, where Pushkin was introduced to Alexandra Fedorovna before the fire [of 1837]; it is a unique image.

> But historically, all watercolors with Winter Palace interiors origi-
> nate from the main gathering, which was inherited by the Depart-
> ment of Western European Art. . . . And then the Russian Department
> says: "We want it"; and Western says, "Okay," but all the items of
> the same artist with the same image are kept by us. (Member of the
> Sector of Acquisitions)
>
> On my exam I was asked: "Where should the item be stored that
> was [formerly] stored in Pavlovsk, but then discovered to be origi-
> nally from Peterhof?" I said that the thing is primary, and we must
> consider where this thing will best fulfill the museum's functions.
> (Member of the Russian History Department)

In fact, climatologists—the spokespersons of physics in the
Hermitage—play a judicious role in such arguments, as they advocate
the interests of the physical objects. It should be noted that in recent
years the advice of climatologists has been increasingly heeded.
One of the main reasons for this rising deference is their use of new
technologies that has increased their persuasiveness, as the domain
of climate control is changing much faster than many other areas
of expertise within the museum. For example, during the last two
decades it has become possible to produce a transparent glass show-
case, to use humidifying devices, and to filter large particles of dust out
of the air in display areas. These technological advancements stabilize
certain issues and provide fewer opportunities for argumentation.
Difficult negotiations occur when both departments in an interdepart-
mental contest are capable of providing good storage conditions.

RECORD AND DESCRIBE

Employees refer to accounting practices using two terms that mir-
ror official terminology. The first mode of accounting is *record-
ing* (запись). For an object to become a museum item it has to be
"accepted" and "recorded." The set of mandatory identificatory
parameters are fixed in an "inventory template" book, which is
stipulated in appendix 13, instruction 290 of the Instruction of the

Ministry of Culture. Recording items is not a trivial task, as the particular properties of an object open up a wide range of possibilities for its documentation.

> Consider earrings. They must be recorded in [a standard] inventory and also in a special inventory for precious metals. Each earring might be a separate record, or [the pair] might be one [record] in both inventories.... So there are at least four possible combinations. (Member of the Scientific Documents Department)

Already at this stage in the process, some conceptual questions emerge, such as what constitutes *a single* thing and what objects are to be considered *parts of* another thing. A related question, though it is a rare one, is how the discovery of a fake should redefine the location and value of the item in question. However, during the recording stage there is no requirement to verify the authenticity of an item: recording must simply enable the tracking of an object's movement through the museum by way of a unique identifier. What one sees in the pages of the inventory books is far from descriptive. Instead, it is a list of initial references that later lead to the actual knowledge of the stored object.

The second mode of accounting is *description (описание)*. Description is defined less precisely than recording: its aim is to produce scientific knowledge of an item's history, properties, and value. The descriptive process engages specific expertise, which is believed to be scientific.

> You have to distinguish research and holding functions. I mean, sometimes it is not that important [for the purpose of research] what the item is called in the inventory book. It might be recorded as a soup pot, but it is a piss pot, or it might be recorded as cup for cream, but it is for meat sauce. And [its purpose] might not have been known for a hundred years. So science will tell [us] what it is. And it might change, but the object [remains] with us. (Member of the Western Art Department)

Descriptions are time-intensive products written in unique languages that can and often do differ. The tradition of describing valuable items might have originated for a practical purpose. Krzysztof Pomian (1990), in his work on dealers, connoisseurs, and collecting enthusiasts in Paris and Venice, shows how descriptions were becoming longer and more detailed throughout the eighteenth century in France, as sellers perfected their promotional skills. In the contemporary museum world, descriptive writing has acquired another meaning: it is a showcase for scientific analysis, performed by art historians who now have less time to write directly for journals or publish books, as they must first attend to their objects. A description requires scientific verity, which may be hard to access. It might take a year of research to fill in one column or line in a document; the knowledge of a particular aspect of an item's history may emerge after centuries of oblivion.

As a consequence of the assignment of material responsibility for objects to the museum's keepers and by virtue of large numbers of new items, record keeping prevailed over description and therefore absorbed the lion's share of scientific labor. Following the rapid increase in the number of documents and items, science diverged from simple accounting: at this point, researchers started to distinguish between the impersonal and personal parts of a description. The impersonal is what is required for accounting and tracking the movement of items; the personal is the product of deliberate research activity and is conceived as the writer's (that is, the keeper's) intellectual property. Nevertheless, both functions remain the duty of the keeper alone.

These two inseparable parts of a single process mean much more to the mission of the museum than the simple structuration of accounting activities. They objectify the dialectics between unique and multiple that is inherent to the exceptionally extensive holdings of the Hermitage and to the museum's mission. The first stage in the process is represented by the strict, "objective," standardized criteria of quantification and is performed for purposes of accounting to the state; the second supports the humanistic principles of

education in history and the arts within the framework of the museum's mission within society. Assembling a collection and giving descriptions (not just records) to things results in more than just internal documents: catalogues and exhibitions are consequences of this process as well. Unlike a holding, which can be completely recorded while remaining open to new items, the collection can be complete but is always open to further analysis.

> Sometimes people who write on collections do not hand their material [over] to be print[ed] because they expect to improve it. And this might go on until they die. (Russian History Department)

Conveying records to colleagues or the public would not be a display of expertise. The succinct elements making up the record are only useful for identifying a unique piece by generating a unique number. This one-to-one match is only good for internal documentation. But while we could expect the description to make public the knowledge generated by the keeper, the material conditions of documentation and the form of responsibility over holdings have allowed this knowledge to remain confined.

> If one needs to publish something from our collection, it depends. . . . Sometimes we say: "Please, it is not for publication." If it is important and if I am also dealing with it, . . . why should I refuse them? They are learning, they need knowledge. If it is needed, I do not forbid it, and I don't think I need to. Some say, "It is mine, I won't give it to anyone until I publish." But after a year you do not publish . . . and the item might be very important for some [other] scholar. However, one must contact the directorate, then the directorate contacts me [to ask] whether I can and wish to show it, and then access is permitted. (Keeper of jewelry)

The tension between information and knowledge has been a topic crucial to a revolution in the history of sciences stretching from Ludwik Fleck ([1935] 1981), the famous biologist turned historian of

science, and Michael Polanyi ([1958] 1974, [1966] 2009) to the stud-
ies of scientific knowledge by British sociologists who followed in
the footsteps of David Bloor's (1973, 1983, 1992) reading of Wittgen-
stein's study of rules as local practices. The crux of their arguments
is that the location of science is not where we think it is. Departing
from the view held by positivist philosophers of science, Fleck and
Polanyi detach sciences from their written records (books, articles,
etc.) and reattach them to the living, corporeal scientists them-
selves. Despite the reputation of science as a transparent and literal
activity, which lends itself to cycles of contestation and protocols
of replication, Fleck and Polanyi argue that it really lies somewhere
else, and as a consequence it eschews the kind of rational debates
and discussions that philosophers had imagined to be the bedrock
of rationality. This other topography of science revolves around
the bodies of scientists and the layers of experience they accumu-
late. Bodies are the elephants in the laboratory rooms of the mod-
ern sciences. They are what prevent science from being fully and
exclusively a series of detailed packages of information and a game
of information gathering. Rather, sciences are ineluctably attached
to the bodies of scientists and to the innumerable tools that popu-
late scientific laboratories. The stuff of science, then, is not abstract
information but forms of knowledge that cannot always offer an
account of their own nature. Characterizing the excess of embodied
knowledge over abstract information, Michael Polanyi ([1966] 2009)
notes that "we can know more than we can tell" (4). Polanyi under-
stood this excess to be an irreducible portion of tacit sediment that
actively animates scientific conversations while always remaining
implicit. For him—more than for other social scientists and philoso-
phers who paid attention to the effectiveness of the tacit in shaping
science—this was a virtue of the scientific form of life and needed
to be respected against the calls for ever-increasing accountability
and publicity in sites of science. His was a plea for scientists to keep
control over their world and their activities and for the protection
of their communities. The Hermitage, for all its claims of being a sci-
entific institution, has been more eager to embrace the notion of

the laboratory as an enclave with stridently protected borders than to take on the scientific method, with its insistence on the production of standard documentation. In any case, this method would have been misplaced within the context of the Hermitage, as the affects of individual keepers were always at work in their description of pieces. Instead of writing uniform documents that could be shared and understood by all, the textual traces they would produce and maintain for their collections—in lieu of the collections' actual survival—were personal and at times were even designed to be hard to decipher. The notes surrounding the collections were sometimes more like graffiti (Guichard 2014) than straightforward accounts—forms of appropriation and manners of marking one's territory. But here again, they were a very particular manner of graffiti because they were not intended for public exposure. Here, then, is the question at hand: Under what circumstances do museum keepers produce abstract information or personal knowledge in their descriptions of the collections?

The tension between information and knowledge hinges around the appropriation of the collection by employees who start sorting the objects and develop affection for them. Here appropriation does not mean a legal transfer whereby the keepers become owners of the collections. As with all museums, cases of theft do occur at the Hermitage (Norman 2006). There can also be theft without proximity to and understanding of the objects. Thieves who are passionate art lovers and only steal in order to privately enjoy the artwork do exist, but they are neither common nor even what we observe and document in the case of the Hermitage. More interesting than either the straightforward privatization through theft or the sharing through the public documentation of objects in catalogues, books, or articles, we find this privatization in the personal writing on a public collection that survives in the limbo of paper index cards. The classification activities explored above are different from what they are in the case of objects that are not unique and treasure-like. These latter are like the mechanical parts in the automobile industry: they tend to be fully standardized and thoroughly described technical

artifacts. Auto industry experts having full access are able to touch and assess the pieces directly, and they can produce their own descriptions and engage in disputes as to the proper and adequate language of description. In the museum, the experts' de facto quasi monopoly over the objects and the control that this entails limits greatly the kind of contestation that the classification of standard goods might generate. The allocation of a fund and the discretion that a keeper exerts on his or her fund can rule out contestation over descriptions.

Here we find a trope in the production of knowledge at the Hermitage: on the one hand, a tension between the tradition of paperwork in both imperial Russia and the Soviet Union—a paper trail and system of strict control that exploited the written form—and, on the other hand, the complete discretion of keepers over their funds and the descriptions thereof. This discretion also manifests in a blatant disregard for public archives as a form of memory. This disregard for archives is coherent with the tradition of oral history and the transmission of memories by keepers who inhabit the museum for generations, shaping the discourse and the training of newcomers. As such, we need to understand a second tension that resides within the first: the museum keeps things, but most keepers insist that written documentation kept at the museum is of no value. Things are valued; records are not. Both are kept, only one is cultivated. This perspective had immediate consequences for our research, as we could not bring archival materials into the conversation with our interlocutors without being reminded that archives "do not speak." This disregard, at times even scorn, for written documentation opens wide the space for personal appropriation. It is commonly held that there are too many archives already, and public archives are absent. Written documents are never praised, followed, or even trusted. How should we understand this tension between the substantial investment in writing and expanding the detail of the paper cards significantly, on the one hand, and the anti-archive posture, on the other? There is a solution to this apparent tension. If artifacts are kept, this is done for quasi-domestic

purposes; where "domestic" finds its immediate definition in the context of the holding of the keeper in charge of the artifact, then in the context of the department, and so on, moving ever further outward, possibly all the way to foreign colleagues specializing in the same collection. But the ethos of Hermitage keepers is to look at one's holding as one's own. The circulation of things is contingent upon the goodwill of the keeper. The more one keeps, the less indices of one's work circulate and leak to the outside world, so that this solid culture of keeping is at once a creation of value by scarcity and an erasure of one's presence in the world in the context of suspicious authorities. Despite the mobility afforded by the medium of the index card—an epitome of the Latourian (1983) "immutable mobile," that signature of the modern sciences that has allowed for the spectacular extension of scientific networks outside the laboratories—these pieces of paper are even less mobile than the artifacts they collect keepers' insights about. Because they contain the personal marks of protective keepers, and because they signal the possession of keepers over the artifacts and contain traces of their own intimate colloquium—the product of both the luck of seeing the treasure up close and the curse of being confined with it—they are the less mobile of the two.

THE SLOW ARRIVAL OF THE RECORD-DESCRIPTION

Already in the early 1970s, a few countries had created databanks, information retrieval systems, and computer networks linking museums. The substantial achievements in this area were discussed at the session of the Documentation Committee of the International Council of Museums (ICOM) held in Leningrad in May 1977. The Hermitage was not a late entrant to the experimentation with electronic catalogues. A quite unique collaboration between the museum and the Academy of Science subjected the fund of ancient bronze records to electronic cataloguing. These experiments were

conducted by Professor Vassily Ponomarev, director of the Lenin-grad Computer Centre of the USSR Academy of Sciences, Dr. Vassily Aleksandrov, head of the Ancient Bronze Department, and Dr. Ana-toly Polydiov, who was directly responsible for working out the mini-bank's computer programs. This collaboration was used by the ICOM as one of the greatest and most daring experiments in the nascent field of computerized museology. In an article published after the 1977 ICOM conference, Jakob Sher (1978) describes the challenges and promises of using computers for the retrieval of a museum's catalogue information:

> This introduces at least two difficulties that complicate the automa-tion of data processing, as compared with the problem in the natural sciences and technology: first, the difficulty of establishing a formal-ized description of historical and cultural objects and works of art, as well as of the whole language employed by the museological sci-ences (history, archaeology, ethnography, art history); second, the difficulty arising from the fact that the majority of museum person-nel are not, as a rule, professionally qualified to use computers, or data-processing equipment in general, without undergoing special training. . . . This prompts the question whether it is easier to teach museum staff machine language or to teach the computer the lan-guage of museum science. Experiments conducted by the Hermit-age Museum, in conjunction with the Computer Centre of the USSR Academy of Sciences, indicate that the latter is the more effective approach. (135)

The idea of "teach[ing] the computer the language of museum science" fits the dual excitement over universal best practices unit-ing the community of world museums and intelligent machines paving the way for such practices fueled by the ICOM conferences of the 1970s. This vision was quite different from the actual prac-tices of what one might consider quasi-doodling and semi-graffiti that keepers were applying to the paper cards they attached to their collections. Interestingly, Sher formulates a thought experiment

involving fictional steps that a museum worker would have to follow in order to use an electronic catalogue:

> To be able to use the information stored in the data bank, the museum worker must have a "translator." The information request, written in natural language, reaches the computer operator and at this point is translated into machine language; the translation is not always immediate and may require further consultation with the user. Thereafter, the request is processed by the computer and the answer is translated from machine into natural language and is transmitted to the user. (136)

As interesting as this scenario may be, the collaboration initiated in the 1970s between what was one of the most advanced computer schools in the Soviet Union and a museum with a rich collection did not bear real fruit until the generalized computerization that followed the ascent of the World Wide Web. In the 1990s, the first personal computers appeared in the Hermitage. At that time, keepers mostly used word processors and, less often, database programs such as Microsoft Access. Typewriters were not officially replaced until the turn of the twenty-first century, but even after the decision to do so, several employees were reluctant to make the transition.

Conceptually, it becomes plausible to consider the traces kept by the museum about its own contents as *data*. Before the standardization put in place by networks of computers, which also put an end to the many enclaves of keepers in departments, these latter would at best produce information: the extremely detailed descriptions that keepers would indulge in as part of their quest to leave their mark on their collection or even the individual items in their funds. That kind of information is an early form of the *catalogue raisonné* or monograph dedicated to a single item. The coming of the database did not put an end to this genre. If anything, monographs increased in number, so that the peculiar equation of art history and *catalogue raisonné* that predominantly characterizes the Hermitage's brand of

art science produced by the older generation of the museum's scientists remains. Nonetheless, changes occur as the entrenched custom of privately indulging in objects' descriptions in paper-based lists no longer functions as a stepping-stone toward the public monographs published by the Hermitage Press. Computerized databases create an imperative of relative publicity early on, so that personal descriptions exit the stage, making way for standard accounts. To enter the museum, the item must be transformed into data, with no regard for how unique and precious the item may be.

In the Hermitage, data is accumulated in KAMIS (*комплексная автоматизированная музейная информационная система*), the museum's official database. The discrepancy between the two modes of accounting (record and description) and, correspondingly, the opposition between big and smart data was not foundational to the Hermitage but appeared only recently, and it is still undergoing transformations. To confirm this observation, one must consider both the general historical context and the narrower, retrospective view of media development. There can be no doubt that the turbulent chronicle of imperial, union, and federal reforms, regime changes, revolutions, and wars heavily impacted the life of the Hermitage. In parallel, new techniques for data input and aggregation continually emerged. Items would enter and (sometimes) leave the museum, and these facts were reflected in a media environment designed to account for such events.

One of the most consequential outcomes of the computer becoming the preeminent medium of accounting was the ability to quickly search the collection. Contrary to paper inventories, where one slowly turned over each page and had to scrutinize it top to bottom, the .doc file provided the desired result within seconds.

It has made the search faster. It is great to have catalogues in .pdf format, because the text is searchable. . . . The absence of the photo is the quintessence of the flaws of the former epoch. The record says one thing, but you see another. (Member of the Russian History Department)

Keepers recall how they created their first digital tables, devising the structure of columns. This structure was not identical to that of official documents, because the motive for its creation was informal: the keeper was ordering his or her knowledge through an analytical procedure or tool. While the author of the table had to set out all the required pieces of information, the ultimate goal went beyond this activity. However, these tables were still only isolated islands of information, created by keepers. They were standardized only at the level of the department and could therefore differ from holding to holding. They provided an example of *quasi-data*: semistructured, multidimensional, and often adjusted to a specific narrow sphere of knowledge (e.g., "French porcelain of the eighteenth century by master of Royal Court," or "Selection of items which stood in the guest room of boyar John Doe").

In the first decade of the twenty-first century, a technological shift occurred that forced the (re)unification of knowledge and information, when the personal notes about museum treasures initially recorded on paper cards were incorporated into a single digital database. With the implementation of KAMIS, all the traces were required to be digitalized. This laborious process was substantially simplified in the case of holdings that had already been recorded into digital tables by the people in charge of them. Yet the arrival of the database had an ambiguous effect: it changed the way museum employees, both keepers and technicians, thought about "collections." Seen from one angle, a database softens the conflict between holding and collection: though a collection is dispersed among several physical locations, it can quickly be assembled in the form of an electronic report, a list, or a table, which represents some ideal entity. The playfulness of the tabular presentation of electronic records, with its quick shuffling and reshuffling, departs from the care and caution that any physical movement of an object from the collection would necessarily entail. It is a powerful tool for the professional imagination, one that can (re)configure the structured multiplicities of items for the needs of exhibition, analysis, or inspection. Seen from a different angle, it has imposed

a standardized vocabulary and a pattern of description that cards, with their open-ended comment sections, did not force upon keepers. Technology and descriptions are interdependent in the sense that databases impose standardization on descriptive vocabularies. Old media, though not as fast, allowed keepers to indulge their creative side to a much greater extent.

> The description had to be very thorough then. And mistakes still occur even now, with the photos. More than that, inventory books must be (according to the law) stored in a fireproof safe; they are documents of perpetual storage. (Member of the Russian History Department)

The record is quite resistant to technical innovations. Though it has been upgraded by digitalization, the core of its content—the item's unique number—continues to prevail over new mediums and identificatory possibilities.

> The numeration is not consistent. So, the knob from the chair in my holding can be numbered 6, but the [same] chair . . . in another holding might have the number 7. Or, 5,600 and 300, respectively. . . . Some write the adjective in the first position, and some write the noun in the first position. Some use diminutives for small things. So it can be the same thing but with two names, and KAMIS won't find it. (Member of the Russian History Department)

The large number of items in the Hermitage has resulted in qualitative peculiarities in accounting procedures. One such peculiarity is the deprofessionalization of recording insofar as the Hermitage has outsourced to outside contractors the keying of content from old inventory books into the electronic database. If crowdsourcing is considered a resource for the accumulation of information (Schöch 2013), it is also and primarily a risk to the quality of information. In some ways, thumbing through pages or even the manual typing of data brought keepers closer to their materials, inevitably allowing

them to recall things they didn't need at the time but eventually referred back to at a later date. Additionally, the speed of acquisition may exceed the speed of description, but the speed of recording must correspond to actual changes in the museum's holdings. In the case of rapid acquisitions, the gap between recording and description could potentially grow in proportion to the number of objects acquired, especially if one considers the museum's continuously expanding areas of interest. This expansive tendency is, in fact, one reason why the museum has become more selective in its acquisition process. Interestingly, the software implementation was partly influenced by the quantitative specifics of the museum and its different regimes of accounting.

> A: We tried initially to use some foreign software, from American distributors. It was sharpened for descriptive purposes and lacked what Russian reality needed—that is, accounting.
>
> Q: Could you specify this moment [in the process]—what is the distinction between the account and description?
>
> A: Account is the description of documents, in a way. Keeping items generates a lot of documents. . . . Every move of the item within the museum or beyond its borders must be documented. It has no such meaning abroad. They have smaller [numbers] of documents. Since we are asked on a regular basis for statistics, reports, and so on, we wanted to automatize it. (Member of the Scientific Documents Department)

The specific procedures of accounting in the Hermitage necessitated that programmers and the museum cooperated to improve the software. In fact, the museum could not use the standardized programs offered by developers until they were adjusted specifically for the Hermitage:

> The problem is that some departments have huge collections. And KAMIS, for example, has no option for globally changing the record of a keeper for all items at once. But Microsoft Access has it.

I checked the Hermitage twice as a participant of the inspection committee, and I saw that they worked in Access and were satisfied, because by that time many museums had changed to KAMIS. But Access is more adequate. Now KAMIS has improved, but [this] is only due to museum employees—KAMIS designers work with each museum and gather their experience. (Specialist from the Menshikov Palace)

The integration of photographic material into the database has not replaced the primacy of text in the documentation of material objects. Judging from our interviews, photographs are not completely trusted, while descriptions provided by experienced professionals are. To put it colloquially: a computer can be broken, but the fireproof storage area with paper documents inside is safe. Still, the human resistance to software is also based upon experiences in which shared databases fail to compensate for the sharing of interpersonal knowledge that is a feature of the traditional system. Unlike biological databases such as DNA—for which "no outside of the genetic text" (Doyle 1998, 304) exists—museum description has no comprehensive rules or clearly defined limits.[3] One might reasonably ask whether it is even possible to create a truly complete description of an item, or whether the item in its entirety must remain unarticulated. Personal communication (which can be reduced by digital databases) often appears as the only chance for this kind of unstructured but deeply insightful knowledge to become social—that is, known to more than one person.

Moving into information embedded in a digital infrastructure presented a challenge to uniqueness. Anything and everything had to be described with conventional words that would be understood by others and potentially ascribable to other, similar objects. In fact, the impracticality of using isolated vocabulary was the origin of one of several longstanding qualifications for a museum expert: that is to say, a limited quantity of clearly and widely understood words had to be selected for registering objects. The associated space limitation is not officially declared, but in practice it results from the

need to account for new items. Common language is required for the proper understanding of objects by experts, inspectors, and a broader audience. Before the unification of isolated databases, the degree of access to knowledge about things was largely proportional to the level of physical access to those objects. KAMIS broke this tradition, providing remote access to knowledge. The problem is, however, that making the database understandable for oneself is much simpler than making a database understandable for everyone. Yet the database as a medium that unifies large amounts of data is a significant factor in knowledge production. Digital databases mean new possibilities for knowledge dissemination along with new risks and responsibilities: "I need it simple, operative, so that my colleague could get into and use it. . . . The descriptions must be understandable for foreigners," says a member of the Russian History Department. The idea of partially opening the database on the Hermitage's official website is sometimes discussed. Such a project would make the Hermitage's knowledge accessible to those who cannot visit Saint Petersburg in person.

> There was an idea to make the database common to all Russian museums, but we had different ways of naming the same thing in Moscow and Saint Petersburg, and no one wanted to change their tradition. So we would need unique, very long classifications. Otherwise you need to search all the synonyms. (Member of the Russian History Department)

Digitalization is making this kind of property more vulnerable, because everyone can easily find out what keepers have. However, supporters of the idea see a potential in this openness. One of our interviewees, from the Scientific Documents Department, talked about the database as an instrument, not the ultimate goal. He referred to an example of one small museum for which "accounting is already boring" and which uses KAMIS to make a gamified, interactive, publicly accessible web resource. The Hermitage has taken the first steps in this direction.[4]

One collateral effect of digitalization is the changing status of oral memories in the cultural era of the digital text. The Hermitage has historically been a place where oral knowledge played a crucial role. Due to the discrepancy between description and record, the description was not actually written until it proved to be true—and the period of uncertainty could last for years:

A: Sometimes KAMIS is usable, but sometimes our old employees remember something.

Q: By "they remember," you mean that they have it written down somewhere?

A: No, they often just keep it in memory.

Q: Can you credit this memory when turning it into [a] record?

A: No, we usually try to document and prove [it] ourselves. Another case is when some photos have been found; then I visit keepers and ask them whether they have this thing in their holding. Visual memory is very important for keepers, especially when keepers travel around the world and choose items for purchase. (Member of the Russian History Department)

The absence of written evidence is still a relevant problem for Hermitage scientists. Younger generations report writing down facts and hypotheses that their predecessors mostly used memory to retain. The whole research infrastructure is reoriented towards written sources, leaving the orally communicated ideas on the margins of "trusted knowledge":

Q: So you have to discover something twice?

A: Or three or four times. Sometimes you feel, but you cannot prove. (Member of the Russian History Department)

From an outsider's perspective, it is remarkable that people in the Hermitage continue to produce so much confined knowledge. Hermitage scientists invest hours in investigations and produce an impressive output of publications on classification, history,

genealogy, and other topics that require in-depth analysis of their collections. They elaborate terminologies and figure out the historical details for particular items that they present at conferences, seminars, and via personal consultations. Sometimes they open their collection to those who have an interest in their area of expertise; and they lecture at universities. The results of these long and disciplined investigations are located in the "special notes" column of inventory entries; this part of the database is iteratively changed, completed, edited, and perfected. At times, this knowledge can take shape and materialize as scientific literature, but this is neither the most common outcome nor the most desired in the context of the hierarchy of academic productions. Thus, this scholarship is often invisible; this is especially evident in light of the protective behavior that keepers display in relation to "their" database—a protective stance initially directed toward the objects that was then quite naturally extended toward their documentation. In other words, in the Hermitage there exists an enormous gap between the sufficient (in terms of the information required in the database) and the existing. Why do employees invest so much time and effort in an invisible or at least poorly accounted form of productivity, such as "notes," descriptions, and temporary exhibitions?

Here we may reflect on *passionate interests* as a form of professional engine at the Hermitage.[5] At some point, it was passionate interests that moved the media history of the Hermitage forward. First, databases were "bottom-up" initiatives. Since the end of the 1990s, keepers, one after another, began to duplicate their information in electronic format, and digital input soon began to exceed analog procedures in specificity. At that point, there was no institutionalized demand for this activity, and no unified template of digital record keeping existed. Optimization turned out to be economical because it saved time for the "most interesting part of the job." The new practice was adopted by an increasing number of departments and adjusted to the peculiarities of the objects under scrutiny. When KAMIS began to merge these disparate databases at the end of the first decade of the twenty-first century, these earlier

undertakings had to be considered. More than that, the arrival of KAMIS has not displaced the personal databases: now, keepers simply manage two databases. These employees may have come from areas of professional activity far removed from the museum (such as medicine), or they may have become keepers after several years of working as museum technicians. Yet they all maintain an additional personal database as a tool for personal education and knowledge production. Thus the human factor and media technology merged into a surprisingly productive constellation. To make possible the production of collective and shared knowledge, researchers have to produce information. This means that one person must combine the skills of both a mature and experienced scholar and a clerical assistant. One may, perhaps, perceive a sly human resources trick in this development: the passion for the collection is used to limit the people in charge. Still, the employees offer another vision:

> We do not have that division of duties: like some are keepers, and others are researchers. When one keeps things for a long time, knowing how they move and are restored . . . he will surely gain a deeper engagement with and understanding of them. (Member of the Russian History Department)

3

ART HISTORY FROM THE COLLECTIONS UP

The Hermitage exceeds normality, with a sequence of vicissitudes unique among museums of the same caliber and a growth of its collections that has set the exercise of art-historical science in a tragic context unheard of among its peer museums. With even the most cursory look at the institutional trajectory of the Hermitage, one is struck by the contrasting conditions that serve as a backdrop to the exercise of museology: difficult and hampered by the geopolitical conditions of confinement and relative isolation following the Revolution of 1917, but unique in terms of the seemingly infinite collection at the disposal of domestic scholars working in the museum.

These two conditions, combined, have contributed to making the Hermitage both a conflicted place and a sort of paradise in which art historians enjoyed unlimited access to precious artifacts. And this environment has proven surprisingly liberal considering the otherwise rigid conditions of the institutional cultural industries

With Nikita Balagurov, Evgeny Manzhurin, and Ekaterina Dyachenko.

in the USSR. With more than two hundred keepers of collections of different kinds, each of them a research fellow, the Hermitage is one of the most populous research centers in the fields of visual arts and material culture. This facet of the museum's activities is a key element in its public presentation, first as a reaction to the visitors' stereotyped vision of museums as storage and window display, and second as an argument in the years-long struggle with the state initiative to subordinate all state museums to the Ministry of Culture's exclusive management, with subsequent cuts in funding from the Ministry of Education and Science. So far, as opposed to other state museums in Russia, the Hermitage has been able to retain the *nauchny sotrudnik* (research fellow) position for most of its employees and avoid the application of the title *nauchnyi sotrudnik muzeia* (museum research fellow), described as "humiliating" by Hermitagers. This rather symbolic distinction stands for "true" academic science done within the Hermitage walls.

At the same time, the museum resists being approached as a normal academic institution, and otherwise-standard performance criteria are arguably inapplicable. Unquestionably, museum scholars present a profile of accomplishments that are not comparable to university-based scholars, however varied these could be. They write in different genres: monographs, articles in art history journals and magazines, *catalogues raisonnés*, short articles in the museum magazine, and internal documents for employees in other departments. And not to be forgotten are the descriptions of items from the keepers' collections that we began to explore earlier. Employees also organize exhibitions and edit exhibition catalogs. In addition to this variety of activities, all traceable under normal circumstances, some Hermitagers cultivate a marked disdain for the written account and praise the oral tradition as proper to the kind of education that art historians need to promote. This is one paradox of the museum, with its tradition of heavy paper trails in which each and every decision regarding its collections or employees is documented. Rules and protocols are explicit and detailed, and the circulation of works of art is strictly recorded. In the face of these

textual traces, art history is praised for its essentially oral perfor-
mance made in close relation to the treasures, not couched in paper
volumes likely to be shelved forever. This disregard for the written
is coherent with the tradition of oral history and transmission of
memories by keepers who inhabit the museum for generations and
get to shape the discourse and the training of newcomers.[1] Orality
serves a distinctive purpose for generations of art historians in the
context of two significant obstacles under the communist regime:
it increases the researchers' value as unique experts of collections
that had no contemporary equivalent, and it provides them secu-
rity in the absence of a job market, where they could have promoted
themselves by way of publication. They shape themselves as *specific
assets* (Williamson 1981) precisely because they do not detach their
expertise from the intimate conversation that they cultivate with
their collections. At the same time, they protect themselves against
censorship and the risk of being seen as too close to materials that
are not in tune with the taste of the USSR's leaders. Either way, it
is a very different scientific gesture than communalism, that Mer-
tonian virtue of openness and cultivating a culture of sharing long
celebrated by scientific communities (Merton 1942).

Studying the scholars of the museum casts light on two related
issues. First, we apprehend the gargantuan nature of the Hermitage
as an institution harboring and cultivating art history in a country
where it is paralleled by no other museum in size and in radiance.
Second, we encounter the growth of Hermitage art scholarship in
the context of the confinement of the museum from the early 1940s
to the early 1990s. These two observations yield the image of a sin-
gle isolated museum. Unique among other Russian museums, the
Hermitage has also been cut off from the scholarly ties that have
otherwise animated art history discussions since the 1930s. Hermit-
age art historians are the product of the Saint Petersburg intelligen-
tsia, having found shelter in a forgiving and welcoming institution
during the frequently perilous vicissitudes of the twentieth century.
The refuge of the Winter Palace has meant a confined conversation
in art history, driven by the treasures accumulated therein. Things
have changed recently, but Hermitage scholarship has long been

organized around the inner life of the museum, differing somewhat from art history in countries home to museums of similar size, such as England, the United States, Italy, and France. Under these circumstances, what kind of art history was produced in the museum?

THE GOLDEN (CAGE) GENERATION

Between 1941 and 1944, about two thirds of Hermitage treasures were in exile in Sverdlovsk (today's Ekaterinburg), accompanied by between twenty and forty Hermitagers. Conservation of artifacts in the cramped and unheated temporary storage facilities in Sverdlovsk and the truly heroic salvaging of the artifacts remaining in Leningrad became celebrated as a heroic page of Hermitage history. Hermitagers saving the objects from bombs and flooding in Leningrad or protecting them from cold and risk of fire in Sverdlovsk developed unusually strong personal attachments to the collection. On return from evacuation, the wartime keepers faced an equally daunting challenge in putting things in order again. Those who went through the evacuation and return had little time for research or exhibition activity and eventually developed a sense of envy toward younger Hermitagers, who could simply work with their holdings in the normal peacetime fashion, with less responsibility and, arguably, less dedication. Soon after World War II, Soviet science was severely stricken by the so-called anticosmopolitanism campaign. For the field of art history, this meant that only Soviet art remained a safe topic for scholarly research. While many graduates and PhD students had to switch their areas of speciality to Soviet art—from whatever they had been studying before—others, luckier scholars, still managed to negotiate their old Western European art subjects, navigating between the contemporary ideological agenda and the availability of artifacts in Soviet museums. Alla Vereschagina, who had been studying art history in the late 1940s at Leningrad State University, recalls:

> Our program required that in your third year you had to choose a major. I had attended children's programs at the Hermitage when

I was at school and was familiar with the expositions, so, being a "Westerner" in terms of my [academic] preferences, I was hoping to do medieval art of Western Europe at the university. Therefore, I went to talk to the department's chair, Professor Mikhail Dobroklonsky, who turned me down under some minor pretext. Those were the years of campaigns against "rootless cosmopolitanism," and he, I guess, was trying to protect his department from the orthodox anticosmopolitan hawks, especially since my "cosmopolitanism" was of a medieval kind. (Nikulin and Pavlov 1998, 46)

Apart from ideological constraints and censorship, another major limitation for Soviet scientists, and Hermitage scientists in particular, was the limited degree of contact with the outside world. Soviet citizens had few chances to go abroad. There was even a term for people who were not permitted to go abroad—*nevyezdnye*. This status was assigned to people belonging to professions deemed risky by the state and also as a punishment for those considered ideologically unreliable. Visits by foreigners to the USSR were also limited, as was the access of domestic art historians to foreign literature. This was the new line, and as a drastic framework it was enforced more or less to the letter. Compared to other Soviet academic institutions, the situation of the Hermitage was both privileged and problematic. The museum was one of the cultural "ambassadors" of the Soviet Union; after the 1960s the exhibitions of its masterpieces were actively used by the government for establishing and reinforcing international ties. That meant that Hermitage scientists had more chances to establish contacts with foreign colleagues than most other Soviet scientists. One of the vectors of international mobility for keepers has been the mobility of their collections. A longstanding tradition has attached keeper and pieces lent for exhibitions abroad, so that the opening of the Hermitage to the outside world of museums has entailed more than just a play of paperwork between the Hermitage and the lending institution. Each exhibition organized abroad has represented a moment of interpersonal communication and face-to-face encounter that showed the face of the

museum to the outside. Some Hermitagers used these opportunities to start correspondences.

> Starting from 1958 there was an extensive correspondence. When I wrote my thesis Levinson-Lessing helped me a lot, because he received photographs. We sent them ours, and got theirs. (Keeper of the Department of Western European Fine Art)

But this was a two-sided coin: the treasure accumulated throughout the museum's history was as much toxic material as it was an asset for the Party to exploit strategically. This ambiguity was to structure much of the scholarship of domestic scientists in relation to their Soviet colleagues working at other museums, as well as their (rarer and riskier) relations with foreign colleagues. It was only in the late 1950s that Soviet scholars had the chance to go abroad to view in person the art they had been studying. These visits, however, were not easily accomplished. Even for the Hermitagers, international travels were very rare, a privilege reserved for "trustworthy" employees willing to demonstrate their loyalty to the regime and able to evince diplomatic prowess. The presence of these qualities was less evident in Western European art departments, or at least such was the assumption developed during the anticosmopolitanism campaign, so scholars of Russian and Soviet art and staff of relevant departments became the first to go abroad. Evsei Rotenberg, one of the leading scholars of Western European art at Moscow's Research Institute of Theory and History of Visual Arts, recalls that he was the last to be sent to the institute's villa in Italy—allowed to make the journey only "by chance" (Chakovskaia 2013, 514) after the entire Soviet art sector had already visited the villa. The Research Institute for the Theory and History of Visual Arts, organized in 1947 within the newly created Academy of Arts of the USSR, was to present a new, Soviet approach to the discipline. A number of big publishing projects were launched at the institute, including the six volumes of *World History of Art*, *Monuments of World Art*, *History of Soviet Art*, the two-volume *History of Russian Art*, and the multivolume dictionary

Artists of the Nations of the USSR. As the first comprehensive histories and dictionaries on art written after the revolution, these volumes not only met the need for the new—new, that is, relevant to the contemporary Soviet agenda—discourse on the arts but also marked the preeminence of collective projects over individual research work in Soviet academia. An impersonal text on a broad issue would be expected from a Soviet art historian working in a research institute. In addition, a lack of specialists in some spheres of art history led to a situation in which scholars had to write about objects that were completely unfamiliar, let alone visible.

However, things were different in the museum world. After the war, museums—the Hermitage above all—were still in need of workers able to attribute and classify numerous artifacts preserved within their walls. Attribution work required specific knowledge, and research papers produced at the time were written only for the few specialists in the field. Hermitage publications for the wider public, which inevitably had to keep in mind the official discourse, were not particularly numerous and comprised a small fraction of researchers' creative output. Sorting out the Hermitage treasure was the priority, and not much else created incentives to write. The discrepancy between the general line asserted and enforced by the Party in research institutions like Research Institute for the Theory and History of Visual Arts and the on-the-ground necessities of figuring out and attending to the needs of the items was gaping. This gulf separating the political priorities and the daily maintenance of collections was made more daunting by the type of collections tended by Hermitage keepers and analyzed by its scientists. Some of the most well-regarded pieces were not reflecting the kinds of popular arts promoted by the Party. Under these conditions, becoming an art historian in the museum was an endeavor aggravated by a few challenges. Aspiration for a purely academic career, as expressed by the writing of a PhD thesis, was regarded with suspicion by the older, normally non–degree holding generation of Hermitagers. Nina Biriukova, a young employee in mid-1950s who had just finished her PhD on French porcelain, was transferred from

the porcelain department, where she had been working for several years, to the tapestry department, while a colleague from the tapestries department took her place in porcelain. As she explains the situation, the non–degree holding keeper of the porcelain collection did not want to have a young employee with a PhD in the department. Moreover, when in the early 1980s Biriukova informed one of her older colleagues that she was working on another doctoral thesis (the *doktor nauk*, a second dissertation similar to the *Habilitationsschrift* in German academia or *thèse d'etat* in the French system), she was called "a selfish person," her "selfishness" ascribed on the grounds that no one in the museum actually needed her second thesis (Biriukova 2009, 85–86).

For Nina Biriukova, writing a doctoral thesis was only half of the battle. Finding an academic board to finally defend her thesis turned out to be an even more challenging endeavor. In 1984, the only academic board accepting doctoral dissertations on art history operated at the Soviet Academy of Arts, in Moscow. However, the chair of the board, Vladimir Kamenev, declined Biriukova's thesis as failing to satisfy the requirements for a doctoral dissertation, central to which was the requirement "to have as an object *contemporary, Soviet, visual* art [emphasis added]," (86) while Biriukova wrote about French applied art of the seventeenth and eighteenth centuries, a topic that did not match any of the three criteria. The situation changed, however, when Biriukova's group mate from Leningrad Academy of Fine Arts became the chair of the board. After that she had all the necessary paperwork completed within a two-month period in 1986.

A doctoral degree as well as Communist Party membership were key forms of capital if the Soviet art historian wanted to spend time abroad. Nina Kalitina, a young PhD candidate, not a Party member but a student in good standing at Leningrad State University, was offered a yearlong internship in France in 1960. She was one of a group of young specialists sent to France. At the time, such internships were rare and precious. Kalitina was lucky to avoid almost all of the official duties normally accompanying such visits. She spent

her year attending lectures, working in libraries, visiting museums and galleries, building contacts, and making friends with whomever she wanted. Her sojourn in Paris made Kalitina the leading Soviet expert, on par with international researchers, and allowed her to integrate her work with the wider discussions in the discipline (Biriukova 2009, 114). Kalitina's trip was not typical, however. More often, Soviet art historians were sent to accompany an exhibition with an associated official, propaganda-driven mission. Such was the case of Biriukova, then a PhD candidate specializing in Western European applied art. A party member, she was sent on a number of business trips abroad, sometimes taking the place of colleagues who were more professionally appropriate for the mission but who had inappropriate records in their files. Such, for instance, was the case with one of Biriukova's colleagues, a specialist in maiolica, whose brother had emigrated to Germany in the mid-1980s, thus barring her from international travel, and it was Biriukova who attended a colloquium on maiolica held in London in 1987 in her stead. When trying to avoid professionally irrelevant tasks such as presenting contemporary Soviet artists to a Swedish audience, Biriukova was reproachfully reminded of her party membership and PhD degree, the implication being that it was her duty to follow the instructions of the Soviet administration. Biriukova was more enthusiastic, however, to serve as a manager at a gallery in the boulevard Raspail in Paris. The gallery was operating under the auspices of the Soviet embassy in France and received temporary exhibitions from the USSR. Every year an art historian from Moscow or Leningrad would come on a year-long visit to organize exhibitions. Carrying out these duties in 1976 and 1977, Biriukova had time to write three-quarters of her doctoral thesis (Biriukova 2009, 76).

Those who were not lucky enough to be sent on an official trip, however, were still earning enough to take a cruise or a tourist trip. This was the normal way Soviet art historians would see capitalist Europe and the East for the first time and, if they had the time, get acquainted with their colleagues. Such was the case with Olimpiada

Galerkina, a specialist in medieval oriental art and associate professor at the Academy of Arts who, in the early 1960s, went on a tourist trip to India, Nepal, and China. She was also able to be "an active participant in all sorts of Oriental art symposia, congresses, and conferences. In 1969 the cities of Tashkent and Samarkand hosted an international UNESCO symposium on the Timurids. Many contacts with foreign Orientalists can be traced to that event. For an extensive period, Galerkina exchanged letters and books with NYU professor and Islamic Art Consultative Chairman at the Metropolitan Richard Ettinghausen as well as Basil William Robinson, keeper of metalwork at V&A" (Nikulin and Pavlov 1998, 59).

Western scholars, on the other hand, were permitted to visit the USSR before their Soviet colleagues were allowed to go abroad on a regular basis. One of the vectors of communication was international conferences hosted by the Hermitage. In 1963, a joint meeting of the International Council of Museums (ICOM) Committee for Scientific Laboratories and the ICOM Sub-Committee for the Care of Paintings (later combined and renamed the Committee for Conservation, the ICOM CC) took place in Moscow and Leningrad, with scholars and specialists from across the world and across many disciplines. Two more ICOM committee or group conferences, in 1968 (ICOM SECA) and 1970 (ICOM ISMAH), also took place in Moscow and Leningrad. In 1977, the general conference of ICOM was cohosted by cultural institutions of Moscow and Leningrad and brought so many scholars from the West that it was decided to close the museum to the public during the event in order to host all the participants properly. During these international meetings, ties were built, sometimes friendships were struck, and correspondences between Hermitage employees and their Western colleagues were initiated. In addition, the Hermitage library continued to receive books from abroad. Thus, the Hermitage was a unique place in the Soviet Union, one where the study of Western art was approved as necessary museum work, and whose employees were in touch—if they wanted to be—with their colleagues in other museums of the world. The contacts with the Western world

became more frequent in the 1970s—a period of increasingly frequent exhibitions abroad. In the early 1980s, Hermitage scholars were first allowed to cocurate exhibitions abroad. Inna Nemilova, an employee in the paintings department and an expert in seventeenth- and eighteenth-century France, curated the exhibition "Largillière and the Eighteenth Century Portrait," held in Montreal in the fall of 1981. Yury Kuznetsov, a specialist in Dutch and Flemish art, organized the exhibition "Stilleben und sein Gegenstand," which toured Dresden and Moscow in 1983 and 1984.

The period of the 1960s and 1970s was marked by a problematization of art history as a scientific discipline. As Rozalia Kopylova (2008), who had been working at the then Leningrad Institute of Art History recalls, scholars working in Humanities had suffered an inferiority complex toward the "hard" sciences (10). In the USSR, the 1970s was a period of great schism between the so-called traditionalists and the innovators, who were trying out new languages in the discipline. The latter demanded formalization and correctness of terminology in art historians' texts, and they ridiculed the stereotype of colorful and metaphorical writing normally associated with the field. The traditionalists defended the importance of metaphors in showing the complexity of the object. The more important line probably was drawn between university and museum art historians. Piqued by the discussion on the need for accuracy in the discipline, the museum community was critical about any speculations on art not grounded in close study of the objects.

[Since my time as a student in the Art Academy], I have been somewhat dismissive toward art history as it was practiced at museums. I thought that understanding and solving bigger problems in the field was much more interesting, and what they did was boring. My advisor, Nikolai Nikulin, told me I was making things up and that, on the contrary, they thought what they were doing was the true art history, but for me at the time museum science was second best. [The fact that I now think otherwise] doesn't mean that I learned

something—[development of such an understanding] is an inevitable process for anyone who comes to work at the museum. If you are in the slightest degree sensitive to art, then, when you find yourself in intimate contact [with artifacts], when you carry this painting somewhere, when you look at it in inclined sunlight, look at the canvas's backside, discuss it with restorers, these things turn out to transgress conceptual frameworks to such an extent that they adjust [*stroiat*] the person; they instill a sense of humility, an understanding that all your ideas [*prof theki*] can shatter. The pieces are endlessly more complex. And all the considerations of style, of tendencies in history of art, are so helpless at explaining anything. . . . Artifacts are more complex and more beautiful than any concept we can come up with. After some time you just can't theorize too much. You still have respect for elegantly construed speculations, but those are useless in museum work. (Member of the Western Art Department)

Similarly, some university scholars treated the museum workers condescendingly, as unwilling to transcend the materiality of the artifact. But the barriers separating the two communities were by no means impermeable. It was a normal practice for Hermitage keepers to give lectures at the State University or the Art Academy, where they traditionally recruited new employees.

The difference [between museum and academic tracks] has always been clear, but there is the magic word, the "Hermitage." Museums are different, but the Hermitage is something special—always special, but back then much more special because in a closed country behind the Iron Curtain, when no one could travel [abroad]. The Hermitage was always such a non-Soviet, such a nonprovincial institution, something very special, completely unlike anything else. Teaching would mean integration with the Soviet system and the Hermitage, [which] in its profile [*po svoemu iskhodu*], in its very image—is an ivory tower. . . . This was the only place where one could work with Western European art. (Member of the Western Art Department)

TRANSITIONS OF GENERATIONS

The attachment of researchers to specific collections has played a crucial role in the formation of the conceptions and limits of expertise and science as they are understood at the Hermitage today. The Bolshevik acquisitions of private collections and the reshuffling of museum holdings in the 1930s sent to the Hermitage a great number of objects that were not fully described and classified, let alone studied. At the same time the museum lost some of its expertise, and there were cases in which collections were dealt with by employees without sufficient qualifications to even understand the object's purpose:

> This, for example, is not an ice-cream bowl. This is a gravy boat. And that's science already! Because it was thought to be an ice-cream bowl for a century, and now, thanks to archival research and the work of our colleagues, we found out that it's not. (Member of the History of Russian Culture Department)

During the evacuation of personnel during World War II, some of the museum's expertise was lost. For this reason, and due to a flow of new pieces after the war, the collections were large and sometimes rather messy, with many pieces unrecorded. The keepers at the time acquired a broader expertise simply due to a broader and more varied bulk of artifacts under their purview. Since then, with the eventual cataloging of the holdings, the ratio of the size of collections to the number of keepers (as well as other staff) has fallen. One consequence of this development has been a growing specialization among keepers. The current image of a Hermitage keeper as primarily an expert in a very limited area has a history: the division of labor in the museum and the fields of expertise were direct consequences of the rapid growth of the collections. The complaints of older employees, who lament the diminishing general knowledge of the arts, have this precise historical and administrative

explanation. New recruits now enter a collection largely, if not entirely, already charted, whereas the generations of Hermitagers who started in the wake of World War II were moving in a field rife with surprise treasures. Hermitage art historians were privileged not only by wider international opportunities but also by access to a huge and varied collection that was, however, contingent on their personal relationship with other keepers. On the other hand, this same personal factor, together with a growing specialization, makes free, firsthand access to items outside of one's collection less likely. For the increasingly specialized keeper, the collection in his or her holding ceases to be unfathomable, and a *catalogue raisonné* becomes a logical output of the scientific work of the keeper as it is understood at the Hermitage. While older Hermitagers complain about expertise growing narrower, they also highlight the Hermitagers' competence not as art historians but as *historians of culture*. Claimed as a unique feature of the Hermitage, with its encyclopedic variety of collections, this approach has a history of its own, one that might help our understanding of the Hermitage's position in the field. A new approach to exhibition design, which some keepers contextualize in terms of the New Historicism paradigm, has produced a new demand for larger expertise on the period, surrounding social niche, or other contextual dimension of a given artifact. Exhibitions employ more and more diverse media, combining a large variety of objects and attempting to show ever subtler aspects of cultural and/or social life. This approach is even more relevant at the Hermitage because since the 1990s the museum has been playing a growing role in the representation of Russia's reinvented statehood. The New Historicism seeks to place an artifact (a text) into an ever-broader context and to explore its hidden characteristics and meanings, which can only be rendered apparent by recourse to a variety of different sources. Given the limited opportunities for access for art historians working outside of museums, such researchers end up at a disadvantage. They not only have very limited access to most objects, but also are simply not aware of their existence and whereabouts due to the lack of transparency

with regard to museum holdings. At the same time, for museum workers, access to printed sources is only a matter of will and free time. As keepers themselves comment, with a degree of irony:

> Science [reading literature and writing papers and books] is something we do in our spare time, on weekends or on holidays. (Member of the History of Russian Culture Department)

The New Historicist paradigm established at what point significant achievements had occurred in attribution and cataloging and gave the keeper a new self-image: not as a keeper of objects but as a keeper of meanings and histories.

> We are not keeping a porcelain cup; rather, we are keeping observations occurring to people. [Because] these are two completely different things—what we see now and what they saw then. (Western European Applied Arts Department)

These meanings accumulated by the keeper in the course of his or her everyday, artifact-centered, "who-when-what-where" method of science, meanings fixed on inventory cards, eventually pile up in volumes beyond the need of the inventory or the *catalogue raisonné*. This knowledge, should it ever become available to anyone other than the keeper, can only be passed on to the next keeper orally, appear in publication, or be used to create an exhibition; the last two outcomes arguably entailing more complex genres of doing science than cataloging. Unlike many Western museums, the Hermitage does not generally bring in outside curators for its exhibitions.[2] The Hermitage keepers themselves take on the responsibilities of curator when necessary, which cannot help but "raise the bar" for the keepers. For them, designing and mounting an exhibition is a way to project their expertise into the outside world. Exhibition is arguably a more powerful means to demonstrate one's expertise than publication, since it normally involves a publication as well—be it a paper or section in the exhibition catalog or an introductory text. It is as if the keeper,

whose main strength and interest was compiling exhaustive knowledge of his or her holdings, is getting replaced by the keeper-curator. The latter, at least, gets most of the publicity and is more likely to become a prominent figure in the Russian cultural landscape. Arkady Ippolitov is one such example of an extremely successful curator and writer who nonetheless remains a keeper, as if his fame would not support these accomplishments without the Hermitage trademark on his creative output. Putting together an exhibition always means making new contacts, getting outside of one's collection, trespassing the field of expertise guarded by other keepers.

BECOMING A HERMITAGER

There have been a number of ways in which one could begin a career as a Hermitage researcher (a keeper) that were open during both the Soviet and post-Soviet periods in the museum's history. Some start as tour guides, others as officers at the Department of Research Documents (*Otdel nauchnoi dokumentatsii, OND*), or even in the utility services, where a few deputy directors started their Hermitage careers. There the new employees are out of direct contact with the collection, giving older employees a chance to get to know the new hires before granting them access to the artifacts. These departments serve as a testing ground from which the honest and the dedicated can go on to work in the more prestigious jobs closer to the artifacts. To the Hermitagers themselves, two such avenues seem to be the most popular and most natural, as has been repeated in several interviews:

> You either come as a *laborant* [research assistant] or as an *aspirant* [Hermitage doctoral student]. (Member of the Western European Art Department)

Research assistant positions are more numerous and entail providing whatever assistance is required by one's department, or

sometimes individually by the assistant's superior. The remuneration has always been very modest, but the position (provided it is a permanent vacancy) has two main attractions. First, as a way into the Hermitage with guaranteed (albeit for most, rather delayed) future promotion to *nauchny sotrudnik*, and second, as a guarantee of a flexible schedule. The latter does not only give opportunities to combine with part-time (and sometimes even full-time) education but actually gives the *laborant* surprising freedom.

> I started in my final year of undergraduate studies, and when I was accepting the offer [to become a research assistant] I knew that I would be able to do whatever I want [in terms of research]. And so it was: I would finish my duties in two working days, and I had the rest of the time to myself. For instance, I wrote my diploma thesis on the job. I had access to the library [and] some of the collections, and I didn't mind staying at the museum late. (Member of the Department of Classical Antiquities)

When a position becomes vacant, it has normally been offered to graduates or senior students of Saint Petersburg University or of the Art Academy. Most of the time, the candidates are personal acquaintances of Hermitagers whom they have come to know as professors giving classes at the university or academy, or as reviewers for their diploma theses. Details can vary, but the rule of thumb is that the candidate must have proved trustworthy and/or come with a recommendation of a Hermitager, who then bears responsibility for bringing the newcomer to the museum.

> During my tenure at the Hermitage, I personally brought eight already. And if any of them is found guilty of theft, I'll just have to go hang myself. (Member of the Western European Fine Arts Department)

Another trajectory that will show how the relative confinement of Hermitagers forced them to invent resourceful methods to keep

producing and to maintain an intellectual excitement is the career of a guide tasked with the preparation of lectures who went on to become a historian respected by Western colleagues and a legendary figure in the museum. Natalia Brodskaya entered the museum as a guide, coming straight from the Academy of Arts. After a few years of preparing lectures for visitors, she was gently pushed into doing research. Far from being assigned a preexisting job by her mentor and head of department, she was encouraged to find holdings not yet studied by prior scholars. Young scholars who had shown respect for the ethos of the museum—the key to understanding this relative freedom—were used to investigate the rich collections that had sometimes been recorded but not systematically sorted out, or studied properly to ascertain their possible authorship. Deserving close scrutiny are precisely the mechanisms of appropriation of the holdings before they would be formed into collections or at least sorted out and distributed into other departments. The primary, if tacit, policy of department heads at the time was to let young scholars seek out their own treasures and develop their passions by digging informally through the holdings. A policy of "first come, first served" was the rule (which was not always without tensions), never explicitly formulated but encouraged in practice. When a young researcher would elect to write a text, conflicts of authority could surface, but these were precisely the sign of an actual freedom and many degrees of liberty within what might seem like a rigid organizational framework. A happy anarchy survived an apparent formality established by the division of labor. This anarchy was premised on a series of shared qualities that helped older employees recognize the presence of a member of the Saint Petersburg intelligentsia.

The extremely rare occasions when the newcomer missed the nursery stage or moved too fast up the ladder of status made such Hermitagers an object of envy, distrust, and ill intentions from colleagues. When an Academy of Arts graduate was assigned as keeper in early the 2000s and seemed unwilling to follow the traditional track and partake in the Hermitage ethos, he remained an

outsider and at times encountered strong hostility, as when he was accused of having himself infected his collection with fungus in order to avoid formally coming into possession of it. He refused to follow the traditional routines when he found them "idiotic." When he protested against having to fill out in handwriting the inventory for the collection he was receiving, he was allowed to type it on a computer. Yet when a shier female employee wanted to do the same and referred to the precedent, she was refused with the rejoinder "It's okay for X, not for you." He was eventually deprived of his collection (something almost unheard of at the Hermitage), and his dramatic career at the museum constitutes a remarkable exception to the rule.

THE HERMITAGE DOCTORAL PROGRAM

Like the *laborant* scheme, the Hermitage doctoral program is not open to applicants from outside; it is reserved for those who are seen as potential keepers. This emphasized the already familiar reliability requirement: the candidates have to be careful with artifacts they are entrusted with and be impervious to any notions of theft. Therefore, places in the program are available to either personal acquaintances of Hermitagers or those recommended by a trustworthy colleague. Sometimes the program takes on people already employed at the Hermitage. But one could not normally combine being an *aspirant* and a *laborant*.

Between the establishment of the doctoral program in the 1930s until its formal (though not actual) disestablishment in 1985, there were several periods when the dissertation topics were predecided at the Ministry for Culture, and the Hermitage had to find the people to write on a topic that had been decided upon elsewhere. Under such conditions, the doctoral students had to either postpone their enrollment (sometimes for several years) while waiting for a better-suited topic, or compromise and take what was offered. Boris Aswarisch wanted to work on German Romantics but ended up doing a

PhD on the German art of the 1930 and 1940s because the ministry excluded all non-twentieth century proposals from consideration. Whenever possible, the doctoral program was also employed to serve the museum's interests, which sometimes managed to make the doctoral student work with a specific Hermitage collection, most likely with something that had not been previously catalogued. After the massive nationalization following 1917 and the turmoil of evacuation and return to Leningrad, the Hermitage was in need of attribution and classification of numerous artifacts preserved within its walls. Understaffed for the task at hand, the museum was looking for cautious hands. The interests of the museum could prevail even if the doctoral student was recruited from within the Hermitage. As for the outsiders, the chance to enter the Hermitage was so precious that it overruled their actual research interests.

At the Academy I specialized in Old Russian art. The head of the Hermitage doctoral program was the keeper of the Byzantine cross I researched for my undergraduate project, and she praised my work and invited me to apply to the doctoral program. So I was told that there would be a PhD studentship in Western European silverware available, and I was invited [to take up the position]. Since it was the Hermitage, there was no doubt on my part, although I had little idea how I would handle the new topic. I managed rather well as I was the only PhD student to have completed the dissertation in the three years one was allocated, but still there was uncertainty since I was not a Leningrader by birth and therefore could not obtain the registration (*propiska*). It was only after I married a Leningrader and obtained the registration that I was able to join the Hermitage. Since my doctoral topic was German silverware, I received it [as its keeper] and abandoned my Old Russian and Byzantine pursuits. (Member of the Western European Applied Arts Department.

The aspiring Hermitage doctoral candidate in his or her turn had to have the desire to eventually become a keeper, or there would be no material for his or her research. Among the Hermitagers

interviewed, quite a few were from the doctoral program. Only one or two, however, completed the thesis in the prescribed time, and many more failed to defend the thesis within a few years after the formal deadline. Two of the most popular explanations for these delays are the bureaucratic formalities and the intrigues and competition of older colleagues working on related topics or similar objects. As mentioned earlier, the generation of keepers who were in charge and in a position to select *aspirants* were mostly not PhD holders themselves. They may have had publications, and have at times even enjoyed world recognition despite the obstacles to communication with the wider community of art historians, but a younger colleague obtaining an official degree on a topic that they may have planned to write about or contribute to severed their monopoly on the material. The bulk of our interviews suggests, however, that for most Hermitagers their doctoral training did not become a memorable period in their research career at the Hermitage—some even failed to recollect the name of their advisor. The doctoral program was mostly important as an extended probationary period. After 1991 more opportunities for short-term contracts became available and such contracts now play a similar role. If things went well and the doctoral student did not demonstrate any shortcomings—and not writing the thesis was *not* considered a serious shortcoming—she was offered a position of keeper when one became vacant. While many prominent Hermitage researchers have been successfully working without the formal doctoral qualification, and some have become head of a sector or even a department, obtaining a PhD is increasingly considered the natural way to become a Hermitage scientist. And although some interviewees can sound dismissive of its "uselessness" and "formality," the more successful the Hermitage scholar is, the more regularly she is regarded and treated as a "doctor" (especially by Western colleagues). Thus, a virtual title is ascribed to and "grows on" those who are considered to be real scientists by others.

The history of doing science at the Hermitage and the broader context of the academic weakness of art history among the

branches of Russian and Soviet academia provide an explanation for the current academic situation at the Hermitage. Museum management stimulates the defense of more PhD theses with the accompanying official and informal financial bonuses, but with the doctoral program formally disestablished, writing and defending the thesis is not becoming easier, especially since now a Hermitager would have to have a formal affiliation and thesis defense at another institution. The attitude toward the doctoral degree has been changing over the recent decades: today the Hermitage not only encourages its employees to get a PhD degree with the prospect of a salary raise but also requires a doctoral degree for top administrative positions. The Hermitagers themselves, however, differ in their attitude toward pursuing this track. Most of the older generation say they are too busy and/or unwilling to struggle with the humiliating bureaucratic hurdles associated with thesis defense procedures. They might, however, spur on their young protégés to write their theses, wishing them a higher salary or position in academia or seeing it as a means of self-discipline and self-education in terms of the ability to structure their thoughts, given what is seen as the decreasing quality of education with which young Hermitagers enter the museum.

THE KEEPER-SCHOLAR

As is often asserted by Hermitage keepers, their position in the museum world is unique due to the fact that all of them are employed as both keepers and researchers (*nauchnye sotrudniki*). As one of the keepers put it:

> Unlike the Russian Museum, at the Hermitage the keepers are the scientists; for us, for the Hermitagers, it would look silly otherwise. You can't have a researcher if they're not keeping a collection. And when you become a researcher, you automatically get a collection to keep. (Member of the Western European Fine Arts Department)

Or, as another Hermitager put it:

> No one sane would want to come to the Hermitage and not be a keeper. How else, then, will they do research? (Member of the Oriental Department)

Keepers not only consider themselves to be the core Hermitage employees; they also see themselves as more involved in research than their nonkeeper colleagues at the Hermitage and at other museums. This proposition is supported by the claim that the Hermitage system in which all keepers are also *nauchnye sotrudniki* is "unique."[3] When an employee is appointed to keep a collection, she starts with a formal acceptance letter which is tantamount to a contract binding the keeper and the museum and setting the responsibilities and prerogatives of the keeper in relation to the pieces she is entrusted with. The bottom line of this agreement holds a keeper legally accountable for the collection in her holding. In the course of recent decades, the volume of paperwork and the number of formal duties associated with accepting a collection has been constantly growing. While there were times when the acceptance required nothing more than a single signature, now a new keeper has to check the holding for the availability and condition of every item. As one holding can comprise thousands of items, the fulfillment of these responsibilities might take over a decade after the previous keeper's retirement or death, leaving the holding in a strange limbo. This preliminary thorough assessment of the holding has given birth to the ironic self-description of *kladovschik* (storage attendant). Many Hermitagers indeed show considerable irony toward their duties as keepers. One of them, for example, a member of the Western European Art Department, could not (as was the case with many other interviewees) tell the number of artifacts in his holding with any precision. When asked to at least give an order of magnitude, he put on his keeper persona, walked up to the computer, and gave the number in a mock–office clerk manner. Self-segregation from the formal duties associated with the role of the keeper can also be

achieved by clearly demarcating its irrelevance to one's research interests. The same keeper pretends to not be able to pronounce the official title of his position as a keeper, but, he hints, it really should not matter because what he is working on now ("Don't ever ask a Hermitage keeper what she is working on now" [Member of the Western European Art Department]) has nothing to do with his holding. The gap between keeping responsibility and research interests can be even wider, and the Hermitage allows for this phenomenon, at least on an informal level. As one art historian close to the Hermitage recalls:

> There used to be a self-made Picasso specialist at the Hermitage who in fact was employed at the Prehistoric Culture Department, and when he was called to produce a piece for some Moscow exhibition there was an outrage on the part of the "established" Picasso scholars. [Male, 63]

However, most of the keepers, with a few (albeit bright) exceptions, base their research firmly on what they keep. No matter how indifferent the Hermitagers may seem to their holdings, to a large extent holdings provide them with their status within the museum (as opposed to those who don't have any collection to keep or in comparison to other keepers with "better" or "worse" collections). The holding shapes the everyday routines of its keeper, making her the lord of her own realm, with powers to keep others away. In some sectors of the Hermitage, it is actually possible to redivide or even swap collections in order to better match them to the interests of researcher-keepers. "Good"—that is, rich—collections have enough research material for the lifetime of their keepers. A keeper of Greek icons was once taken to be a fraud when he failed to demonstrate sufficient professional interest in a collection of Sinai icons. The reason he gave for his lack of interest was his realization that he had one of the best collections of Greek icons in the world in his holding and, unlike his colleagues from other museums, was not studying Mount Sinai icons for their own

sake but rather to contextualize his collection. "Bad" and "good" can also correspond to the mobility opportunities the collection provides for its keeper.

> They were going to give me a good collection, but then this older employee (who was at this time accepting another, bad collection) found out, and I ended up with the collection from minor cities of the Kingdom of the Bosphorus, which no one was interested in. This meant zero [international] travel opportunities. (Member of the Department of Classical Antiquities)

This concern with travel was especially relevant during the Soviet period, when international mobility was a very scarce commodity. Getting a collection that was in demand on the international exhibition market meant travel opportunities at a scale unavailable to most Hermitagers. But more important than these opportunities is the de facto monopoly that keepers enjoy on their collections. The keeper has been and is still to a large extent the only person responsible making the formal decision to share, lend, or make accessible for a quick peek elements of his collection. A keeper's decision to let a museum piece circulate for an exhibition is contingent upon the safety of the trip and can thus be dismissed by the restoration committee, but the first decision to share lies with the keeper, and if he or she decides not to authorize the visit of a colleague or the loan of a piece, few alternatives are left to the inquirer. This formal rule leaves space for discussions with the higher administration, and in the case of exhibitions designed to position Hermitage and Russia on the world scene, the keeper is advised of the great significance of a loan.

The tension between the two different approaches of the Hermitage collection is primarily a matter of generations. With an increasing number of the properties of the museum now charted and recorded, the new generation of keepers have fewer opportunities to explore freely the storage room to train their eyes and learn the style of artists not yet categorized. This division of the treasure was

not in place in the 1950s, when young Hermitagers were exploring a vast, unknown territory. Any young keeper has almost certainly taken the dream job of another Hermitager. As a result, his or her expertise will regularly be challenged by those who have not been promoted but linger in the museum in some subaltern function. Much of this will take place behind his or her back and, of course, questioning a keeper's knowledge and scientific qualification are the most "decent" ways of challenging his or her authority. This competition is not exclusively the plight of Hermitagers, but it has an impact on a kind of hierarchy of judgements between museum colleagues and outside experts working in other museums or abroad. The experience of the slight "arbitrariness" of collection assignments creates a legitimacy crisis in the museum. How does one endure the envious looks of colleagues who have not been given the same trophy? The question would be less relevant if the pressure of colleagues was not so strong, given the confinement of the museum. Working in peace on an advantageous but unfairly assigned collection might be possible if the walls of the museum were not so high, and necessary. We should not forget that conditions in the outside world are not so rosy as inside the Hermitage, particularly when it comes to a perk like a coveted collection. The consequence of this intense competition for collections, coupled with a strictly internal promotion policy, is a culture of generalized knowledge and a display of local expertise meant primarily for the museum employees themselves. One cannot hide from peers and enjoy his collection entirely by himself, but many keepers shy away from exposing themselves to the outside world, sometimes due to the very lack of any "external" world, at other times as a way of keeping a hand on the material they have been entrusted with. Hence the very unique form of oral expertise that combines local performance and control over collections.

Hermitagers in every department repeat the mantra of being "scientific" in their work, be it keeping, cataloging, or designing exhibitions, tour programs, or texts. Yet the quality praised most often in interviews is charismatic, orally demonstrated connoisseurship.

As a posture, it has a long tradition (Brainerd 2007; Brown 1995; Price 1991). All aristocracies have dabbled to various degrees in some form of connoisseurship. One of its tenets is the dismissal and even the scorn for any form of division of labor or specialization, virtues associated with bourgeois and entrepreneurial societies following rules rather than intuitions based upon the embodied knowledge of the real amateur. Against and in reaction to these modes of activity, connoisseurs insist on amateurism and celebrate it as a virtue. There is an economic condition underlying connoisseurship in settings other than the Hermitage: the ability to travel freely and expose oneself to all kinds of art in order to train the eye and expose the senses to the complete artistic experience. The connoisseurship we observe in the museum is of a different kind, yet it is also the identity of a caste, minus the traveling. As a member of the Special Programs Department reflected:

> The lectures we give as part of our educational programs at the Hermitage are not your typical art history lectures. Apart from being scientific and written by true experts, they have to be engaging and produce a sensual impression (*vpechatlenie*) on the listener. And at the Hermitage we have a long tradition and a technology to develop just such lectures. . . . I continue to write papers and publish them, and I go to a conference every year, and they know that my presentation will always have an aesthetic value of its own, and they expect and value that. . . . When you do a lot of tours, then . . . return to your research, you suddenly find yourself using the same devices that you did during the tours.

In this otherwise balanced and diplomatic view of the respective expertise of classroom art historians and museum art historians, a slight scorn for the latter group's abstract and lofty mode of presenting cannot be missed. The *vpechatlenie* is time and again mobilized as the special mark of presentations by speakers and writers who have lived long enough and close enough to the works of art that they can convey their irreducible material qualities. In a

broader perspective, the obsession for the intimate relations that can only be built by proximity has a consequence on the peer system of the Hermitage scientists. The Hermitagers who become true stars and legends in the museum are those who are able to speak and discuss their field of expertise with Hermitage colleagues and demonstrate their expertise in conversation, not those who are recognized for what they publish. Perhaps it is the larger-than-usual number of lectures and tours the Hermitagers had to give starting in the early twentieth century that brought forward this "public lecture" format of knowledge. Can the theater-like taste for sensational attributions and counterintuitive discoveries originate in the greater importance—in comparisons to other universal museums abroad—given to the verbal performance of expertise? Recognition inside the Hermitage is very important, and it is perhaps more easily achieved by means of performing one's expertise, erudition, and charisma orally.

> I earned recognition outside of the Hermitage first, and it was a while before I was recognized at the Hermitage. There I would often be corrected in my writing by other specialists or, say, people at the publishing house. I constantly had to defend my scholarship, and eventually I realized that I had to present my work at the Hermitage a lot more—talk about it, get people to know what I do. Because when they don't, rumors that you don't actually do anything are more likely to develop. (Member of the Oriental Department)

If you work at the publishing house or in the Educational Department, everyone (including you) knows that this is second best to keeping. Since mobility within the museum is unpredictable, and it is hard to get a collection to keep, you want to constantly demonstrate your expertise and establish that you deserve the collection, not someone else. Infighting, when it occurs at all, is conducted verbally, not in the pages of scholarly journals. So the Hermitage, by its size and by the variety of its collections, has grown a form of domestic credit premised on a broad and general knowledge of the local

treasures rather than on a deep knowledge of a very narrow sector of the art world. This unique form of scientific credit cultivated in the museum contrasts with another form of scholarly credit, one that has faced a series of difficulties—namely, reputation built by way of recognition by outside specialists of the knowledge embodied in standard documents such as articles and books.

PUBLISHING

In this confined and, at times, parochial world of keepers highly concerned with local performance and oral displays of expertise, one might wonder how scientists are led to publish outside of the museum. One manifestation of scholarship among Hermitagers is the book. Hermitagers write books in a number of different genres, but they all tend to sit nicely in a personal library. Not coincidentally, one of the most common memories among employees is their early introduction to the arts through books held in family libraries:

> My dad would tell me, "Irina, why don't you read in German. See, . . . we have all of Goethe in German; don't read it in Russian; the book was written in German; read [it] in German." Our library meant a lot to us. It was in our family and had been for ages. We had old books, really old. In Saint Petersburg, and at the Hermitage . . . I mean [among] people who work here with us . . . there is a deep respect for books. This is what we have in the museum . . . with works of art, of course. And this is what we had at home too. I like books and so I write books, but books that I would like to read. (Member of the Education Department)

Books published by Hermitagers are important to understand because they straddle a series of worlds that are not usually brought to bear on the dynamic of a museum. This last quote—one among dozens of its kind—shows the book as a domestic element. This was

also one of the key findings of the genealogy of catalogues observed in the previous chapter. The protocatalogues sketched by keepers were local inscriptions with personal description keys and sometimes individual styles. The inadvertent equation of books and works of art takes us in the opposite direction. Far from being personal works, quasi diaries where notes on collections' items are scribbled, they are the devoutly worshipped pieces standing for the past and containing its wisdom. In between these two forms of books stands the *catalogue raisonné*. Initially a personal take on a collection, it is now often a massive book not necessarily meant to be read from beginning to end, an object resembling a luxury book in a solid and colorful box.

These boxes, just like the museum itself—which, one will remember, we ventured to call a "box" in the introduction in order to test its specific resistance and porosity—have never been solid enough that they could not be cracked. There was even a time when they were seriously scrutinized for their content. They were written, let's not forget, by intellectuals who had education, personal libraries with books sometimes no longer authorized by the regime. Censorship was one of the crucial features of publishing in the Soviet Union. Authors knew about the rules of censorship to an extent, but with censorship being decided at many different levels of the Party administration, the case-dependent application of the rules was what would decide the future of a manuscript. As a consequence, intellectuals played around these rules as much as they were surprised by them. The range of experiences of censorship is now understood to be much wider than the West's initial understanding of the phenomenon, which posited a simple and transparent enforcement of the rule of law. Against the views that authoritarian regimes could straightforwardly enforce rules regarding appropriate publications, a new understanding of censorship has emerged to offer a more complex view of its economy. In the wake of a more nuanced scholarship of post-Stalinist era, it would be tempting to reformulate censorship as closer to the rules of publication scholars encounter in nonauthoritarian regimes

and to insist on the continuity of these practices rather than on the stark discontinuity of a liberal-authoritarian divide. It is not so much an intellectual temptation as it is a recognition of the layers of complexity that working and publishing in the Hermitage added to the Soviet situation. How, then, to understand the experience of content control and limitations on publication in the context of the museum?

In 1948 Joseph Stalin had closed as ideologically dangerous the State Museum of New Western Art, in Moscow, which showed the paintings of impressionists and postimpressionists—Van Gogh, Gauguin, Picasso, Matisse, and others. After the closing, about half of the collection was moved to the Hermitage. It took eight years to show the paintings to visitors, and even later, in the 1960s, the museum struggled with state officials for the right to display them. But if the impressionists were not welcome, neither were they destroyed or sold away on a large scale. Stalin understood the value—if only the monetary value—of the collection. It only needed to be kept silent as a form of late-bourgeois art, and the Hermitage already possessed a series of such masterpieces, both glorious treasures and embarrassing manifestations of the West still living in the heart of the Soviet Union. This has been the hard luck of Hermitagers during the Cold War: they were in charge of toxic material, but that material needed to be preserved. As keepers, they were also toxic themselves because they were in close contact with the material. The layer of complexity introduced by the museum qua organization came from the compromise made by the authorities in Moscow to accept an enclave of decadent and bourgeois artworks in the periphery. Leningrad, formerly Saint Petersburg, the city of the last hours of the czarist reign, was found to serve well as a safe and a coffin for the arts. The idea of publicizing these dubious and suspicious collections could not be well received.

There was a time when you just could not work on the Western art . . . or you should have criticized it, in the introduction, for

example. The book on postimpressionism was published with a big introduction, written by Antonina Izergina, who had worshipped this art—but she had to write about its shortcomings, otherwise they would not publish it. (Member of the Department of Western European Fine Art)

The restrictions and censorship concerned not only books but all kinds of texts, whether published in USSR or abroad. In the latter case, as a Soviet citizen one was obligated to submit one's manuscript to the Ministry of Culture to obtain permission to publish it with a foreign publisher. The political climate, however, was not invariable during the Soviet period. The limits of freedom shifted; some topics and ideas moved from being forbidden to being allowed; others experienced the reverse trajectory. Still, the ubiquitous possibility of censorship remained until *perestroika*. One of the topics considered "unwanted" for public discussion was Russia's czarist past. The only allowed modality of discussion was the accusative, which created difficulties for those who studied Russian art and history:

> I published an article, it was 1984, in the journal *Decorative Arts in the USSR*. It took a long time to justify it, because their attitude to Fabergé was somewhat cautious: "He worked for Nikolai [Nicholas II]; czarist Russia; we don't like all this." . . . To publish this article I had to come to the deputy director for science and ask for permission. . . . Then I thought, "It is interesting for our [readers]; probably it would be even more interesting for the West, this material I have discovered." Again, we sent the paper to the Ministry of Culture, waited for the permission for foreign publication. . . . Not getting it, or any papers, I just sent the article, at my own risk. They published it at once. (Member of the Western European Applied Arts Department)

Since 1960s the museum had been collaborating with foreign publishers to produce albums and catalogues for an international audience. The first such partner was the publisher Artia, from

Czechoslovakia. When Hermitage researchers and items began to travel abroad, the museum started to produce joint publications. And again, to publish abroad one needed to obtain official permission. A still-unpublished memoir by one of the Hermitage curators, Nikolai Nikulin, recounts how he went to the ministry to obtain permission for foreign publication of the catalogue on the Flemish primitives. Nikulin (2010) tells how he foresaw a long fight with the bureaucratic machine, and when he got permission very quickly, he could not believe it. For keepers, opportunities to take trips abroad were dependent on the items one was in charge of and on how interesting these items were to the foreign audience, as imagined by the cultural authorities. These constraints shaped the publishing policies and practices of the Hermitage. A principal effect was that the publication of Hermitage collections was hampered:

> Not all the paintings were included [in the catalogue of the collection, published in 1977]. We had many more paintings in inventory books, but in the catalogue we included [only] those with the attribution, and some of unknown artists, but not too many [because] . . . to have about half of the paintings unattributed—that would be kind of awkward. Another thing is that the curators understood perfectly that we did not have opportunities to do research abroad. We will give them the material—and they will publish it under their names—but those are our things! (Member of the Department of Western European Fine Art)
>
> Our tragedy is that most items in the Russian [department] are associated with the monarchy. You could not publish this, or write about it, or even declare that you have it. Either they take it away, or cut it down, or accuse you of anticommunist ideas, and so on. (Member of the History of Russian Culture Department)

Apart from the difference between what the museum had and what it showed, there was a gap between what the researchers knew and what they wrote about in the works they published. After

the revolution the government abolished social classes, and any mentions of titles of nobility were not welcome unless they were necessary.

> When we published albums with Aurora [a partner publisher of the Hermitage] we could not use the title "prince" or "count"—they deleted them, left only last names. What can you do with this? One of the editors found a solution—she put those in the footnotes. . . . She was reprimanded for that. (Member of the Department of Western European Fine Art)

Sometimes the name of the owner of paintings could not be made public. One of the keepers told us how she was punished for indicating in her work that some paintings were from Menten's collection. She was not aware at the time that Pieter Menten was a Nazi war criminal, which made impossible any neutral mention of his name. That was enough for officials to ban the researcher from submitting manuscripts to academic publications for five years. The Hermitage director allowed her to publish her works in the museum serials during this embargo period. This case lets us assume that one of the reasons why the museum did not close the publishing department even during the most "centralized" periods was that it wanted to save the opportunity to publish monographs in its own way. The Soviet state did not offer much autonomy to its citizens; still, scientists had some maneuvering room because they were in an institution entrusted with propagating socialist art. Cracks formed in the propaganda mission, so that other art traditions, not directly in line with the Party's cultural creed, could slip through. Between texts positively welcomed by "the system" and those definitively banned, there was a grey area—topics, ideas, and practices which met with one kind of reaction one day but had a chance to meet with another the next day or in another place. Hermitage scientists were encouraged by their superiors to do research and write papers and books even if they had few chances to be published for the moment.

Those who worked with Mikhail Artamonov, Hermitage director from 1951 until 1964, remember him saying that "the hardest thing to publish is an unwritten book." So the museum was full of texts and documents in publication limbo, their authors waiting for the rare opportunity to submit them formally when a lucky alignment of friends would open the door to publication. Right after *perestroika* was announced, a series of books on banned topics were very quickly published. These were not quickly and hastily assembled pieces; rather, they were academic pieces that had long matured behind the walls of the museum.

INTERLUDE 2

Mobility at the Hermitage

I n this book, I circle around the idea of the "unprofession-
alism" of Hermitagers. Rooted in the long durée history of
intellectuals in Saint Petersburg versed in the cultures of the
West as much as of the East, this notion has also been shaped by
a discreet series of events experienced by the museum during the
long twentieth century. That period produced remarkable trajec-
tories among a group of Hermitagers who joined the museum soon
after the war as assistants and went on to complete their careers
as deputy directors.[1] The comparison of the Hermitage with other
museums of comparable size shows us a pattern of vertical mobil-
ity and fluidity that stands in stark contrast with the image that
the museum sometimes offers to visitors. Having been exposed to
the culture and the intense cultivation of myths glorifying legends
of the past—highly "amateurish" tales, in the positive sense used
by the Hermitage's polymaths—I broach the topic of this mobility
here by using data produced by the Hermitage Human Resources
(HR) Department.

The Hermitage keeps close track of its active population of
employees, in particular information on the trajectory of employees

from their arrival at the museum to their current position. The limitations of this data source stem from two characteristics of the information collected by the museum. First is its exclusion of employees who left the museum before their data was collected by Human Resources. The department's picture of the museum workforce is perfect as of early May 2014. It provides us with all past and current positions held by each current employee. These positions tell us a great deal about mobility within the museum, but with a caveat. The documents of the HR department used to be on paper. Only in 2003 did the museum switch its HR records to electronic format; from then on, the detailed tracking of employees' circulation is precise and lends itself to fruitful statistical analysis. For employees who entered the museum before 2003—that is, a majority of the workforce in 2014—the information we have is limited to the year they were hired and their first position. So, for employees who joined in 1973, we have a thirty-year gap in which we lose sight of their mobility. Second, the HR classifications were not designed for this study. They predate the study and meet needs that are not (necessarily) those of a social scientist interested in peeking into the professional culture of a museum. So not only can we not make the dead bodies of the museum talk, a situation that most social scientists have to accept if they prefer the method of interviews, but the living have been seized along dimensions that are not tailored to our study.

Departments vary in size, so I built a measure of mobility assuming that the size of the departments did not change between 2003 and 2014. Since 1993 and the beginning of the tenure of Mikhail Piotrovsky, an informal policy by which employees are not forced to retire has been in place. This policy has, over the years, skewed the age distribution, with the average museum employee older in 2014 than in 1993. The full effect of the policy had probably been felt by 2003, so that since then the age distribution has not shifted considerably. From our perspective, with our interest for the mobility of employees within the museum, this aging of the population is unlikely to yield an additional mobility effect. Employees who are kept on payroll longer stop changing departments.

Using the distribution of ages observed in 2014, we build the theoretical (meaning reconstructed after having assumed the homeostasis of the population between 2003 and 2014) departments' and subdepartments' populations for each year. The mobility that we measure is only produced by employees still at the museum in 2014. One could legitimately ask whether the employees from our database, those who worked in the museum at some point between 2003 and 2014, were not moving actively before they either left for another institution or passed away while still employed by the Hermitage. The former case is rare. The HR director indicated that Hermitage employees had slightly different working conditions from those found in similar institutions in the West: acknowledging that salaries were relatively modest, he insisted that the perk of being a Hermitage employee was the museum's less oppressive conditions. He did not deny the frustrations that coveted and quasiprivatized collections could generate among keepers who were excluded from them, but he noted the space for self-realization that could emerge from so many positions and the cracks left in between these. Simultaneously, and asserting his function as HR director, he also insisted that his mission was to supervise the mobility of employees and the kinds of functions, tasks, and deliverables that could be expected from them by the institution. We will come back to this statement—shared throughout the museum, irrespective of age. Can we imagine that the "ghost population" contains ex-employees who would have experienced a distinctly low level of mobility and, as a consequence, would have decided to quit out of professional frustration? This would be a breed of high-achieving employees with high expectations who resented the slow process of moving up the ranks in the museum. By leaving, they would have automatically boosted the observed mobility rate. This is a theoretical possibility, and one that would constitute a major drawback in any other organization in a competitive field where (similar) job opportunities are available and where the institution in question does not enjoy the form of cultural capital and cachet that the Hermitage features.

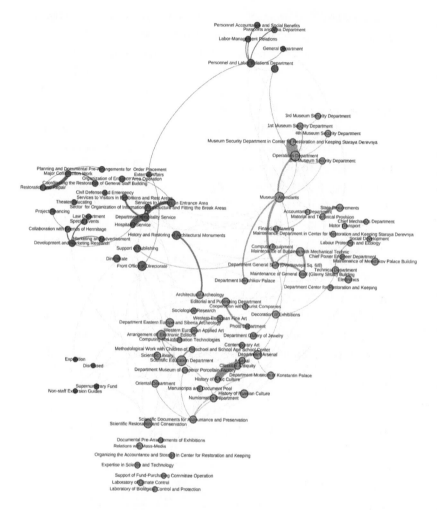

FIGURE INT2.1 Visualization of all employee movements.

Taking into account all employees who moved at least once, I produce a map that sheds light on the structure of mobility between departments. A view of the map of aggregate mobilities should direct our attention to the bridges of the subdepartments. The Department of Major Construction Work is a feeder for a series

of other subdepartments, including the Department for Restoration and Repair, which in turn leads to the bridge, History and Restoration of Architectural Monuments. This is an important insight for the claim of high mobility at the Hermitage to the extent that it shows the relations between the directorate and management of the museum. Typically, decision-making departments can interface with the outside world as well as the coordination center and other subdepartments, notably "architectural archeology," which is a unit belonging to the sciences. So (to simplify things), work on the maintenance of the buildings leads work on to the science of buildings, in this case the study of architecture. The unique configuration of the Hermitage, a palace containing collections that is also itself a collection, organizes this equally unique circulation of employees. That is how taking care of a building can cultivate artistic sensibilities to the point that the employee in question can move to the scientific section of the museum. A bridge department links different worlds and creates a form of conversation among different issues. There, a rare and notable characteristic of the Hermitage (one shared with the Louvre)—namely, that it is a museum not initially designed as a public museum—has given shape to a stream of mobility, leading employees who started in the construction work subdepartment to join the architectural archeology section.

What is the distribution of mobility chains during the ten years we are able to study? We have so far analyzed mobility by looking at subdepartments as our primary unit of museum territory, so our standard for mobility is the jump from one subdepartment to another. Simply put, when an employee jumps from one position to the next, we count that as "1 mobility." Whether an individual moves once every year for ten years, or ten individuals each move only once over the same period, the resulting measure of mobility will be the same from the point of view of the institution.

Now we look at a slightly different question, that of "chains of mobility." For that perspective, we count numbers of jumps by individual employees. (Some never move or move just once: we do not consider them here.) Now, from the "chains of mobility"

perspective, our thought experiment of one highly mobile employee versus ten stable employees illustrates two very different things. Someone moving ten times tells us a lot about the departments that accommodate him for a brief period only. In the previous measure and visualization, we could assess the role of departments, but only on an aggregate level. (For example, having Yuri join department X and Oleg leave department X was the same as having Yuri join X and then leave X.)

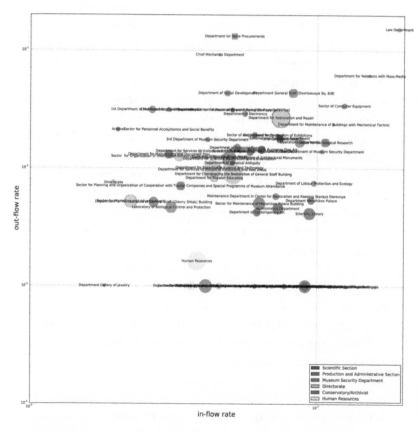

FIGURE INT2.2 Visualization of the "ricochet" properties of subdepartments.

In figure int2.2 we use chains of mobility, that is, employee-based mobility as opposed to the subdepartment-based mobility used in figure int2.1. Using our population of serial movers, we have plotted the subdepartments in the in-flow/out-flow space. Each department can have employees coming in from and leaving for other departments. The two rates are measures of porosity of each department in relation to the whole museum organization. Departments with high in-flow receive many employees from other departments. If they have a low out-flow, they are end-of-career departments. Employees may be far from retiring, particularly when it is their decision alone whether to stay or leave, but they will not leave their department for another Hermitage department. On the other hand, departments with high out-flow are transition departments, leading to another assignment elsewhere in the museum. To push this principle to the extreme: if there were a "dispatching department" exclusively designed to assess the qualities of a new employee before his or her real assignment and never meant to retain employees, its out-flow would be very high and its in-flow would be zero.

We are interested in what we call the "ricochet" subdepartment, defined as a subdepartment bridging two other subdepartments of the museum. The subdepartments acting as ricochets (figure int2.2) are listed alongside their rate of ricochet.

The highest rate of ricochet is from the Production and Administrative section and from the Directorate. The Scientific Department is represented thanks to a high mobility between subdepartments. We excluded employees who had moved only once, including only those who moved between two and five times.

With this new representation of serial movers, we can qualify the bridge initially detected. The edge between the directorate and the science departments is now thinner, indicating a less frequent circulation of employees through these subdepartments from others or on their way to other subdepartments. The strong bridge observed with the previous map of aggregated mobilities (figure int2.1) indicates a correction in job assignment, namely, employees initially recruited to the directorate moving to the science department.

SUBDEPARTMENT	RATE OF RICOCHET
Production and Administrative Section_Department of the General Staff	1
Production and Administrative Section_Department for the Maintenance of Buildings with Mechanical Techniques	0.625
Directorate_Sector for Collaboration with Friends of the Hermitage	0.5
Museum Security Department_Operations Department	0.41
Production and Administrative Section_Department for State Procurements	0.36
Conservatory/Archivist_Department of Scientific Documents for Accounting and Preservation	0.33
Production and Administrative Section_Department of Electronics	0.33
Scientific Section_Department of Western European Applied Art	0.33
Directorate_Sector for Support of Publishing	0.25
Scientific Section_Department of the History of Russian Culture	0.2
Scientific Section_Department of Western European Fine Art	0.2
Scientific Section_Numismatics Department	0.2
Directorate_Department for the History and Restoration of Architectural Monuments	0.2
Directorate_Department for Restoration and Repair	0.18
Production and Administrative Section_Department for Maintenance of the General Staff (*Glavny Shtab*) Building	0.13
Scientific Section_Editorial and Publishing Department	0.11
Directorate_Department for Services to Visitors in the Entrance Area	0.07

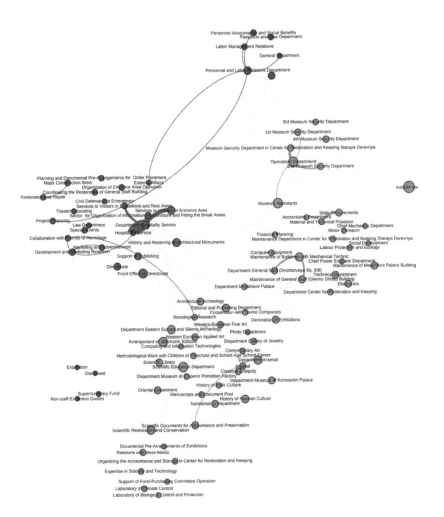

FIGURE INT2.3 Visualization of the unique trajectories of "serial movers."

The new serial mobility map also clarifies other interactions across departments. The Technical Department and the Maintenance Building of the Production and Administration Department also feed the bridge subdepartment History and Restoration of Architectural Monuments, confirming the centrality of the museum as a

structure and the activities of maintenance and study in animating the circulation of employees. This transfer route is crucial for our understanding of the role of the museum as both a site of perpetual maintenance and an object of study. More than just a bridge organizing a transfer from one position to another, this sequence epitomizes the vertical mobility spoken of by many older employees of the museum. Starting typically from an administrative or technical position, young employees learn the back stage of the museum and develop knowledge of the collections from this perspective.

4

THE NOSTALGIC MODESTY
OF HERMITAGE RESTORERS

During one of my early visits to the Hermitage, I walked through the halls of the museum with one of the keepers and asked him: "Is it possible to notice the traces of restoration on the art pieces if you are not a specialist?" It is indeed possible to do so, yet museum visitors usually do not think about the manipulations of conservation and restoration that allow them to enjoy the masterpieces on permanent display. However, they generally do think about pieces in terms that directly relate to the essence of restoration—through notions of authorship, authenticity, conformity to particulars of the period, veracity, and so forth. My companion pointed to one of the pictures in the Italian Icons of Sienese School hall and said: "Do you see this left-hand angel? It was painted by Liphart. . . . Do you see this big hole?" Here he drew my attention to the picture opposite. "Liphart would never leave it as it is."

Figure 4.1 is the *Madonna with Two Angels*, by Paolo di Giovanni Fei (mid-1380s); the figure 4.2 is the *Madonna and Child Enthroned with Hagiographical Scenes in Stamps*, created by a fourteenth-century

With Olga Olkheft. Olkheft is an independent researcher based in Saint Petersburg.

FIGURE 4.1 *Madonna with Two Angels*, by Paolo di Giovanni Fei (mid-1380s).

Sienese artist. The paintings are held in the same collection under the responsibility of the same keeper, and the same restorer exposed them to complex restoration techniques over the period of many years. They were recently placed back on permanent display. If we translated the keeper's comment into the language of restoration, we would see that both pictures were seriously damaged over time and through previous restorations, and, as a result, sizeable areas of *losses* formed on the image. Ernst Liphart restored the first painting at the beginning of the twentieth century and filled

FIGURE 4.2 *Madonna and Child Enthroned with Hagiographical Scenes in Stamps,* by an unknown Sienese artist (fourteenth century).

the loss through painting—in contemporary terms, he *reconstructed* it. In the second case, the loss was not filled; instead, the restorer left a hole in the painted surface so that, rather than painting, we see the wooden plank beneath the surface. According to the keeper, if Liphart had restored this artwork, he would have undoubtedly filled the loss and hidden the plank through means of painting. Ernst Friedrich von Liphart worked in the Hermitage as a curator of paintings between 1906 and 1929. He is an important and respected figure in the museum's history, made famous by his correct attributions of the *Madonna and Child with Flowers* to Leonardo da Vinci and *Saint Peter and Saint Paul* to El Greco. Being not just an expert in art but an artist as well, he combined keeping and restoration activities. The fact that he restored *Madonna with Two Angels* is documented in the Hermitage archives and mentioned in a recent exhibition catalogue: "The angel from the left was totally repainted with tempera and gouache by E. K. Liphart" (Nemchinova 2014, 40). This is a rare case indeed, in which we are given the name of the restorer in relation to a specific part of the painting. While present-day curators and restorers express their reverence at the mention of Liphart's name, his contemporaries judged him more harshly. Alexandre Benois (1980), a famous and influential art critic of the beginning of the twentieth century, who served as curator of the gallery of old masters in the Hermitage Museum from 1918 to 1926, mentioned that Liphart "was not capable of self-criticism" and "regarded himself as a successor of the old masters" (583). Levinson-Lessing (1985), one of the great Hermitage keepers of the twentieth century, was no less scathing when he wrote: "Being in charge of art restoration, he abused by repainting, covering not only the damaged sections, but also the adjacent healthy areas of the picture" (235).

The criticisms by Benois and Levinson-Lessing, and the restoration solutions adopted during the period, take place within a larger conservation debate that intensified during the twentieth century, one involving cultural heritage in general and the restoration of paintings in particular. If at the end of the nineteenth century the repainting and filling of losses (accompanied by notions of

improvement or renovation of paintings) were common restoration practices, the twentieth century witnessed a progressive limitation of restoration interference (Thomson 1970, 1978). New technologies developed during the twentieth century brought changes to restoration techniques. X-rays, infrared light, microscopic examination, new chemical materials—all these redefined the conservation process and established new scientific standards, which assumed that museum preservation does not just deal with technical manipulations or art renovation but, above all, studies objects. These new tools allowed restorers to draw a crucial line between layers produced by the original artist and those added by later restoration. This led to a revision of the "restoration after restoration" problem while provoking discussions and harsh criticisms of the "so-called scientific approach," a dismissive expression referring to radical cleaning or drastic (synthetic) varnishing (Gombrich 1960; Walden 2005; Beck and Daley 1996). At the same time, this new scientific approach sparked a renewal of the old theoretical opposition between John Ruskin and Eugène Viollet-le-Duc.

The restoration department currently includes fourteen laboratories. Their activity encompasses easel painting, tempera painting, mural painting, oriental painting, graphic works, sculpture and colored stones, applied arts, organic materials, textiles, clocks and musical mechanisms, precious metals, furniture and chandeliers, and photo materials. It has 172 staff members. Over the course of each year, around four thousand items are subjected to conservation and restoration treatment. Yet restorers are among the least visible operators in the Hermitage, despite being the ones performing the most pressing task in a museum for which maintaining artworks ranks among the most prominent missions. Our most immediate experience as museum visitors is premised upon restorers' sleek, invisible, and efficient operations. Our most fundamental belief as museumgoers—that we are viewing a piece of the past when we set foot in a room of the museum—hinges upon the expertise of restorers. Are we indeed observing a piece of the past, with the aura of a master lurking above, or a work of the present and the outcome of

decisions of shadow workers who interpret what the artist may have meant to paint or sculpt? But restorers' concern is not only about preserving the past for the present. They are engaged in a more complex relation with time as they ponder the need for restoration: at times, the promise of future methods and techniques can make restorers postpone interventions in the present that would threaten to either damage pieces or cover traces in them that would allow keepers to attribute them. Restoration, therefore, is not a business conducted in a known and complete universe where works of art can be simply and unambiguously attributed. Quite the opposite, restoration stirs things around in search of identity. It moves pieces from storage areas to laboratories on their way to exhibitions, where they will get new exposure and where their nature will be tested. Restorers explore the museum as they poke and probe works of art and at times discover what a treasure is or what it contains. In that capacity, they engage and at times question the boundaries and the identity of the museum and the identification of its treasure. The relatively restrictive and conservative policies that govern the museum are here put to the test by restoration: both agents trained to preserve the assets *ad vitam aeternam* and *tam quam cadavera* and a risk for the assets that are moved even the shortest distances away from their natural site of rest, restorers thrust a scientific take on collections, so that they may be considered as much explorers and discovers as agents of conservation, the role traditionally attached to this profession.

From this angle, the Hermitage is a worthy specimen of study through its dual role as a guardian of cultural treasures and a research institution where scholars and scientists excel in the field of art history. Indeed, storing valuable pieces of art through the ages and fighting the natural process of decay are among the priorities of the Hermitage, a mission that sets it apart from other museums of the same caliber. Here, we try to identify the kind of ethical problems and responsibilities this philosophy engenders, and to determine how the process of restoration affects its objects and how the

subculture of professional restoration influences the image of the Hermitage and its collections. Restorers are an important population inasmuch as they act out the tension between visibility and confinement documented throughout this book.

THE SPECIFIC POSITION OF RESTORERS AT THE HERMITAGE

After World War II, restorers became central actors of the museum, as the collections had to be reviewed and maintained following the chaotic years of the war. If they were cultivating an ethos of invisibility and modesty in the wake of the Liphart scandal, they also found themselves in the center of museum activities and engaged in many of its curatorial decisions. While the Getty Conservation Institute and the ICOM pointed in a famous report to the problem of curatorial collaboration with conservators in 1986,[1] for Hermitage curators the duty to pay attention to restoration had been a fundamental practice and principle since at least the end of World War II. But the attention to the fragility of the collections has an even longer history.

From the point of view of the sheer number of tragic events experienced by the Hermitage, probably only the Dresden Gallery could compare. From its beginnings the museum's buildings have suffered numerous floods. The big fire of 1837, which raged for three days, completely destroyed the interior decoration of the Winter Palace. During World War I the Winter Palace was used as a hospital, and in 1917 a large part of the Hermitage collection was evacuated to Moscow. After the museum's nationalization, the collection was unsystematically doubled through the addition of various aristocratic collections. As seen in previous chapters, the harried period of industrialization in the Soviet Union led the government to sell about seven thousand items, among them one thousand pictures sold at auction between 1928 and 1933. These sales came to be

considered both a tragedy on a national scale and a personal tragedy for every Hermitage employee at the time and to this day.

One of the distinctive features of the museum is the World War II ordeals both of restorers—most of them deceased by the time I visited the museum—and collections. The evacuation of the museum in 1941 entailed a major disruption of storage areas, which were thought to be solid and stable locations for the art pieces. Completed in a fortnight to protect the collections from possible seizure by the German army, the moving and boxing of pieces on display and in storage areas created additional work for the restorers when they eventually resettled in the building after 1945. Mending and caring became one of the priorities of the museum employees, including those not strictly defined as restorers. This episode was foundational for the museum and for the sense of mission bestowed upon the guardians of the pieces. The blockade and the evacuation coded the mission of employees as protection of the treasure against the risk of capture.

The instability of life during these episodes, compounded by the rapid influx of objects in the early 1920s and the selling off of many pieces during the USSR budget crisis of the early 1930s, quickly followed by the massive relocation of the collection between 1941 and 1945, set the stage for restorers as central figures in the mission of the museum. Simply being a museum, maintaining the pieces, and presenting things of the past in decent conditions forced the restorer to work around the clock from the late 1940s on. During the postwar period, restoration was a priority beyond the Hermitage as well: at the state level, a full-fledged campaign to heal the ravages of war was launched—about six million rubles, a large investment for that time, was spent on the complex of the State Hermitage. This reconstruction and renovation of the buildings has taken time and has been spread unevenly across the years since then, but "by 1984, the facades and 152 exhibition halls had been returned to their prewar state" (Maddox 2014, 87). In the course of postwar reconstruction, new workshops were opened, new personnel training

programs were launched, museum-based restoration laboratories were expanding everywhere, and significant funds were being allotted to that end.[2]

In 1954, the USSR Ministry of Culture formed a commission tasked with defining the qualifications of restorers working to conserve and restore historical and cultural artifacts. The work of the commission strengthened state supervision of monument protection, and it screened dilettantes out of the world of restoration. One Hermitager, Andrey Aleshin, remembers the commission with the rhetorical drama so common to employees' memories of the treasure.

> As paradoxical as it might sound, given the absurdity of the moral and aesthetic doctrines declared by the official USSR ideology, it was [precisely] here—in the world of art and science—that [a] peculiar atmosphere got formed, allowing [one] to perceive the practice of preservation of cultural heritage as explicit and selfless service to art. Upon seeing the irreparable damage inflicted on the monuments by the restorers influenced by ideological or commercial interests of various communities, cultural workers nationally initiated the establishment of a special commission to supervise these activities. (Aleshin 2006)

The lack of a free market for art in the USSR and, with its absence, the paucity of other stakeholders in restoration (i.e., art dealers and collectors) rendered professional restoration an attractive occupation for only a small community of enthusiasts, since their sole employment prospect was a position at a museum. But there was an upturn to that ordeal and its limited financial incentives: financed by the state, and intended for the education of the population, museums were not seeking visitors and were not required to turn in accounts of visitors' experiences. In the 1980s, such a management trend for public institutions (which had originated in the West) did finally arrive at the Hermitage, but it was long kept at bay by the

unique history of the objects coming to museum. The dramatic circumstances marking the circulation of the treasures, most pointed during the twentieth century, shifted the emphasis to the need to preserve and maintain the treasure. The other imperatives of the museum—particularly that of educating by showing—took a back seat in the face of the emergency and gave special prominence to the restorers.

Nationwide, the aftermath of World War II was marked by a new set of rules meant to avoid what had happened in the 1930s, still a trauma among many in museums and by then an unfortunate episode understood to have cost the USSR a fortune and its artistic credit. The rules established in 1954 and fleshed out progressively in museums were problematic on at least one count. Investing in preservation of monuments and art collections could not be confused with a fetishization of bourgeois obsessions. Beyond the facades of the Hermitage museum, many collections stored within were signs of the decadent bourgeois world: foreign collections accumulated by Catherine the Great—the products of aristocrats touring Europe in search of the latest artistic fashion—these artifacts were not easy to reconcile with the taste of the socialist state. This created a tension between state investment in restoration of public buildings and monuments meant to host and educate the people, on the one hand, and the culture of the museum—with its own rules and its confined modus operandi, shielded from the supervision of state rules—on the other. The tension created by the funding for the preservation of decadent arts found a solution in a compromise that the rest of this book documents further: the Hermitage was part of the national framework, abiding by the rules set in Moscow by the ministry of culture, but because it harbored many collections that were not celebrated by the domestic Soviet taste, a large degree of autonomy was granted to the museum so long as it kept confined a toxic treasure that could not be celebrated in foreign circles because some of the pieces were not officially property of the USSR. It had to be kept but not celebrated. This compromise turned restorers into the central cast of the treasure's preservation.

EDUCATING

The artistic talent and temptation of restorers is taboo at the Hermitage, as it is elsewhere in the restoration world. The question of whether contemporary restorers could work as artists, so that the viewer would not notice the difference between an original and a copy, usually remains outside the scope of museum discourse. Even in special catalogues of exhibitions dedicated to restoration, this issue is hidden behind elusive formulations: "The restoration retouches on the losses areas are largely saved. Partly the reconstruction was made. . . . on the saved [artist's] painting the slight tinting was held" (Nemchinova 2014, 40).

The professional tension animating restorers, identified as either quasi artists or employees in charge of the museum's maintenance, is exacerbated in the Hermitage. For much of the twentieth century, the origin of keepers and restorers was the Academy of Arts. Interns coming to the Hermitage had been trained in the arts in very practical ways rather than for the purpose of writing monographs on artists or cultural history pieces. The sensibility of keepers in relation to their collections, a quality praised by Hermitagers and questioned by outside scientists for the monopoly over collections that it creates, may be situated in the wake of this socialization of Hermitage scientists. But the appropriation of collections by keepers never interferes with the material qualities of the objects themselves. Colleagues can be kept at a distance and books and articles presenting the materials can be made exclusive territory of the keeper but the silver lining of this territoriality is that the things themselves remain off limits. If anything, the zone of exclusion thus constituted protects the objects under custody. The lack of a professional code of conduct and the celebration of a culture of amateurship has positive consequences for the destiny of objects. The keepers' motto could be: "Love your collection as much as you can; embrace it; become so familiar with it that you can enchant your readers. The collection will be glorified and will keep its integrity." Opening up the scene

now to restorers who are in close contact with the objects and who have to work on them to retrieve their original state, the possible conflict of interest becomes more acute. In their line of sight and action stand the objects: they could be left to rest, modestly preserved, or heavy-handedly restored. The Liphart story is an example of the confusion of roles between keepers and restorers with an artistic bent. The Hermitage case is particularly acute among other world-class museums' restoration departments precisely because Russian academia did not feature a standalone, specialized art restoration department until the late 1960s (Klokova 1994).[3]

Apprentice restorers who came to the Hermitage before the days of the academic art restoration department could have become artists themselves; they merely bifurcated slightly to fashion themselves as restorers. This professional bifurcation came after an initial career decision which manifested a resistance to the collective and communal philosophy of the Soviet regime of the 1950s through the 1970s. The Academy of Arts was still a place where artisans and artists were groomed. Not quite the poster children of the Soviet regimes, they would be exposed to drastic discipline in the academy, but they would cultivate their own abilities and genius. In many ways, the academy was sharing the DNA of the museum: they were both shelters, very competitive in their own specific ways but immune to most of the rules enforced outside. Drawing and painting were skills that did not translate necessarily into socialist realism; they could even be a space of personal freedom and autonomy. So, more than in Western art schools, the combination of a traditional canon and the surrounding cultural repression produced artists. The transition between the Academy of Arts or academic restoration departments and the Hermitage happens at the outset, before apprentices join the museum. Hermitage restorers often belong to the academic committee of these departments; many of them also teach in these schools. As a result, talented students usually have the opportunity to undertake an internship in the museum immediately following their time at the university, and in some cases they stay there.

After World War II Soviet science was strongly stricken by the anticosmopolitanism campaign, and the Hermitage became one of the few places in the Soviet art history landscape where one was allowed to work with Western European art, a safe haven for practicing scholars and a dream destination for professional restorers. Isolated from developments abroad due to the lack of foreign training and restoration materials, Hermitage restorers did not feel acutely insulated in terms of restoration theory and ethical principles. For example, Harold Plenderleith's (1956) best-selling book *The Conservation of Antiquities and Works of Art: Treatment, Repair and Restoration* was first translated into Russian and published in two parts in 1963 and 1964. The first face-to-face meetings between Hermitagers and Western restorers took place at the ICOM conferences held in the Hermitage and Moscow in 1963 and 1977, respectively.[4] As early as the 1960s, the keepers and researchers of the Hermitage were in active correspondence with their Western colleagues, and indeed, special attention was paid to stocking the museum library with professional journals and books. Thus, in theory the Hermitage was transformed following its increased openness to the rest of the world, but in practice the restoration laboratories worked in largely the same way as other Soviet laboratories—that is, nearly exclusively with domestic materials. For many laboratories the situation was acutely detrimental, as was the case with Oriental art, which requires original Chinese and Japanese materials.

In 1995 I took a two-month international tutorial on restoration of paper from ICOM in Austria. It was for only one person [per country] from sixteen different countries. The course included seminars on European methods, Japanese methods, special biology, chemistry, environment—it was real scientific and practical training. I learned materials, tooling, techniques of papermaking. In 2011 my younger colleague and I studied in a two-month course of research and restoration of scrolls in the Shanghai museum. In 2013 we repeated that course and also invited specialists from the Shanghai museum to

come here—they gave a masterclass and restored one of the scrolls from the Hermitage collection. Such a partnership allows [for the study of] original techniques, which have a very ancient tradition in China, and there is no other place where you could study it. (Head of the laboratory for Oriental painting)

Other departments did not suffer from such isolation. The laboratories for oil and tempera art, for example—the oldest in the museum—felt comfortable detached from global trends. After the academic restoration programs were instituted, it became obvious that handcraft traditions were not enough for scientific restoration and that restorers needed to know chemistry, physics, and biology and cultivate a deeper understanding of the physical nature of objects. In 2016, all newcomers have a professional education in restoration. Yet the museum continues to train them. This practice is typical in the Hermitage because restoration laboratories there have state-of-the-art equipment and scientific methods and approaches that are not taught in schools. Nevertheless, the main proficiency handed down from older generation to younger colleagues consists of a code of ethics, and can be described as "humility":

When you just come to Hermitage you think that you could do a lot, and sometimes to improve, to do better [for] some artifacts, and older colleagues hold you [back]. But with time, when you get some experience, you understand and start to hold yourself back and younger colleagues [as well]. Our goal is to [preserve], but not to improve. And at the same time you have the opportunity for creative work. You get an inspiration for creating your own things. (Head of the laboratory for easel painting)

Restoration demands honesty, tidiness, assiduousness, but first of all—the extinguishing of your own ambitions. The restorer should show not himself, but the [artist]. The restorer should stay in the shadows. (Restorer of easel painting)

Much depends on a person's culture, on the degree to which he understands what he's working with, on his audacity, how

presumptuous he is—like, "I can do anything"—or how submissive.
Thus young restorers must have every step they take approved by their
colleagues. There ought not be any independent activity. One must
stop one's hand all the time. It's like plastic surgery: only signs of life
ought to remain on the patient's face. (Restorer of Oriental painting)

These statements, bordering on canned, professional discourse,
remind one of Max Friedlander's *On Art and Connoisseurship* and
a famous passage on the discipline of restoration:

> The business of the restorer is the most thankless one imaginable.
> At best one sees and knows nothing of him. If, out of his own inven-
> tion, he has provided something good he has got mixed up with
> the dubious company of the forgers; and with the despised one
> of the destroyers of art if what he has done is bad. His accomplish-
> ment remains out of sight, his deficiency leaps to the eye. Judgment
> regarding the performance of the restorers is even more unreli-
> able than that regarding works of art. And that is saying something.
> Restoration is a necessary evil; necessary, inasmuch as threatening
> decay can be stopped by the laying down of blisters, stabilization of
> the pigments, strengthening of the ground that carries everything.
> Moreover, artistic value can be increased through cleaning, through
> the removal of later disfigurements, of retouches and of varnish,
> darkened or even ruined and gone opaque. Thirdly, and here the
> intervention begins to become of doubtful value, the restorer supple-
> ments, fills in holes, from a delusion of being able to re-establish the
> original condition. (Friedlander 2008, 267)

The ethos described by Friedlander has a history and is now
the product of a division of labor, solidly present in the mind of
the restorers working at the Hermitage. An important role in the
Hermitage is still played by the tradition of manuduction. When a
young employee would come to the laboratory, one of the experi-
enced restorers would become his or her tutor and teach him or
her special techniques and methods for a subspecialty, while at the

same time the young employee would study and learn different techniques from all members of the department.

> You can clean or "open" a picture in very different ways. When I came to the laboratory, all the people working here were very talented and artistic. Mostly they were professional painters from the Academy of Arts. And they all had their own theory on how to clean pictures. And one of them came to us, to the youngest, and [said], "Clean like you paint: look at the picture; feel it; it should not lose its lightness, space, transparency. . . . Because restorer or painter, they don't apply colors layer by layer: somewhere it is thinner; somewhere thicker. When the painter worked on the picture he applied the varnish in the same way. So, don't clean without thinking. Build the picture, clean like you [would] paint it." Another famous restorer worked in another way—she was very pedantic, careful, intent . . . and she cleaned [a painting of] Judith with a microscope. It was a very difficult and very long job. She urged me to be extremely careful. But it is a concern for all restorers— turning oneself into the [artist] is a taboo! That's why whatever we do, the layer of the [artist's] varnish should stay. Protect the [artist]. My tutor never pressured me; she always asked what my opinion was on all matters. She was very careful; she taught me to think and to create my own conceptions, plans for future work. But not just she—all people who worked in the laboratory exert incredible influence on us, professionally and personally too. (Restorer of easel painting)

COLLEGIALITY AND COMPETING EXPLORATIONS OF THE TREASURE

Methods and approaches differ from one laboratory to the next, and they are different so far as the objects are different. Yet all of them share a basic principle: collegiality. The tradition of collective decision-making arose in connection with a major scandal around Hermitage restoration that took place at the beginning of the twentieth

century. Around 1912 to 1915, a Hermitage restorer named Bogo-
slovski was working on fifty canvases, and his work provoked an
explosion of public criticism. Alexandre Benois wrote a crushing
article on Hermitage restorers in the October 20, 1915, edition of the
Saint Petersburg newspaper *Rech*:

> Of the vandalisms in the Hermitage, committed by restorers of the
> day, the worst is the irretrievably ruined portrait of Cardinal Pal-
> lavicini, attributed to Sebastiano del Piombo. . . . The perpetrators of
> this crime have, however, a small caveat: the picture was completely
> repainted prior to these last restorative efforts, likely sometime in
> the eighteenth century, when it was still in the Crous collection.
> But, gentlemen keepers of the Hermitage, bend your knee to the old
> restorers whom you mock. They, at least, were educated people and
> careful technicians, who handled their victims with tenderness. Your
> protégés are bona fide barbarians, whose attacks on paintings are
> wholly akin to German cruelty.

Several other critics joined this public outrage, calling Hermit-
age restorers "killers of pictures" (Aleshin 1985, 101). In the con-
text of this public discussion, the "Hermitage Working Meeting"
was summoned in 1916, with the leading museum and artistic spe-
cialists from Moscow and Petrograd laying out new principles for
restoration of easel paintings. These included minimal intervention
in the structure of the restored artifact, documentation of all stages
of restoration, protection of the artist's layer of varnish and of pre-
vious restorations if these did not harm the picture, and the use of
toning so long as it was compensatory for the relevant layer's loss
and did not attempt to repair or reconstruct the work of art. Since
then, all of the most important restoration projects in the Hermit-
age were carried out only with the permission of the commission on
the basis of these established principles. That was the first and the
last scandal in the museum's restoration history, one that brought
on new, fundamental principles of collegiality and visibility through
documentation, which are still active today.

Contemporary working processes in restoration fall into several stages. First is the annual review of the state of items. Every keeper works in tandem with one restorer, and together every year they check the condition of each item in the storage facility. Priority is given to the pieces in need of urgent restoration. Another stage of restoration work is geared toward pieces going to temporary exhibitions. Every piece going to outside or inside exhibition should be checked and prepared for moving. Once the keeper and restorer have defined the list of objects in need of restoration for the year, these pieces go to the Restoration Department. Then the restoration committee prescribes the procedure to follow for each piece. The restoration committee is at present a group of specialists appointed for every restoration laboratory. It is made up of keepers, restorers, climatologists, and chemists, assigned according to the special requirements of the objects. All decisions are made collectively and are recorded in restoration documentation. The collective decision-making minimizes the risk of a restorer acting out his "artistic side."

> The first stage in any restoration is a study of the picture. X-ray examination [roentgen] allows you to determine the percentage of losses. An infrared transillumination makes it possible to consider the lower layers, including the shape of [the artist's] ground and [the artist's] drawing. UV [ultraviolet] survey gives an idea of the later restoration retouch and the condition of varnishes on the picture. Chemical analyses provide an opportunity to evaluate the [artist's] ground, the quality of the clutch of paint layers, the ability to distinguish the [artist's layers] from subsequent layers. Then, the results of all these manipulations are assessed by the restoration committee, and they determine the next stage—mechanical restoration (conservation), usually [there] is new stretching and doubling [of the] canvas, fixation of [the] paint layer, and so on. . . . Only after that [can] restorers start the art restoration—cleaning, removing of old varnishes, replenishment of losses. The commission chooses the sample plots of clearing for checking the [artist's] painting. But restorers have one strict

rule—they should not go deeper than the [artist's] varnish slick. In the case of losses, they fill them in and retouch them, but only if retouching may be washed [off] at any time. (Head of the restoration committee for the laboratory for easel painting)

The exploration of the museum collections by employees is primarily the privilege of keepers. They get to come close to the collections, both the visible parts and the invisible ones kept in storage areas. Restorers enjoy another privilege. They can come very close to the objects and scrutinize them like nobody else, subjecting them to tests and "opening them up," while keepers do not touch the objects and visitors cannot even see them. This opportunity to navigate among many different objects belonging to a physical class (glass, metal, fabric, etc.) cuts across the circulation of keepers within their collections, usually defined along other criteria. Keepers are in charge of a class defined less by the physical properties of the objects than by the theme of the collection. It sometimes happens that the theme of the collection and the physical composition of its parts are aligned, but this is not a rule. This decoupling of the collections' perimeters and the perimeter assigned to a restoration department by virtue of the skills of its employees marks a possible tension between two modalities of envisioning and exploring objects in need of restoration. Keepers are now less schooled than restorers, and they still celebrate the culture of amateurship from within their department or collection, whereas restorers are among the most technically schooled employees of the museum and enjoy the privilege of trespassing the borders set by the assignment of a collection to a keeper. A unique excitement characterized our discussions with restorers, a set of emotions that we did not find among keepers who enjoy another kind of feeling in relation to their collections. If keepers appropriate their fund, restorers—who are also the most technically and professionally trained scientists in the museum—still get to explore and probe many more kinds of objects. Unlike keepers' horizontal appropriation, counted in numbers and rows of records, restorers enjoy a vertical appropriation measured

by the form of exclusive piercing of the canvases or objects they subject to analysis. Not everyone can spend days with a painting or a piece of ancient ceramics. This difference contains the seeds of a clash of expertise between two worlds.

Restorers repeatedly mentioned, as part of a kind of mantra, the experience of being "humbled" or "belittled" by the vast skills and knowledge accumulated in the galleries and storage rooms of the museum. They share with keepers a taste for the past of the pieces that stop in their laboratories. If keepers have access to lists of previous owners and other vicissitudes of their funds' items, restorers have access to the layers, superficial and deep, that make the items. There too, the dramas of these items' trajectories show up, their wounds and scars magnified under a microscope, and, like talented chiropractors, restorers can list the series of environments and accidents experienced by the ailing pieces they care for. But unlike the list of owners, a contingency of history, the experiences that led the piece to the lab are mostly irreversible. They can be repaired but not taken back to their initial, flawless time. This irreversible path of collections is essential to restorers, and it directs their attention to a more material and physical temporality than is experienced by keepers, for whom time has stopped with the items stored at the museum. Things happen in the museum, but the pedigrees of the objects are complete, and, given the inalienable nature of funds, their past circumnavigations have come to an end. Their decay keeps going. Unlike perishable goods, which could be traded before they really perish lest they lose their value entirely, museum items do decay but they cannot be offloaded to another party. There to stay, the pledge to maintain the national treasure in a static condition produces the future, in its simplest, ticking quality, looming. Nothing good can come out of this time as far as the physical conditions of the items are concerned. The difference in approach between keepers and restorers working around the museum's objects goes back once again to the tension between property and properties, a theme we keep visiting as we dissect how the mission of maintaining the treasure pulls different groups in different

directions. Keeping track of series of owners and of previous stations of the objects works toward building their cultural history. Looking into layers of varnish directs restorers toward a history of the quieter and at times completely hidden maintenance actions that have kept pieces intact throughout the ages. This distinction leads to the question of the dynamic of collaboration between restorers and keepers as scientists. To a large extent, restorers survive much better in a state of isolation because their main mission is one of maintenance and conservation. They survive isolation better, at least, than do keepers, who are expected to go beyond the literal dimension of conservation. They tell stories of acquisitions, collections, and artists, and they need to weave together various pieces of history and judgement to produce what their colleagues will appreciate as a novel piece and a worthy contribution to their field. Even the conservative approaches to art history, intent not to stray far from the paths of objects themselves, engage in detours that cast the object in relation to its contexts, whether a school or the trajectory of an artist or a period. These considerations are distant from what a restorer in love with his object would agree to consider proper to his mission. Novelty is not one of the virtues currently celebrated in the community of restorers.

Yet restorers too escape literal and exclusive conversation with the object as soon as they start peeling off the envelopes of a painting or a fabric to expose the layers that constitute it. If the scientist necessarily "amplifies" the piece of art he or she comments on, the restorer does something opposite but similar in its consequences. Restoration explodes the piece in fragments and layers; it breaks down certainty regarding its date of birth by dating all the touches, possibly spreading the period of its birth over a few months, or even several years. These two explorations are possibly infinite to the same extent, but they yield two different infinites. The art historian's infinite—slightly despised by Hermitage tradition—can take off from the materiality of the object and indulge ad infinitum the game of interpretations, whether by way of semiotics or otherwise. The restorer's infinite equally loses sight of the object displayed in

the museum, but not by the conceit of contextualization. Instead, it is the intoxication of the material and the lure of the techniques that make possible a better definition of the object:

> One time our Hermitage van Eyck, the one sold to Washington, was brought in to us, and we had the pleasure of viewing it simply in ultraviolet light. It was delightful in the exhibit, not just a picture but a real charm. But when we viewed it in ultraviolet, there was nothing there that had gone unaltered. Well of course it was entirely retouched. But if we're to look from this point of view, then what will we see—if we look from the point of view of the authorial authenticity of each item? Very little, I think. (Restorer of tempera painting)

These two infinites matter to us because they meet when restorers and keepers cross paths. Restorers and keepers never work as a duo, aloof and distant from their respective departments. The commission is organized and summoned to surround decisions that could otherwise express restorers' and keepers' exclusive views. Beyond the commission meetings, they communicate on a regular basis and effect an intersection of the two different approaches of art history and physicality of the items they discuss.

> How could the keeper influence us? We are consulting all the time. It is a joint work because nobody except the keeper could tell you what the picture is. The restoration committee should first of all define the task for restoration, because the restorer by himself has no right to set these tasks. I could show and explain to them what is possible to do in every case, but a moment will come when we have to decide what to leave and what to remove, and this decision could only be made by the commission and the keeper; I can't decide it. . . . But not always does a restorer want to accept the decision of the commission. And in such cases, the commission could give up on the restorer, or the restorer could give up on the commission and refuse to do something. (Restorer of tempera painting)

Indeed, restorers are still the only people who may interfere with the material structure of the objects and change them, but now the decision as to the extent of these changes is made by committees, that is, by a group of keepers. The two modes of exploration—property and properties—can also at times migrate from one group to the other. Most often the keepers appropriate the restorers' approach. Keepers could play a key role in forcing a piece into restoration when they need new information for attribution or when they want to use the object for exhibition. This means that objects can come to the restoration departments not for restoration's sake but for other reasons. More and more, contemporary restoration aims not only to save the object but to extend the frontiers of the keepers' science. For that reason, in some cases restoration brings unanticipated and adverse events, as in the case of a new masterpiece emerging from a long period in storage:

> Lorenzo Lotto's *Madonna delle Grazie*—it was a case when the restoration followed the keeper's idea. This picture was not attributed and was kept in fund B (where the Hermitage keeps pieces of the second order), [attributed to an] unknown artist of the nineteenth century. And when I saw her for the first time, I made a supposition that it could be [a] late Lotto. And it was possible to check, because his late works are fixed in the "invoice book." So, [according to] this book, [the only works by Lotto in the museum were] two pictures with Madonna, which were not identified. One of them is mentioned in this invoice book three times, and described [as] "Madonna delle Grazie with three angels." But in our picture there was no angel. And when I thought that [the unattributed picture] could be that thing, the first thing I did . . . [was bring] it for X-ray and infrared checking. And when we did it, it was possible to see the angels covered by the late retouch. So, my hypothesis was fully confirmed, and this meant that the picture had to be cleaned. (Keeper of Italian paintings)

The case of the Lorenzo Lotto discovery represents a story of "restoration after restoration." Somewhere in the past, following

the taste of the time, restorers retouched the picture and hid the masterpiece behind curtains. Then, the development of restoration techniques offered opportunities to get rid of the previous retouches and bring back the original state of the work. Following this new exploration, the keeper managed to provide the museum with a new attribution. Accordingly, this represents a case of collective practice bringing a new masterpiece to the museum. Reattribution is not a rare thing in restoration, and it happens both ways: when the hunch of a new attribution starts the restoration process, or conversely, when restoration results lead to reattribution. Consequently, contemporary restoration is not just a technical safety procedure or "renovation" practice; it encroaches on the competences of other spheres—primarily the science of keepers, interested in defining the treasure of the museum. Inserting themselves in the process of attribution from within the object (the fabric of the canvas, the directions of the stroke observed under X-rays, etc.), restorers can destroy the reputation of artworks long held to be masterpieces.

THE THREE MODESTIES OF RESTORATION

With many masterpieces on hand, a community of specialists paying attention to the slightest events occurring to these pieces, and a body of restorers still largely trained in the arts—although the latter are transitioning to become a more specialized group of experts confining themselves to their material—one issue that can arise is that of the restraints and limitations set against the kind of risks that give rise to collegial decision-making. How should one explain the limited number of problems raised by "rogue" restorers, those individuals unleashing their creative side or paying attention in an excessively personal manner to the voice of the master? Feelings and callings can at times bifurcate into personal stories and very strong views of the spirit or the soul of a piece. This practical and highly consequential question was given a series of answers by interviewees, all of them hinging on modesty, the notion most

celebrated in the restoration departments. It was the most frequent signifier used by restorers when they were prompted to describe their general ethos. It covers a variety of meanings, all deploying a specific understanding of time and history, positioned at the intersection of the biographies of the artist and the restorer and mediated by technologies.

Invisibility is one of these meanings, and it is cultivated both as a psychological quality and a characteristic of the organization. Restorers very rarely have their identity revealed, even after a major repair. A department may be congratulated, but individuals remain in the shadow of collective decisions. When individual restorers were identified publicly on a plate accompanying the return of a piece after its repair, it was because the restoration had been funded by an outside corporate sponsor who wanted to attach a name to a piece of work. This is not yet a trend and will probably never become one so long as the metaphysics of the pure presence of the work of art and the myth of the artist-as-lone-genius keeps prevailing over the documentation of its conditions of production and endurance. Invisibility is translated into a psychological quality, but one that sets the restorer in a conversation with his objects rather than with his peers. In clarifying the qualities needed to become invisible, restorers talked about a conversation with a difficult interlocutor:

> A restorer should engage in a dialogue with objects because they are alive, like patients, like people. An object can show itself from such an [unexpected] side! To show off [выкаблучиваться], to resist [не поддаваться]. In such situations you could leave it for a while, or start a dialogue. It's very important for the restorer to feel the object and for the object to feel the restorer. They should feel understanding, or be in [a] good [relationship]. (Restorer of easel painting)

With this highly personal and psychological understanding of modesty as invisibility, the time deployed by restorers is the biography of the artists they take responsibility for through their works in the museum.

A second form of modesty borrows a different route, the opposite route to the invisibility ethos otherwise solidly rooted in the restorers' value claims. Instead of giving in to the secret language of masterpieces, modesty can also mean documenting and making explicit every action undertaken with regard to the collections. With each intervention on a piece, a record is produced tracing the restorer's every action and documenting the trajectory of the piece in the museum. This documentation system was put into practice at the beginning of the century. Initially, it consisted of the restoration passport, which included information on all documentary interventions pertaining to an object.

> This type of document was developed in 1928 by the head of the restoration laboratory back then, Jaremich. He was a great expert, even though he was not a restorer himself. His version of the passport included all topics that we still use now: restoration number; inventory number; the title, author and school; the size and technique; the description of the object before restoration; the description of the safe state; the assignment of the restoration committee; the description of the work executed; information about special analyses and photos. (Restorer of easel painting)

A passport contains the trace of all contributions by restorers, so the documentation (the book with the information pertaining to the entries at the level of the department—e.g., which pieces were checked in and when they were checked out) and the passport itself, enumerating the actions undertaken on the piece, track the restoration process and attach pieces to restorers. Later, the registration restoration books containing the descriptions of the condition of the object under maintenance (Книга регистрации и описания сохранности) completed the passport system. They include the same information, but all items coming for restoration are written there one by one. So, it is a double-entry system of sorts—the book shows all items coming for restoration, and the passports contain information about all restorations executed on one piece.

This system allows for the retracing of every step at any time and for the keeping of information on the life story of the object. So, if the object goes to the restoration department another time, the future restorer will immediately find information about all previous restorations by way of the restoration number. This is a simple— and old—technology of responsibility through discipline, one that makes visible the decisions of the committee and of each individual restorer. It represents responsibility by visibility through time. At any moment in the future of a collection, past work on an item will be retrievable by the opening of its passport. There, the name of departments and individual restorers having played with its physical properties are accessible to all future inquirers.

A third form of modesty displayed by Hermitage restorers deserves greater scrutiny to the extent that it creatively revisits the history of the Soviet period and formulates a theory of the promise of future technologies. Restorers rarely carry good pieces of news; when they do, the good news usually comes only after very bad pieces of news, as when a visitor has decided to lash and cut through a painting. Such news may disrupt the orderliness of the world of the Hermitage. Restoration entails the mobility of artifacts and of people, both a physical mobility and a category mobility. In an institution like the Hermitage, where the culture of the "safe" is solidly attached to the experience of the museum employees, mobility is problematic. In addition to the overall culture of the immobility of the treasure, built in reaction to an agitated twentieth century, a strong sense of proprietorship over their collection and a "hands off" policy leaves keepers in charge and with the last word in many important decisions. Legally, the keepers are responsible for pieces that may disappear. For the restorer, no such responsibility exists so long as he or she does not himself steal an artifact he or she may have in custody during the time of restoration. But restorers repeat that they have a much greater responsibility than keepers because they engage a much larger audience than the sole restoration committee summoned to decide what to do with pieces on the move or discovered to be in poor condition. This larger audience

and invisible committee is the series of past restorers, present colleagues, amateurs, and future art historians who pay attention to the artifact not only as a binary unit (i.e., here or absent: the mode of assessment in a keeper's work) but as a set of qualities, infinitely exquisite, infinitely open to discussion because leading to interventions on the art pieces. This entails a responsibility to a large audience and one that questions what a piece is beyond the "here or absent" alternative.

But restorers also root actively for rest and peace to be granted to the objects they have in their care. They experience tension at times amounting to torture between the new possibilities offered by technologies, letting them peek into these objects, and the concern that any drastic moves might irreversibly damage them. This tension is in no way found exclusively at the Hermitage: this is the lot of restorers across the museum world, torn between the missions of conservation and exploration. The Hermitage's history adds a special drama to this professional puzzle. The recent surge of activity manifested in exhibitions and partnerships has accelerated the circulation of items that would have been less agitated under the Soviet regime of circulation. Back then, artifacts would circulate primarily among communist countries, friends or allies to the Soviet experiment in eastern Europe. Many of the most celebrated collections were not even shown on the museum premises after Stalin had declared in 1946 that paintings of the New Western Art (exhibited in the museum of the same name, in the Morozov mansion in Moscow) had to disappear.[5] The Hermitage collection of the Shchukin brothers did not circulate or even surface for a long time. If keepers experienced frustration because of this situation, restorers, at least, enjoyed the favorable preservation conditions produced by the ban on Western art exhibitions. The end of the Soviet era and the active policy of promotion of the museum abroad by the new director, Mikhail Borisovich Piotrovsky, breathed new air into the storage houses of the Hermitage. If one looks only at the number of exhibitions held in England with artifacts lent by the Hermitage, the count went from twenty-nine for the whole period of

1950–1990 to eighty-eight for the much shorter period of 1991–2012. France shows an even greater increase, with exhibitions involving Hermitage pieces rising from thirty in the 1980s to sixty-two in the 1990s and increasing at an even greater rate in the first decade of the twenty-first century, with a record-setting eighty-two exhibitions. These two countries are not exceptions. Figures 4.3 through 4.6 provide a breakdown of the foreign mobility of Hermitage items for the five decades following World War II. They distinguish two kinds of exhibitions abroad: Hermitage-centered ones and others. An example of the first kind of exhibition was that presented by the Hermitage in Amsterdam between March and September 2010, "Matisse to Malevich: Pioneers of Modern Art from the Hermitage." Such exhibitions typically offer to the host museum a collection of the Hermitage as a package. Designed and organized by Hermitage curators, they showcase the museum outside of its territory.

These graphs present only the circulation of Hermitage pieces through the countries that have dealt most often with the museum

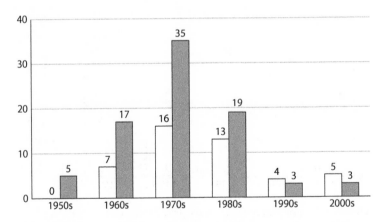

FIGURE 4.3 Hermitage exhibitions in friendly countries (Czechoslovakia, Bulgaria, East Germany, Hungary, Poland), 1950s through 2000s.

In these diagrams, we project by decade the number of exhibitions held in different countries involving Hermitage pieces. The gray bars represent "mixed" exhibitions, where Hermitage pieces were presented along with pieces from other museums. The white bars indicate exhibitions that were dedicated exclusively to Hermitage collections.

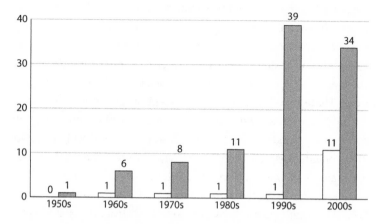

FIGURE 4.4 Hermitage exhibitions in the United Kingdom, 1950s through 2000s.

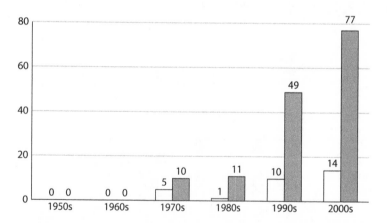

FIGURE 4.5 Hermitage exhibitions in the United States, 1950s through 2000s.

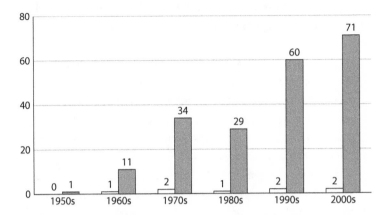

FIGURE 4.6 Hermitage exhibitions in France, 1950s through 2000s.

since the new era of opening. From the 1980s to the 1990s, the increase is dramatic across all countries, with a growth factor of four to five; the subsequent decade does not witness a jump as dramatic as that seen in the 1990s. There are only so many museums that can host exhibitions, and there is a factor of saturation in some countries such as France, which was already a strong partner as early as the 1970s. Apart from England, which shows a giant leap in the Hermitage-centered exhibitions between the 1990s and the first decade of the twenty-first century (an increase from a steady count of one exhibition per decade going back to the 1960s to eleven exhibitions), the dramatic increase in Hermitage-involved exhibitions abroad is primarily the consequence of the many exhibitions to which the Hermitage contributes only a few pieces. Unlike the Hermitage-centered and Hermitage-celebrating exhibitions that are efficient in terms of investment by the museum in its image, the loans for other exhibitions entail the mobilization of a restoration specialist for a few exhibits (at times just one exhibit) only, which will be presented among other exhibits in a show that will not directly promote the museum. With checks and verifications of all items leaving their storage area to go to public display areas within the museum or to

exhibitions organized in other museums, the consequent overload of work for restorers has been experienced with frustration:

> What has changed in fifty years? [On the] one hand we acquired won-
> derful microscopes. When I entered the museum we had only one
> microscope for the department. Back in that time, the restoration
> commissions were huge, and they acted decisively . . . questions like
> how thin the varnish layer should be on different parts of a picture.
> The head of the commission at that time was Levinson-Lessing; the
> members were Izergina, Nikulin, Nemilova, Banck, Koscova—such
> names! Back then, the Hermitage enjoyed the reputation of a very
> good restoration and conservation culture, with a very delicate
> attitude to the objects. Now, we have a lot of specialists. But this
> understanding, that the main thing is not to promote the views of
> the keepers or restorers but the objects, now we have lost it. And the
> main problem with this is the large [number] of exhibitions. Now all
> we do has to be fast, fast, fast. Now time goes by very quickly. But
> restoration—it is about saving. And if you cannot touch the object, it
> is better not to touch it. But now, it goes to exhibitions, and you have
> to do something with it, to prepare it somehow. I remember the time
> when commissions didn't let the objects go to exhibitions. Paintings
> on wood or transferred pieces were never allowed to go to any exhibi-
> tion, because it is too dangerous. But then, there was one precedent,
> an exception, then another one, and [all] hell broke loose. Objects are
> alive, they are susceptible to disease. But the time has changed, and
> unfortunately, you can't resist it. Turns out that the Iron Curtain was
> in our favor, and it would be better if nothing changed. (Restorer of
> tempera painting)

The Soviet period, with its inherent features of the laboratory life—an exclusive space, a high gradient of expertise, and a high cost to transfer either the knowledge or the products produced therein to the outside—is often mobilized by restorers. More than keepers, they are sensible to the passing of time and to the irreversible damages caused by the shuffling of the artworks around the museum.

With the new pace of items' circulation, the Iron Curtain is invoked as a glorified moment in the recent history of the Soviet Union, but it also doubles as a mode of thinking about conservation and restoration.

> The Hermitage is a very conservative organization, and this conservatism is good for it. Maybe we are a rare place where the Iron Curtain played a positive role; new materials were introduced into practice in other museums in the world, and we could avoid it because of our closed political regime. During that period we used to work with our traditional materials developed in the beginning of the twentieth century—sturgeon glue and honey. We were protected from Western innovations, and when they start to refuse them because they don't work, we ride out that time. And I think that it is right. The museum is not a place for experiments. (Restorer of tempera painting)

"Not a place for experiments." Throughout the twentieth century, and after the organization of restoration as a specific activity around pieces, the museum has been praised for its policy in this regard, which may be described as a conflation of a restrained vision of restoration and the understanding of the museum as a confined environment. At times, this praise has been instrumentalized in Western debates, with comforting stereotypes of Soviet styles used as a wedge in conflicts among Western trends. A late-Soviet-era review of the Hermitage's ethos was written by Sarah Walden, a vocal critic of "crimes against pictures," who visited Russia and came up with a judgment as to how Russian methods differ from those of the West:

> In Russia what matters most is not the decor, the facilities, or visitor statistics, it is the paintings themselves. For a practicing restorer it was a relief to see so many pictures that had suffered so little interference. As I knew from previous visits to the Pushkin and the Hermitage, the Russian conservation tradition relies more on craftsmanship and restraint than on the vagaries of scientific fashion. Not that they

have a Luddite distrust of technology; their scientific advances in the field have been respected abroad. . . . Under communism, the absence of funds for large restoration projects has proved benign. Providing they are in stable conditions, pictures, unlike buildings, deteriorate little if left alone. (Walden 2005)

The history of restoration at the Hermitage as told by its current practitioners weaves together the history of the Soviet Union and the transition that began in the early 1990s. Although it started before the onset of the Revolution of 1917, the transformation of restoration—simultaneously a series of departments, a set of techniques, and a set of principles—was achieved mainly during the most authoritarian of the Soviet cycles, following World War II. The flow of artifacts from the confiscation of assets from wealthy bourgeois and aristocratic families following the revolution was matched and even dwarfed by the latter flow of artworks. The accounts articulated by restoration experts in 2014 are largely a long gloss on the exception that is the Hermitage, being both one of the largest sites for such a dramatically varied collection and one of the most mysterious institutions for outsiders. Articulated in that account are the virtues of restoration: not experiments but a conservative approach meant to let the past always prevail over the present, particularly when the present wants to imagine the future by covering paintings with coats of chemicals that will withstand the wear of time. Conservatism is also roundly celebrated when experimentation with the assets of the museum could question the present—that is, the current scope of assets—by entertaining what the future may bring. In its celebrated and conservative version, restoration knows no salvation by the future. The future is depicted as a series of fads, trends seizing other communities of restorers who let the lure of salvation blind them and make them forget the necessities of sticking to the past. After all, everything comes from the past—above all, the precious artifacts in one's custody.

But we also observe the mobilization of the future—an indeterminate time to come—in the discussion and decision-making

processes involving the restorers and the keepers. At times, when hesitations grip the committee over the timing and opportunity for restoration, the decision can be made not to act in the present and to let a damaged piece remain in its present state despite the availability and accessibility of a technique believed capable of fixing it. This third form of modesty produces yet another modality of time, irreducible to the biography of the artist or the documentation of the objects through its visits to the restoration departments. We can call it modesty to the extent that it defers to a higher principle or authority. We could just as well call it conceit inasmuch as it disqualifies the here and now in favor of an indefinite future, revealing a past beyond the currently known envelope of the work. No longer bound by the creator as he or she is known, open to the revaluation of the attribution through exploitation of new insights revealed by new techniques, this modality of modesty also looks beyond the modesty enforced by the discipline of documentations.

The [primary] feature of the Hermitage approach is its passive stance. Seemingly it should be in the forefront of modern research, but [that] is very dangerous. We don't take new materials—different glues, resins, varnishes . . . We are waiting while others use them, while time [reveals] their behavior, when others will get experimental results. . . . And if some material will get a good reputation, we could get it into our practice. It is senseless to start to use any new materials because now it could seem that it is some miracle of new technology, but who could say how it will behave in years—in a hundred or two hundred years? Here [there are] a lot of niceties, difficult and sometimes even inscrutable cases. All objects we are dealing with used to be restored, and now our main problem is "restoration after restoration." It is great if past restorers used reversible materials, much worse if it was some new [technique], which [employed] irreversible materials. And when this material starts to damage pieces under the influence of time, we have to create something, to find a way to remove them. The process of age hardening [the] restoration materials is a huge problem,

and we need to study it [tirelessly]. And that is why we follow the principle of using only reversible materials—except in some cases, when we really can't use it. (Restorer of tempera painting)

This decision to restore can be made on the basis of a reasoning process worthy of careful, step-by-step interpretation. "Fixing" now means "covering and coating"—and possibly "damaging." This decision would be tantamount to taking and accepting the risk of restoration against the natural wear of time inexorably passing and slowly damaging material artifacts. It would be risky only if the artifact were to be known in the first place and if no uncertainty were to cloud the origin of the thing in custody. The case of Lorenzo Lotto, discussed earlier—and the cases of many other pieces with a fluctuating identity—reminds us that the past may be celebrated but still conceals its truth. The future is mobilized precisely there, from the point of view of a piece that may still have to be rediscovered in the near future. Here the future is encountered as a remedy for an uncertain past. Waiting for future and better techniques—and hence not doing anything in the present—allows one to keep a door open to the past. In the future, with better techniques, the past (represented by a signature, by owners who would have collected an object and marked it) could reemerge and rewrite itself. And this might come at the risk and expense of keepers being confronted with a painting that was solidly attributed to an author now being deattributed.

The status of this imagined technique is considerably different from the debates animating the restoration community worldwide. The bottom line of positions on restoration—which can be infinitely varied and nuanced—is the opposition between the advocates of the "original" and those who embrace the "patina" of artworks. Originalists strive to use restoration technologies to retrieve what the artist had produced back in his time. Patina advocates understand a piece of art to be the composition of the original gesture and all subsequent accidents, including past restorations. Patina is the continuous series of vicissitudes happening to a piece, whereas the

search for the original looks for a single moment. The conflict is a continuous history against a discrete history. The Hermitage largely sides with Ruskin's understanding of restoration:

> The work of art for us is a memorial; it lived its own long life. In the process of restoration, we try to save these signs of life. It is impossible to turn it back to its initial state, because it lived its life, like a person. We don't create a new object. In the restoration our goal is to save, not to do a "remake" (or "modern replica"). [The goal is] not to bring it back to its initial state but to create a whole piece, to make it look cared for, to show all its perfections. But in any case, the object should keep the traces of its life, with the patina of ages. (Restorer of graphic works)
>
> With previous restorations we should be very careful: if they pose no harm to the monument, then perhaps they ought to be kept, because that is history. Just as a person cannot fall back into infancy, so then does artwork live, grow, and acquire new features. (Restorer of Oriental painting)

The praise of the imagined future technique that will reveal the original characteristics of an object cultivates a different theory of time. There, the future—a future point in time—is imagined to retrieve discrete episodes of the past. Hasty and early interventions on a painting would not only violate the continuous past of that piece in search of the chimera of the original, it might also jeopardize the investigation of the scene of creation.

> Still, much depends on the viewer, on the community, on what the community expects of the restorer. And the community, our community, as a rule expects [artworks to display] whole arms and legs and normalcy, in the absence of which restoration is required. If a golden background is shabby, then why is it shabby, and ought it not be retouched? People desire to see a thing as "new" or, as is often said, "as if it had just left the hands of its author." The kind of thing that has only just left the hands of its author you'll find in no museum.

That simply can't be, because upon creation of a thing it begins to live out its own life already beyond any dependence on its author. Were an author to find himself now in a museum, he would not recognize his own paintings. (Restorer of tempera painting)

Attachment to the possibility of investigating the past of collections in the future, with the help of techniques still to come and yet to be tried and perfected, is a quality of restorers that is also a form of modesty. It is, decidedly, a way of bowing to a better future, at least a future better equipped to solve problems of the present; it is also a modest gesture to the extent that it refuses to settle once and for all questions of authorship and identity. It is another thorn in the side of a museum for which the boundary of the collection is not a minor question.

5

GUIDES

Taking Science Down the Galleries

Tour guides are among the most visible elements in the scripting of the museum experience. They stand between the art pieces nested throughout the building and the visitors. They also introduce visitors, who expect their experience to be pedagogical, to the museum. As such, they are part of the general conversation about art pieces that we document in this book. Sometimes, there is a genuine conversation as individuals in the group engage with the guide as she presents the art pieces.[1] More often, it is a "one-way conversation," with the guide's statements triggering no immediate reaction. Either way, guides animate the visits of millions of tourists and amateurs and are crucial actors in the museum's identity. From the point of view of the museum, they are front of stage in a collective performance that starts upstream, in back offices and in the offices of scientists and curators devising the performances that are exhibitions. Guides' visible placement represents a massive delegation of the museum's image and message. And with delegation comes risk. Who talks about the museum's treasure? Who is given the authority to possibly utter the first

and last words on the collections to an audience much larger than most books published by the museum will ever reach?

In the spirit of opening up the definition of "scientist"—a task we began in the first chapters of this book, when we looked at the categorizations of the holdings and collections—we now document the last instantiation of art history as it is produced in the museum through its guides. Stretching the definition of art-historical expertise is both problematic and natural within the context of the Hermitage. We have already documented how the very notion of art history as a discipline was not foundational to the museum. Its history—a series of large waves of new objects entering the museum en masse, interrupted by the sell-off of the 1930s and the post–World War II cataloguing of these treasures in relative isolation from outside traditions of art history—has carved a unique career path for art scientists active within its walls. The absence of external certification as the mark of professional legitimation for curators and keepers has always been claimed as a defining characteristic of their unique trajectory. It has also been challenged by outside scientists and art historians eager to point to the monopoly that Hermitagers hold over their own collections. So, while basing one's expertise on familiarity and intimacy with the collections may be a way of fending off other "certified" scientists' professional envy, it immediately begs the question of proximity: Who is closer to the paintings? Is it scientists who write about pieces or guides who tour and talk about them on a daily basis? This is not a rhetorical question, as it takes into account another central claim that is voiced as soon as a foreigner (in my case) asks about the metrics of scientific efficiency in a museum: Hermitagers are adamant that they do science—in the only museum of that caliber granted the privilege of in-house scholars working on the collections—but they also demand that the knowledge produced be measured with respect to the tradition of oral communication. When asked who most influenced them, Hermitagers point to individuals who were not necessarily active public writers. Their influence was felt primarily through oral instruction, and their overall

mode of education privileged face-to-face interaction over the accumulation of textual knowledge within the museum. Therefore, counting a Hermitager's number of books and articles or even curated exhibitions would most likely miss his or her actual production and effect on the circulation of knowledge. The primary importance of lectures can be observed by any visitor to the museum who comes on a Friday morning and directs his or her way toward the amphitheater, where a lecture on French impressionists (or one of the many other collections) is delivered for the frequently arriving domestic visitors to the Hermitage. Yet it is also likely that the presentation is booked, the room is crowded, and the visitor has had to reserve a seat a few months in advance.[2] One will find a scientist or a guide lecturing alone in front of an audience of a few hundred riveted and passionate individuals—a performance treat rarely experienced by art historians. So guides talk and lecture, and people listen.

Yet the guides' mission is not only about the controlled narrative of a museum that houses so many items that a few simple stories need to be scripted in order to clearly portray its image to as many of its varied visitors as possible. Come the height of the tourist season, the blessing of plenty is also the curse of the Hermitage, when museum employees are no longer primarily worried about crafting a fine narrative but about protecting the building against armies of tourists eager to check the Hermitage off their to-do lists. The peak season marks the most intense moment of the year and produces an imperative of population management and crowd channeling rather than the creation of sophisticated puzzles in the communicative arts.[3] Guides become the operators of a collective experiment: they may not know it, and the museum employees may not think primarily of their mission along these lines, but a global museum such as the Hermitage is a cosmopolitan experiment and a multinational melting pot where diplomacy needs to be practiced in each and every corner of the building's galleries.[4] This experiment results from the large size of the museum's collections and, even more so, from the wide variety

of treasures found therein, which draw visitors from across the globe. On a daily basis, the Hermitage is more diversely populated than the borough of Queens, in New York, requiring the peaceful coexistence of dozens of nationalities. It is an enclave where languages and cultures are stirred up and mixed up between walls covered with art from across the world. This coexistence is a challenge and can only succeed with guides organizing the dance of cultures.

TRAINING THE GUIDES

Guides talk to visitors, and they talk visitors into the building and into the works on display. The museum teaches them how to talk, and a great deal of time and energy is spent on instructing them in how to address visitors. Their education takes place where art history meets crowd psychology because what is expected from apprentice guides is an in situ and interactive display of art-historical knowledge. No longer the bookish, deep, and detailed knowledge of each and every painter shown in the museum, this form of (pedagogical) communication engages an actual audience seized by the whirl of distractions within a large museum. These two perspectives—the scientific and the broadly pedagogical—mark a tension between homegrown guides (hereafter called Hermitage guides), who are groomed by Hermitage scientists, and "outside" guides who respond to the tourist agencies' steering of crowds through the city. This tension is as much a matter of status as a reflection of work conditions within the museum. Although Hermitage guides are trained to adapt the science of art to oral communication directed at a group of visitors, they look up to the museum's scientists as models and inspiration, while outside guides look forward to the completion of their tour, following modalities that vary but usually do not include art history among its primary components.

HERMITAGE GUIDES

Hermitage guides undergo a transformation in the museum, one that is not unlike the imagined transformation of the visitors who will use their services to learn about the Hermitage's treasures. Typically, they follow a trajectory that takes them from a wide but superficial view of the collections to an expert knowledge of a few artists, or even just one; that is to say, they begin to specialize, moving from a horizontal to a vertical foray into the collections. This transformation is central to our understanding of the museum and its unique perspective on education and expertise. As the museum has many collections—items that range from military outfits to impressionist jewels—presenting this wide array of items and the numerous collections that serve to group and name these objects is no minor challenge. The museum itself serves as an overarching example of just such a presentation style: a building used to house items that are grouped together following a few curatorial principles. While their variety and multiplicity may be mind-boggling, still they are encased in one memorable building, whose gigantic proportions compete with the trove of artworks displayed therein. Catalogues are another way of presenting collections in an orderly manner, yet they imagine a reader rather than directly engaging with a person who stands surprised or startled in front of a work of art. Guides do organize the experience of artworks, too, but unlike the building and the catalogues, they move through and transform the ecosystem of experts in the museum, at times challenging expertise. This challenge is not just an abstract possibility; it is a legacy of the post–World War II history of the museum and its growth within a relatively confined space. It is also a result of the museum's unique situation as an art-historical research institution, one that fundamentally differs from art institutes and art history departments: while the latter train their historians together with other humanists and social scientists, the art historians at the Hermitage grow and hone their knowledge and expertise on site, precisely where

the art is kept and maintained. Given a situation wherein most art historians came to the Hermitage and were first trained as guides, the distinction between being "just" a guide and being an art historian is much less clear. The two groups tread the same territory: the museum and its storage rooms.

A formal position and a department have been created in order to provide a bridge for guides and scientists dedicating their time to studying the collections. The Scientific Education Department (научно-просветительный отдел) is where one finds the "methodologists" (методист) of the Hermitage: scientists themselves, to the extent that they publish books about the collections, they have been detached from scientific departments to train Hermitage guides and introduce them to the science (научно) of the communicative arts. The methodologists are a product of the Soviet philosophy of art history and museology: didactic, visitor-based art history designed to teach and clarify messages that could otherwise be misleading for the masses. Playing a central role in the museum, they choreograph the encounter of visitors and the museum's science through the training of guides. The majority of the roughly 120 guides working at the museum have an education in philology, art history, or history; most of them came to the Hermitage after having been trained in the Department of Art History at the Academy of Arts, in Saint Petersburg, by teachers who oriented them to the museum. This mechanism of recruitment has led to a homogeneous body of guides who share a solid if conservative culture. Many of the guides initially come to the museum while still at the Academy of Arts, in order to study and use specific museum pieces as models. Drawing and copying, more than reading the texts of art historians, will have been their diet upon arriving at the Hermitage. On an irregular basis (every two, three, or four years), the museum releases a call for student applicants interested in becoming guides. The advertisement of the opening is "public" without being fully disclosed: methodologists contact professors at the Academy of Arts who have previously groomed guides for the museum.

The students then introduce themselves during an interview with one methodologist from the Scientific Education Department. During this interview, described as a casual conversation by both methodologists and guides, knowledge in art history is not what captures the interviewer's attention. Language, proper behavior in public, poise, and generally good manners will decide who gets accepted. Eventually, twenty to thirty students are accepted—the exact number varies. The training lasts a year.

During the course of the training year, students meet with the methodologists every weekend. They receive information about the collections and a bit of art history, but always within the galleries themselves. Guides remember fondly this "on-the-ground" experience. The fact that the methodologist rarely sits them in a room for an abstract and formal lecture, detached from the sight of the artwork, creates an immediate sense of proximity, belonging, and the appropriation of future objects of discourse—as well as a sense of exclusivity and privilege. The museum is their classroom. At some point during the year students must give a presentation—a simulated tour—of some of the items, always in front of the actual object. An oral exam crowns the training. This exam consists of a general tour performed for a group of methodologists. Apprentices also take two public groups on a general tour, and the methodologists follow and give feedback on style and overall success. Generally, half of the students accepted for the year-long program pass the exam.

Immediately after they have been accepted, guides are assigned three general tours per day. A significant difficulty associated with general tours is that the public books these visits directly: in other words, they are initiated by visitors who have not planned their trip through an agency and who demand an unspecialized introduction to the museum. General tours are offered in Russian and English. The English-language tours are the most difficult and challenging for guides, as they usually host all foreigners who cannot understand Russian but want an overview of the museum given by a Hermitage guide. Alternatively, Spanish and French speakers, for

example, can reserve a guide who will engage with them in their own language and inflect the tour toward the collections likely to be of interest to these visitors. General tours are available every day, as are a few special exhibition tours.

Initially, guides have a short-term contract, and their pay is directly contingent upon the hours they spend touring. With the seasonality of tourist flows, this pay system makes the off-season a difficult one. During this time, the only way to survive is to provide as many tours as possible for visitors from Saint Petersburg schools. The School Department teaches newly accepted guides how to introduce schoolchildren to the collections. This population of visitors represents an ideal test group for the honing of guides' specialized skills, but the material covered by the school tours is usually similar to the general tour.

The second part of the training program runs parallel to these daily general and school tours. It is designed to train guides to handle specialized materials and prepare them to speak with authority on collections that are not necessarily part of the general tour's landmark pieces. Guides begin to specialize during their second or third years as they organize thematic tours offered to visitors who want more than the general experience. The Scientific Education Department is staffed with sufficient numbers of methodologists that a specialist can cover each of the main collections. While the first part of the training sequence exposes the apprentice to all the methodologists, the second part takes place in conversation with a particular expert tasked to supervise the specialization of the guide. This specialized methodologist will also introduce the guide to the keepers of the museum, a world previously kept at a distance. Not every guide wants to invest time in building a thematic tour. Some decide to stick to the general tour regimen. The thematic tours are advertised a year ahead of time, usually in early September. Perhaps not as exotic and unique as tickets to future performances at the Marinskii Theater, they nevertheless draw long lines and a mix of excitement and frustration because tickets are scarce. People book the specialized tours early, and the audience differs from that

of the general tours: those who attend are nearly all residents of Saint Petersburg.

> It is like a lecture; I prepare for that. It forces me to read new books and search for new information. I meet with my teacher, and we work on the plan, what to show first. She advises me. It was difficult for me when I began, coming from the Academy of Art, to put the information in a different way, to not do an academic presentation, because when you write about something, you start with general thoughts, like circumstances and context. . . . When you guide in an exhibition, you immediately start with something, a particular picture, never an element from the [artist's] biography. (Hermitage guide)

Yet in the end, this is still a performance for visitors, that is attached to a list of pieces; this is still a museum tour, with things in motion, where knowledge and individuals (i.e., visitors) are not yet in the scholarly position of established and stabilized roles. The development from general to specialized tour leads to the next phase, when guides are given access to the auditorium, where they give formal presentations to visitors. Hermitage guides talk about this transitional moment as one of consecration: guides start to tread into the field of science when they exit the galleries and transpose the direct, indexical, finger-pointing exercise of grounding an argument in an object from the context of a moving tour group to that of seated group of visitors all enjoying the performance. When the performance moves to the auditorium, all parties are taken away from direct access to the piece under consideration and discussion. Visitors become a seated audience and the presenter stands at the podium. The piece (more often a series of pieces) is now a slide projected at some distance, and although the podium may be no closer to the screen than the front rows, the projection of images, as opposed to the passive viewing of images, consecrates the authority of the speaker. It also means—or at least implies—that the speaker has had direct access to the piece and that he feels confident that his presentation will capture this former proximity and grant him

enough authority to stand in front of motionless, seated visitors. In an interesting twist on Walter Benjamin's ([1935] 1969) thesis on the reproduction of art,[5] here the slides do not perform the function of leveling the playing field and democratizing access to art; instead, they are precisely what establishes and secures the hierarchy between the one who saw the piece in person and can now speak authoritatively about it, while using a reproduction, and those who have only seen the piece's onscreen image. Far from leveling access or experience, this image—the reproduction of the piece itself—sets up a difference that may well be the founding moment of art history as a discipline. One might even suggest that art history became possible when images were mobilized to buttress an argument about a piece of art, rather than with the advent art itself, visits to view art objects, or discourse about art and artworks in general. The image, instead of animating a conversation, establishes a hierarchy. It is also a moment when art history as a discipline and a discourse detaches itself from the Benjaminian presence of the works of art. With the reproduced image (still very important within this performance), the work of art itself, with its unique and exclusive presence, is momentarily let go of and substituted by the grammar and repertoire of art history as a discipline.

OUTSIDE GUIDES: THE BUSINESS OF GUIDING

Outside guides have a wider range of training than do Hermitage guides. One of their few common features is their legitimation through various certificates granted by the Hermitage to those who have passed an exam administered by the museum. Beyond that, trajectories vary. Yet another common feature is the command of a foreign language. Tourists from the Russian Federation or native Russian speakers do not usually hire outside guides. As a consequence, language departments supply many of the outside guides attracted by the prospect of working with foreign tourists in Saint Petersburg. The most common trajectory for the formation of outside guides is that of language students from the Saint

Petersburg State University moving to dedicated tourism schools. The oldest school of tourism in Saint Petersburg is Intourist, an institution that held a monopoly during the Soviet era. It now competes with many other tourism schools but still retains the aura of proper Soviet cultural training, with a special focus on Saint Petersburg.[6] The school trains students in a variety of fields: each course is focused around a special subject, from Peter's fortress to Kazan's church, and the Hermitage (its history and collections) is one of the main topics in the curriculum. Intourist crowns the education of its students with an exam and subsequent certification by the school that its graduate is qualified to work as a tour guide in the city of Saint Petersburg. Although the students graduating from tourism schools have already taken and passed their respective schools' exams, expertise in the city's largest cultural landmarks requires them to take additional ones. A way of controlling the discourse delivered to visitors, the exam taken at the Hermitage is designed by the methodologists to assess the outside guides' ability to talk "properly" about the museum's artwork. The courses that outside guides are required to take at the Hermitage are held for five hours a day for three weeks. Each course covers a particular section of the museum. Once students are certified, the museum offers dedicated courses to update their skills. The cost for the initial exam and the updates is 20,000 rubles, and each year guides also pay the museum a fee of 10,000 to 12,000 rubles to be licensed as "authorized guides." Every year the museum also provides classes so that outside guides can take an exam to maintain their art history proficiency. However, these classes are scheduled on weekday mornings, and few outside guides actually attend.

Tourist agencies employ certified graduates. Judging from the interviews we conducted, the norm seems to be that guides freelance for several agencies simultaneously. One of the consequences of this employment model is the importance of contacts. The absence of long-term contracts—at times the absence of any written document bearing evidence of the work relationship between guides and tourist agencies—is also apparent in the payment system, in which the

overwhelming majority of transactions are in cash, as reported in our interviews. Agencies that offer short-term contracts for the peak tourist season are few; outside guides never work for only one museum or tourist attraction, so their allegiances are mixed. They are nearly all part-time workers who cannot survive during the off-season, which brings fewer tourists and a city that operates in slow motion. In the summer they work for tourist agencies, and these have duties to the tourists themselves—that is, to provide them with qualified guides and adequate tour options. Establishing a working relationship with an agency is the most important goal of a new guide trying to break into the market.

Agencies offer a host of different sightseeing packages—from the standard service, in which tourists are bundled up for a few visits without control over the composition of the group, to a fully customized service for small groups of friends or acquaintances who want a personal guide. Operating in an unregulated market, agencies feature a vast continuum of offers. Yet package offers are, in fact, often greater than the sum of their parts, as agencies charge a premium to bundle the excursions included in the package. In return, however, the museum facilitates quick access to the sites, not a negligible perk during peak season, when regular admittance can take up to an hour. The relationships between the museum and tourist agencies take many forms. To begin with, tourist agencies contact the museum ahead of time and book a time for the visit. On the day of the visit, tourists enjoy a fast track and can consequently avoid the long line that is a regular feature of the Hermitage's courtyard from May to September. With their guide picking up their tickets, entering the museum is seamless. Second, tourist agencies may organize with the museum an efficient passage of the group through the turnstiles of the entrance and pace the visit of the groups in such a way that the museum can roughly estimate when a group will be exiting the premises. Guides, however, can also be a factor in jamming up the galleries. Individual visitors are used to pacing themselves so that they can enjoy the paintings without too much traffic in front of and around themselves. This is indeed a challenge for

art lovers during the peak tourist season: dodging groups, navigating islands of camera-equipped tourists, encountering overlapping waves of somewhat inert visitors. These bodies and their inertia are primarily created by the clumping together of tourist groups, with their injunction to not leave or lose sight of fellow group members. It is important to note that the museum interacts with agencies, not with guides. So if an individual guide provides a freelance, tailor-made tour to a few fussy visitors, the general entrance and the accompanying wait in line are their fate. However, there are several strategies for avoiding the long wait lines: agencies buy tickets in bulk and sell them (at a profit) to guides. Individuals may also buy a large quantity of tickets in advance and sell them to visitors ready to pay slightly more in order to avoid the line. These individuals multiply the points of contact for the museum and organize a local, informal economy around the boundaries of the building, expanding it temporarily and changing the experience of visitors.

In this highly unregulated market, guides often reinvent themselves as quasi–tourist agencies. Many of the guides use their good reputation, cultivated through a network of previous clients, to offer services directly. When they bypass the agencies, they generally respond to a client's idea of a "dream tour." They price and organize the tour, and their reputation is built largely through travel-related Web forums. A lucrative form of guiding is the customized and tailored tour given by a "nonauthorized" guide, often inconspicuous in appearance compared to the official group guide, with her signature colorful sign. For groups of two to three individuals, the tour becomes a much more intimate conversation; indeed it is a genuine dialogue of questions and answers. In a much less scripted affair, the guide offers a personal tour adapted to the wishes of the client.

For the majority of tourists, visiting the Hermitage with an agency is not an exclusive or personal experience; the aesthetic moment shared with the collection in a gallery is just one in a long sequence of similar stops. The natural and necessary conceit of keepers and curators who design exhibitions around a select number of pieces and arrange them carefully in a well-thought-out order

needs to come to terms with the actual experience of tourists, who may see less an exhibit than a competing series of rooms (since at any given time, with several exhibitions going at once, the museum offers multiple possible trajectories for a visit). Not even an exhibition that is carefully chosen by a visitor or group may be fully experienced, as the visitor may be guided by an agency to as many as three tours throughout the day: museums and churches, palaces, and a city excursion.

COOPERATION AND COMPETITION AMONG GUIDES

Hermitage and outside guides tread the same territory. They both steer visitors through the galleries of the museum. At times their groups are large flocks, as on a June afternoon with a general tour fully booked up; sometimes the tours are much more intimate, as when Rembrandt amateurs from the Netherlands order a special visit to see the Dutch master's works. In response to a question about her relations with outside guides, a Hermitage guide in her fifties tells us:

> It is a painful question. They need the license, and they take the course to prepare for the license. . . . Just one phrase—which I heard from an outside guide—could explain everything about them: "I do not care about any of your rules. I work in the way that brings me the biggest possible tips." It explains everything; I have nothing to add. They don't respect anything; they think only about themselves and about their groups. They earn money and have no ethics. I try not to listen to what they say, because I only have bad things to say about their work. . . . Our tours are based on science; their tours are based on the fun: [this] is the difference. They just amuse the tourists. They don't need any soul [to perform their] work. It is a very big problem.

Being a Hermitage guide is a privilege; the title also breeds a sense of superiority, to the extent that these guides have access to

the museum whenever they want, while outside guides can only enjoy it with their groups. So, for the latter, access can at times seem less about enjoyment than simply stomping the stones of the museum stairs in pursuit of their business. Outside guides are aware of their ruthless reputation, and they have a variety of strategies to counter their image of being "just" guides. One of these strategies is to blame the industry and the formulae cooked up upstream, by tourist agencies, for their performance in the city and the museum:

> We have a schedule; I can't spend the time I want in the museum. [Hermitage guides] are art lovers. They are also a bit more naïve. (Outside guide, Chinese-speaking)

They also quickly reformulate the question about the varying types of communication offered by Hermitage and outside guides. The latter all had a few derogatory stories to tell about the arrogance and clumsiness of Hermitage guides:

> It is a gaze[-based] communication with them. They come from behind my group and stare at me, like they are going to shoot me with their gaze. They know me; they should know I don't react to that. I find that so inappropriate. With [such] lack of politeness, [it is they who] should be . . . behaving [more] properly. (Outside guide, Italian-speaking)
>
> [The Hermitage guides'] groups don't have the earpieces, so they have to listen and stay together. But when they have a large group, they really shout. I don't shout. Either I have a very small group and I talk gently, or I have a microphone and they hear me from afar . . . but I would never shout. This is a museum, not a zoo, not a factory. Being loud is really their way of pushing us aside. And it also means "This is my museum; this is my territory." (Outside guide, French-speaking)

Yet the conflict with Hermitage guides usually recedes into the background in interviews with outside guides, who effectively

elevate themselves to the Hermitagers' level by pushing the issue of poor communication lower down the pecking order onto another, subaltern group: "illegal" guides. Outside guides showed a great level of frustration with what they see as unfair competition from foreign students based in Saint Petersburg to learn Russian and eager to take on the guide business and exploit their close connections to certain groups of tourists. Central to this frustration is the perceived liberal policy of the Hermitage, which disregards these students' lack of work authorization and, to some extent, fast-tracks their acceptance to classes and exams for guides in order to have large groups of Asian tourists organized by people who have been certified. Korean students, in particular, were singled out as "illegal." Turkish and Iranian tourist groups also had a notorious reputation among the legal outside guides we interviewed for coming in groups without local guides, or with fake guides only hired to abide by the museum's rules and, clearly, not to convey any information to the tourists. This frustration mixed several levels of criticism: one criticism highlights the inconsistency of the museum's mechanisms governing guides—which, on the one hand, includes proper training for both Hermitage and certified outside guides that is meant to prepare them to speak legitimately about the museum—and, on the other, the current laissez-faire policies observed by the museum itself. With their role as cultural mediators and, at times, as the only spokespersons that entire groups of tourists will hear articulate a discourse about Russia, official, native Russian guides question the kind of introduction to the Hermitage that "ghost guides" (that is, embedded and noncertified guides) can provide:

> I can be critical of the current situation, but I am a patriot. . . . I have the right to talk about my country because I know Russia. . . . These people—they talk about the Russians, their drinking . . . but they know nothing, and they should not be in the museum. [It] is just unbearable to hear them talk about the building and everything in here. This is so completely wrong and disrespectful. (Outside guide, Italian-speaking)

It is important to note that the classification of guides (Hermitage versus outside and official versus illegal, ghost, or embedded) is not an ad hominem formulation. More is at stake than distinguishing one professional group from another, or one mode of engagement from another. What is in discussion around these internal classifications is something that we have observed in earlier chapters as motivating Hermitage employees: a definition of culture through proximity to the treasures housed in the museum and a certain mode of communication. Beyond the idealized definition of the Hermitagers, including the familiar visitors and fans who rub elbows with guides and speakers at the Friday morning conferences, a more broadly encompassing set of categories emerges, pinning nationalities onto a gradient of culture. The distance cultivated between the work of Hermitage guides and the tasks of outside guides reverberates in a classification of publics produced quite naturally by domestic guides. Guides and methodologists identify two main profiles of visitors, akin to ideal types, honed by their constant exposures to visitors. Of course, they have also become masters at classifying nationalities, most prominent among them the large groups of Chinese tourists visiting during the summer. But upstream from this classification is a fixed distinction made between local visitors and outsiders. Here "local" equates to the city of Saint Petersburg and a somewhat idealized vision of the city's glorious past. The description of the Hermitagers' two publics—local and foreign—lingers over the locals as well. These groups' features may be sketched out as follows:

> Local visitors are serial visitors. They are the ones buying tickets in September for the following year's special tours. They are also the ones coming to the amphitheater of the museum on Friday mornings to hear special conferences. This is the public of Saint Petersburg, [and there is] a wide range of ages, from the early exposure of primary school kids to the older ladies investing most of their pensions into the cultural activities offered by the city. The museum and its treasures are nothing less to them than the extension of their

personal libraries. Their intimate contacts with the collections give
them a sense of knowing and owning, to an extent, these collections.
(Methodologist)

There is a marked distinction between Hermitagers and every-
one else, but the identity of the Hermitager may not be tied to formal
employment. Being employed grants one many privileges, but it leaves
open the question of actual control over the artwork. Keepers are the
legally responsible parties, and we have seen the extent of their appro-
priation of collections, but their exclusivity may not be asserted too
broadly against an indeterminate other. It is primarily focused against
other employees who would try to lay claim to the collections; it is also
asserted against other scientists who might publish about collections
that have not yet been systematically sorted. The discourse of guides
in relation to their preferred public emphasizes proximity to the build-
ing, these individuals' frequent visits, their dedication to knowledge,
and their passion for the treasures kept by the museum. These charac-
teristics are, in turn, amplified by and find value in the oral tradition of
guides and their ability to capture and convey a piece of art through an
interaction that occurs in its presence:

> I don't want to look assertive, but I believe I know Goya better than
> anybody else in our country. (Hermitage guide)

Guides, not unlike many scientists, insist that they are public
performers, and that what they do needs to be judged for what it is
and not as an amplified, preexisting text. We hear this definition of
the role of scientists across the Hermitage. The defense of the oral
tradition is probably easier for guides to make, as their work falls
squarely and predominately within this sphere, than for other sci-
entists, for whom there exists a long tradition of tangible academic
production. It is nevertheless worthwhile to also hear this defense
of the oral mode of communication as a possible reaction to the lim-
ited ability to promote oneself beyond the job of guide:

They promote guides to becoming scientists only rarely. There is this keeper of fabric: she is very good, and she started as a guide, but she made great discoveries; she became a scientist, and she is very good because she knows how to talk about what she does. Sometimes keepers are like: "Okay, your questions? Read my book if you have a question." . . . Male guides are promoted. . . . If you are a boy, slowly, slowly you move to a department. (Hermitage guide)

We observe different appropriations of the scientific missions of the museum by different groups, but this appropriation also works both ways. Guides who want to maintain their self-perception as mediators of art and not just as organizers of tours also appropriate this public while excluding the masses. Hermitage guides privilege "real" amateurs over casual visitors, who often forget why they came beyond the need to check a major museum off a mental to-do list. Beyond the ideal "regulars" of the museum, guides have developed strong views about the tourists and their interests in the artwork, the museum, and the things that need to be seen and commented upon. One of the groups often stigmatized are tourists from mainland China:

Most Chinese tourists spend between one and one-and-a-half hours; they can't take more. . . . We go to Da Vinci, Rembrandt, very rarely to the third floor. Taiwan and Hong Kong students are Western oriented; they want the art history, history of the picture, the content of the picture. . . . For mainland Chinese tourists, we make up stories, funny stories. For our purpose, not knowing anything about art history does not matter; language proficiency is what counts. My problem is that I used to know a lot about collectors and time of acquisition and purchase. I don't remember now. Our purpose is fun and joy, so "You tell me as soon as you want to leave" is what I immediately tell my Chinese visitors. . . . Western tour guides have to talk about the pictures and art history. We don't. (Outside guide, Chinese)

French, Dutch, and German tourists have a reputation for questioning the narratives of the guides and testing them by asking questions and pushing them to admit the limits and limitations of their knowledge and discourse. This points to two elements that make the task of guiding tricky. First, guides must develop expertise in the expectations, preferences, and tendencies for resistance of different groups. With Asian tourists, for example, guides assert that more and more artworks should not be pushed on the group because they will not refuse a long tour; instead, they will politely accept and suffer through it, enduring the pain of walking by art they do not really care to see. The guides we interviewed all mentioned the imperative of not letting a tourist lose face should he or she be forced to admit that they would rather go to the cafeteria, for example, than roam the galleries of a world-class museum. Such an event would have disastrous consequences: the group would immediately antagonize the guide for having singled out an individual. It is indeed very important for guides to be able to anticipate the next few moments—whether discrete and specific moments or longer, continuous stretches of time—that they will spend with their groups. Guides all testify that they have become masters at figuring out very quickly the national origins of visitors in groups they have not assembled themselves, and can quickly discern what they expect and how resilient they will be in the face of the ordeal of an afternoon in a series of loud, crowded galleries. The role of the guide is a combination of master of ceremony, entertainer, and diplomat, cloaked in sociological skills not common in other areas of the museum.

In the course of a tour, guides are exposed to a group that is both intense and short lived. Even tourists who have paid an agency for a package of trips and find themselves bound to a group for two or three days know that they will soon disband and go back to a less intense life.[7] The unique nature of these groups is that while they are geared toward a goal, the goal is malleable enough that its achievement for the group per se may be impossible. Obviously, tourists are not often forcefully required to take a tour that they have paid

for, but they may well have bought a package that bundles together different landmarks and then slowly shuffle their feet when taken through the (less interesting) Hermitage. This is unlikely given the prominence of the museum among all the city's landmarks; none-theless, for guides it points to the consequences of working primar-ily for tourist agencies that program experiences upstream of their own intervention. This is a consequence of the success of the museum, which now features in nearly all city tours; not one outside guide could remember a tour package organized by a tourist agency that did not include the Hermitage as one of its stops. These groups, then, come to the Hermitage preassembled without the guide's con-sultation and functioning within a schedule of activities (including visits to other sites) whose timing and sequencing was determined by the agency. The presentation of the museum and its collections happens through this complex interaction that for a few hours brings together the group (ready to disband at any moment), the guide, and the works of art.

MANAGING THE CROWD

The museum suffers from its prestige. If one accepts that one of its missions is to educate, and if this translates into inviting and wel-coming visitors onto its premises, then this also produces a massive overcrowding of the museum during peak tourist season. Between early June and early September, the city becomes the site of a mas-sive influx of tourists, more or less anxiously roaming the streets of Saint Petersburg to consume in various forms the treasures offered to this new, temporary public.[8] Cruise ships come by the dozens at the height of these intense and often hectic months: literally over-flowing with tourists, they drop off their passengers and pick them up again at appointed times, forcing a strict schedule upon them. Guides are the agents of this discipline, and they guarantee that no tourist will be left stranded in the city while his or her ship steams away from the piers of Saint Petersburg. Inevitably, tensions arise

between the museum—seeking to move as many tourists as possible as quickly as possible through the galleries so that circulation flows smoothly (an endeavor made precarious and even painful by the density of warm bodies)—and the tourist agencies anxious to respect the contract with their clients, avid tourists who have been promised Saint Petersburg, high culture, and dramatic historical artifacts, all in a few hours.

The scripts that are supplied by the methodologists to the outside guides sometimes cannot be respected because the circulation is difficult or impossible: tourists suffer, guides suffer, and frustration builds up. So guides look for strategies to fulfill their multiple imperatives, and are often presented with difficult dilemmas: whether to speed up their tours or honor their contract to spend a set amount of time in the museum, for example, or whether to cater their presentation of artworks to the whole group or instruct the ideal visitor, imagined by the methodologists as being authentically interested in the arts. These strategies entail dodging the crowds and traffic jams without leaving a guide in a space where she is unable to comment on some nearby feature; because she has to have something to say at all times, tour routes cannot be fully random and improvised. Spaces that are not central to the experience of the art end up featuring high on the priorities of these routes. Cafés and souvenir shops, in particular, are common destinations, as visits there count toward the set amount of time to be spent in the museum and are less intense than giving and listening to a series of lectures in front of each work of art. They also free the guide from the slightly infantilizing task of making a head count and controlling the attention of their group members.

Peak-season crowds trigger changes to the space of the building and its attendants. The stone and cement walls are not easily moved, so the building seen from a distance may well look the same, save for the lines of visitors overflowing all the way to the Palace Square. Coming closer, however, one sees transformations that are meant to accommodate the seasonal crowd—and push it toward the exit so that the next wave can be let in.

THE ROUTES OF GUIDES

On guided tours, the focus is on the take-away for tourists—what they see, what they are exposed to—and yet their exposure to the museum may, by design, be limited in scope. The Hermitage (through its methodologists) has created a series of tours, sequences of rooms, and galleries that visitors should experience in a specific order. The quality of the visitors' experience is considered, but another consideration features high in the design of the tour: the efficient circulation of visitors within a closed space, one that cannot accommodate disorganized guides visiting rooms at random.

The museum opens its doors for special groups before the hours scheduled for the general public. During this time, groups have the museum to themselves insofar as they very carefully follow the route that the museum has set forth. The pace of these special visits is not left to the discretion of the guide, and on special occasions they may be asked to exit at a specific time. A typical route designed by the methodologists and their guides follows that sequence:

> Entering through the Neva—Winter Palace and its rooms of prestige— the peacock—old Hermitage and Italian painting (or Rembrandt)— Spanish painting—Rembrandt—back to Spanish painting—sculpture Canova—Flemish painting (Rubens and Van Dyck)—back to the Winter Palace and French painting—if the group is still in shape up to the third floor and the impressionists (otherwise the tired ones are offered the possibility to go to the cafeteria and wait until the group comes back and leave the museum)—back to rooms of prestige. (Hermitage guide)

Sometimes when the museum is too crowded, groups of tourists are channeled to the Egypt area before they can even experience the main stairs and the rooms of greatest prestige. In that case, the route is changed: "Egypt—sculpture—climb the stairs to the Italian painting, and then the sequence above. The prestigious rooms come last." Many of the outside guides we interviewed consider this

forced route to be a guarantee of a failed tour—a failed Hermitage—as their group will only glimpse the museum's most renowned artifacts, and in circumstances that are less than ideal.

ADAPTING THE BUILDING TO OVERCROWDING

The threshold of the Hermitage has varied greatly over time: what used to be the entrance is now a fluctuating area, not necessarily the entrance booth, possibly replaced now by agents holding tickets for impatient visitors or holding lists of agencies and their rosters of visitors. The museum adapts its perimeter to the crowd, spreading outward, overflowing its surplus of visitors to its margins and attempting to manage their presence even as they strain its physical capacity. The displacement of the building's perimeter also takes place inside the museum. When crowds invade the interior space, specific areas experience a special strain. While numerous visitors can spread out in galleries when new flows threaten to jam up the space, intersections and platforms around stairs are less easily exploited as neutral spaces for distribution and circulation. This is even truer for the bookstores. In the summer, mobile-salesman-based bookshops are set up along the most densely traveled routes within the museum. These vendors do not carry all the titles on display in the stable, brick-and mortar-bookstores, but lean catalogues of the museum's major collections are available, frequently for under ten dollars. In effect, they stalk the groups and help the guides by filling more time at the end of the tour. These mobile bookshops are the museum's equivalent of agents greeting visitors with prepaid tickets and lists of guests: they distribute the bookstore within the building, helping one avoid the sense of being in a crowd. They also have direct consequences on the memory that visitors bring home from their visit to the museum. Once a purchase has been made from one of these mobile bookshops, visitors are less likely to go to the permanent stores located in the ground-floor gallery. Big and heavy books are not for sale at the mobile shops because they would be difficult to carry for the rest of the tour

without triggering complaints. As a consequence, the bookstore's mobile outposts can only carry slim volumes that will likely remain the one and only illustrated catalogue bought by visitors: in other words, they leave equipped, but minimally. However, the museum's largest brick-and-mortar stores are located on its periphery, or at least on the way to the exit and in its vicinity. This configuration is still premised on a perhaps outdated sequence of experiences: first come the actual works of art; second is the reproduction of their images in a compendium. Selling books closer to the visitors' route through the museum but earlier in their visit inverts this sequence and creates a form of competition between the works of art and their reproductions.

TECHNOLOGIES OF ATTENTION: MICROPHONES AND EARPIECES

Crowds can quickly overwhelm outside guides, and one way of surviving the infantilizing duties of dragging a group through a crowded building is to keep it corralled using a microphone-and-earpiece set. The museum requires that outside guides equip themselves and their clients with an earpiece when groups exceed six individuals. This device also allows guides to protect their role as art historian by de facto dodging the questions that frequently spring up from individuals in the crowds near the group. At times, it may also allow them to quietly ignore the absence of questions. Technologically, the microphone-and-earpiece technology allows guides to reach each member of their group without yelling through the galleries. However, each participant can decouple the service—being told a few important historical facts and pointed toward a few important elements in the sea of paintings around them—as well as loosen their proximity to the guide. This proximity was what marked tours as we knew them before the ear sets appeared in the museum. In the past, guides had to keep the group compact so as not to raise their voices and risk disrupting the experience of others. With this new self-amplification technology, the group can stretch out a bit more

than before. Instead of quasi-round or oval formations, visitors are now a stretched-out network, with individuals and smaller groups clustered unevenly, often trailing behind the guide by a few meters. The exercise of guiding with this technology has clearly changed the rules of the game. The preliminary assessment of this development is that it releases the guide from the imperative of talking about specific pieces. When guides spoke directly to tight groups, in a quasiconfessional interaction, they had to stop walking and wait patiently as the group closed in around them. Although there were always a few outliers and stragglers, the speech of the guide was solidly attached to a finite series of sites within the museum—in front of a sculpture, beside a painting, and so forth.

With the microphone and earpiece and without the need for frequent stops, the guide strolls and gently slows down more often than before, when he would previously race from point to point. Guiding has become more a series of speeds—slowing down around pieces of importance and accelerating in the spaces in between—than a series of stops that collectively respect the artwork and celebrate it through speech. Guides who regularly use the earpiece technology confess a sense of freedom bordering at times on the casual:

> Q: You are not sure they see the pictures you are talking about?
> A: I don't care about this at all. . . . They are all adults. They paid for the tour; they paid for fun. (Outside guide)

From time to time, guides who have grown addicted to the earpiece can even forget about their groups altogether. This technology transforms the genre of guide commentary and the way guides engage with their script. Far from disengaging them from the narrative, it can minimize the tension created by the group situation and its multiple injunctions: without the imperative of establishing eye contact with members of the group, the earpiece allows guides to focus more exclusively on the artwork at hand. Freed from the group, so to speak, guides can enjoy their own

monologue about the work of art they pass by. This has become what might be viewed as a selfish pleasure, yet it is not one that lasts long, as the conditions do not allow for a real monologue: if the pace of the visit slows down and a stop is in order in front of an object not surrounded by armies of tourists, the group once again takes shape, and eye contact and the triangle of tourist—guide—object are reestablished. So the pleasure of delivering an art-historical monologue is short lived.

The earpiece, a "treat" that only outside guides can enjoy, is a device of peace because it dilates the space around the artwork.[9] Space has always been a scarce resource in the Hermitage. Both the scarcity of space and the resultant tensions among guides, however, have been mitigated by the microphone-and-earpiece technology. In many respects, it is a means of fluidifying the various waves of tourists throughout the museum. The unequal access to earpieces during the peak season also has a bearing on tensions between Hermitage and outside guides. The microphone-and-earpiece technology transforms the performance of outside guides in a manner that enhances the art history dimension of an activity otherwise strained by the need for multitasking. Freed from the imperative of channeling groups and corralling visitors, liberated from the anxiety of eye contact meant to gauge the tour group's perception of a lecture, outside guides can reclaim the right to talk about art and the historical features of the building. They also reclaim another aspect of guiding: with the microphone they can roam the building more freely than when they were limited by a preestablished route. Stops are still needed now and then, but the communication device allows for a more fluid timing of these interruptions. As such, the outside guides end up resembling the Marquis de Custine, a central character in Aleksandr Sokurov's film *Russian Ark* (*Russkij kovcheg*, 2002), erratically breezing through the museum galleries as he pleases, engaged only by his imagination, randomly activated by the history of the art before his eyes. Witnessing such flights, one might also wonder who today's guides are speaking to.

FACES AND EARS: THE INTERACTIONS
IN A MUSEUM TOURIST GROUP

Unlike academic art historians, who are able to "not experience" readers and followers—beyond the rituals of academic life's meetings and conferences—guides receive direct feedback from their groups. The situation of the tour group—with its radical spatial instability and uncertainty in relation to the relative skills and expectations of its participants—is of interest to the extent that it sharpens the question of expertise already glimpsed in previous chapters.

> After Leonardo, even that early in the tour, people start complaining: "We are like sardines in a can; this is a mess." So I smile and tell them we all have to suffer for the arts. . . . I am very worried that they could be tired. . . . If I see them losing interest, showing signs of exhaustion . . . I walk faster toward an area where they can sit. . . . [Or] I try to get them back into the tour; I engage them and ask them questions: "So you, sir, do you like this painting?" (Outside guide, French-speaking)

In a classroom, roles are clearly defined, the gradient of expertise is generally steep, and the class group is not likely to dissolve at any moment. By contrast, tour guides who venture with their group into a museum must establish their expertise in a short period of time, sometimes in less than an hour. They may also do so repeatedly throughout the day, a process that either turns the guides into multifaceted experts or threatens to turn them against their will into servile echoers of guidebooks, catalogues, and art history monographs produced by the "real" experts. The situation is very fragile indeed. Compounding the instability of expertise within the context of a series of tours is the origin of its group members: Where are they from, and what do they already know? What do they want? These are the underlying questions that animate the various pedagogical tactics deployed by guides. Groups begin with or quickly create an internal structure, which can translate into a hierarchy. Whether the members of the group know one another well, after

having spent days or even weeks together (as is the case with cruise ship groups), or are put together for a brief visit, the guide never deals with a homogeneous and undifferentiated whole. Little clusters of friends trailing behind and displaying a conspicuous lack of excitement is a well-known reality for guides. The practical challenge quickly becomes one of managing the structure that emerges during the first few minutes of the tour:

> There is one thing I do not like: groups of two. I find it difficult to be quickly intimate enough [with] people. I can't say I am comfortable with that. And when it is only two; they listen a lot. They do not feel they can talk during the visit, so they really absorb. It is tiring. When they are four, they clearly start feeling that they can talk among themselves, so it is easier for me. One client . . . this is hell. Colleagues ask me: "How can you work with a group of fifty?" For me this is a pleasure. There is always someone who is happy and joyful and ready to cheer up the group. When I am with a group, I talk to a group. (Outside guide, Italian-speaking)

What route to take, when to speed up, when to slow down and provide more contextual elements? These are the skills that guides develop to keep the group happy and simplify their own tasks. Satisfaction and simplification are two of a guide's main motivators; they translate into renewed contracts with tourist agencies and a routinization of the guide's tour. Some guides add to these two imperatives a third, which is more or less easily combined with the others: to create excitement through sustained narratives, to challenge the expectations of the group, and to force them to think. However, this modality of engagement can also run counter to group expectations when sustained narratives and contextual additions meant to stimulate the group end up slowing the visit down and thus stand in the way of a speedy tour. At the same time, it can fascinate some members of the group, who then want more from the guide, exposing him to a situation in which he must acknowledge that he is "just" a guide and not an art historian. So engaging the group on the grounds of

art history presents serious risks for the genre of the guided tour. It reminds everyone involved that tours with a quasi expert are a very artificial genre, situated somewhere between what could be a guide's race through the museum, dropping names related to artwork as the group dashes by them, and an art conference constituted as a discourse celebrating the co-presence of the viewer and the piece—a rare treat in art history, where subjects of study are locked in museums and art historians are based in history departments.

THE PERFORMANCE OF GUIDES

Guides are adamant that their job is that of a performance, live and always risky. The summer crowds change the very terrain of that performance. Summer means large numbers of visitors and traffic jams on the roads leading to the museum's masterpieces. And the recommended tour routes within the museum may not be available; museum employees may channel the group in a different direction, into areas less familiar to the guide, who may even find herself in completely unknown territory. Large crowds also mean tour groups that are distracted by noise surrounding the guide's performance and the unavoidable abrasive interactions with other groups in a hot and hectic environment. Other museums are also on the day's agenda, so for many tour groups the visit should be efficient—as much information should be delivered as quickly as possible. Under these conditions, a guide can easily feel she is pitching a performance to a difficult group of clients, ready to burst into a riot for reasons both within and beyond her control. Nonetheless, it is the guide who will be the first person to hear complaints; hence the high stakes of the performance, and hence its problematic nature, with the speaker only repeating a script supplied by scholars who are nowhere to be found. What builds trust within the guide–visitor relationship? The answer may be that the guides (particularly outside guides) know just a little more than the visitors. This is a strange performance based upon a thickly detailed script—many scripts, in

fact, with several studies for each work of art (and at times a signifi-
cant proliferation of theories for the most popular pieces) available
to the guide.

So why come and listen to a guide, at best a docile and concise
reader of studies written by others? What do visitors expect from
guides? Generally speaking, they expect a great deal of material on
Russia itself, and at times this leads to very trivial questions. There
is some curiosity about the present-day situation of the country
that may be sparked by a visit to the museum's first rooms—the
rooms presenting the glorious past of the czarist era—and manifest
as questions for the guides about tangential topics: What is life like
for Russians today? What does the guide think of her president?
This drift of questions is clearly staged and in some ways encour-
aged by the museum building itself—formerly a royal palace and
subsequently a museum, with treasures collected over more than
250 years. It is probably not by chance alone that the guide's tour of
the museum is regularly taken off its purely art-centric track. The
packaging of the museum as an icon of the longue durée of Russia
is reinforced in each and every city guidebook. Many visitors come
to the individual guides who introduce them to the city having read
(more or less in depth) the relevant paper guides. The latter have
already organized and promoted the various landmarks of the city;
some of them even offer tips and insights on how to bypass a human
guide altogether. In this crowded and narratively competitive con-
text, many stories are told—and some of them are made up:

> I don't think I cheat them when I make up stories. . . . They do not
> know history. . . . Sometimes I hear crazy stories from my tourists,
> like Lenin kicked Peter the Great out of the museum. . . . The thing
> is that there is too much history here. Not just the art pieces: this is
> clearly one thing where we can tell them a lot. But the building, it has
> a long history, many twists and turns. We have to explain some very
> basic things here. (German guide)
>
> When I have groups who are a bit more passive, I try to spice up
> my story, providing them with more intimate details. (Italian guide)

Managing the group is the guide's main task, to the point that art (hi)story becomes a flexible tool mobilized at various depths. Never a blueprint, not quite a roadmap, it can become a pretext to keep peace and order within a short-lived group. The least cynical of the outside guides we spoke with acknowledged the frustrating nature of their tasks. The real-life work conditions do not allow them to be the guides they trained to be, and peak-season tourists make them experience an unexpected embarrassment at producing a discourse on art:

> So when I was taking classes I bought a lot of catalogues and books, but in my work I use very little of these. I wish I could talk about specific features of paintings, but it is very difficult because there is no interest. They want the name of the painting, basic things. It is a problem for me to talk about Cézanne or Van Gogh because if I do it in the Russian style, the old school way, pointing at features and things of that kind, it is completely bullshit for Chinese tourists. . . . They say, "Of course we see it." This is very boring for them. So for Picasso, for example, I just take them to the third floor and I simply name things. . . . Actually, I usually don't go to the third floor; I avoid it. . . . There is a lack of conceptual common ground, nothing to do with language proficiency, really a lack of understanding. (Outside guide, German-speaking)

Guides are central but often overlooked mediators who produce the cultural identity of a museum, a city, and most often the country itself, as tourists who visit through agencies rarely travel to more than two cities, Moscow and Saint Petersburg. As a city, Moscow is less obsessive about its cultural landmarks than Saint Petersburg. A more recent cultural center, one only needs to remember Benjamin's (1986) accounts of his days in Moscow, in which the city is described as nothing more than a series of disconnected villages, to measure the cultural anteriority of Saint Petersburg. This perceived cultural depth has only increased with the explosion of Moscow as the capital—attracting money, active political power, and

networking structures. While this asymmetry may have been partially recalibrated by the Putin administration, cultural attractions are still a major asset for Saint Petersburg, and the flow of capital to the city still cultivates its landmarks. If anything, Putin's administration of the Russian Federation has exacerbated a division of cultural labor: Moscow attracts artists and cultural activists while Saint Petersburg has a mandate to celebrate Russia's rich past—with the consequence that the tourism industry plays a large part in the city's economy and life and the Hermitage, in turn, plays a significant role within that context.

6

SPACES AND SURPRISES

Technologies of Vision for a Long Winter

The Hermitage is one of the museums that started as a residence and was only later converted into a museum. Not designed to harbor the collection it boasts today, the conversion has entailed and continues to entail new configurations and a changing city footprint. This book pays close attention to the spatial organizations of the museum. It does so not only to understand the puzzle created by a building whose architectural prestige puts it on par with the collections themselves, but also because the collection and its management present a spatial problem. The museum's scientific claims—the definition of what the collection is, what exactly has been stored there behind the colored walls of the palace from the time Peter the Great started collecting up to the present day, when acquisition teams scout the city to detect pieces missing from the many collections—have as their utmost concern the problem of space. Managing space is not a problem that only besets the Hermitage; all museums of equal caliber are currently besieged by the growth of their collections and the limitations that buildings impose on their spatial deployment. At the Hermitage, Mikhail Borisovich Piotrovsky has long engaged in a discussion

with architect Rem Koolhaas on the future of the museum, at a time when museums are all confronting the possibility of deterritorializing their activities. New buildings have been acquired that provide new exhibition space in the immediate vicinity of the museum's historical footprint, located between the Neva River and the Moika Canal. A new storage facility has been designed in an attempt to increase the area where artifacts can be shown, a move that daringly questions the distinction between storage and display spaces.

Space is important to museums for the same reason as for any collector: when collections grow, they soon exceed the material possibility of remaining entirely under the gaze of their owner. Overflowing and soon colonizing spaces we thought immune to the conquest of inanimate things, collections can soon evade control precisely at the moment we think we have them solidly in our possession. They may be between walls, allegedly attached to their designated storage slot, but surreptitiously their sheer number makes them escape our control. Any collector, even the most modest of stamp collectors, has had the experience and the mixed feelings attached to the sense that the collection's assets are growing even as the collection as a whole is becoming estranged from its creator. The Hermitage museum, with over 2.5 million objects, has long since reached that threshold of excess, and the institutionalization of the museum has been geared toward controlling it.

The space of the museum becomes an issue because there is never one area where the collections can be deployed in their entirety, under the protective gaze of their keepers or the museum's director. Spaces become the problem of collections because they limit the latter's ability to be here and now, public and visible. For all the exhaustion visitors of the Hermitage experience after viewing the long galleries of the museum, these are only a fraction of the much longer galleries of the storage areas. To add to the frustration of visitors who want to experience (or conquer) the Hermitage—just as they have "done" the Louvre, in Paris, or "seen" the National Gallery, in London—the space of this museum is as much premised on keeping things in hiding and secret as it is on showing its masterpieces.

With most of the collections kept secreted away and beyond even the purview of their keepers, who will know what is in the museum? Although the collection and the gesture of collecting, as famously studied by Krzysztof Pomian (1990), feed on a metaphysics of presence and invent a media form that flips most other mediatic formulas, the growth of collections destabilizes this premise by ruling out the presence of the collection as a whole. The cult of presence and the immediate, face-to-face encounter with an object—be it a canvas, a statue, or a royal sword—directed people to navigate around objects. Unique among other media experiments, museums organize the space around objects, whereas most other media forms we know of and use organize space around individuals. If one thinks of a book, a sound object like a song, or an image, and even if we refrain from naming them "messages," the questions of media have always been about stable individuals—about us—and circulating messages. What museums disrupt in this scheme is the idea that what circulates is a message; there, unique pieces are kept, maintained, and sometimes shown. There, the discourse on the direct experience and the presence of things has made the site of collection the new fetish of modern societies. This is the case, at least until too many objects rule out the possibility of a face-to-face encounter. From that point on, keeping unique things but keeping many of them in one site runs counter to the idea that collecting and displaying can coexist. When a state of excess has been reached, the relatively direct technology of knowledge that is based on sight—a space of direct experience—is replaced by media that create a new space.

SEEING THROUGH THE SPACE OF COLLECTION

This new space is built on top of a different technology of vision, allowing collections that are too big to be presented as a whole to nonetheless be accessible, but this time in a different existential mode. Documents and archives held in secure new sites—no longer the rarefied sites where the fetish of the presence rules—have become

the solution for many items kept by the museum. With these information infrastructures permeating the museum—from the website, to their use in various internal departments and for the convenience of visitors preparing their trips or tour routes through the museum, to the daily management of collections by keepers and scholars—a visitor in 2019 would be hard pressed to experience the museum in terms that would exclude entirely the use of such technologies of knowledge. Even professional museumgoers do experience the museum treasures indirectly at times, so that the pose of direct contact with the objects has become a rarity. From catalogs and books to virtual galleries, museums are playing the game of the extended space, and in doing so they have engaged in an experiment that both enriches their collections and disqualifies the metaphysics of collections—that is, things cherished for themselves and attached to a single site.

What is particularly worth studying in relation to the growing role these technologies play is a set of new issues that arise to beset the claim that the museum is a media form premised on "presence." Collections are still there, somewhere, but what we are authorized to see as ordinary visitors is not the grand, dizzyingly numerous treasure. Similarly, and with more vivid consequences for employees who have professional ties to their collections and intimate interactions with them, knowing what the museum has when colleagues from other museums query about artwork being considered for exhibitions is crucial. A few public masterpieces are well known by the community of art specialists, keepers in other museums, and art historians, so that one can say they are physically at the Hermitage and simultaneously in the mind's eye of many. The characteristics of these well-known objects have attained such a degree of public knowledge that they have literally become figures: the size of the painting, the tone of the colors—everything has been dissected and shared in the public domain to such a degree that one wonders what exactly an art historian would hope to find by requesting a special, one-on-one viewing of the piece, now reduced to its most scientific figures. But here we are talking about a handful of items when, in fact, the museum boasts a few million and acquires

more every year. As the transformation from a place where physical presence rules and structures the behavior of all, to a space where collections exist under different guises and are not tied to a unique site, the flipping of the museum formula deserves to be studied. This is not just an experiment in media within a museum that has not embarked casually and hastily on new media forms; it is also rich with consequences for the conduct of science in the museum.

If most of the holdings are now even beyond the purview of keepers, who knows where which objects are? Sight needs to be complemented by memory so that unseen pieces can be recalled without engaging in a blind search of the storage area. The local memory cultivated in the museum is designed as an infrastructure of knowledge: with over 2.5 million items and finite building space (which has been only marginally increased in a city where land is expensive), all the collections must be captured and summarized in an inventory catalogue. This process is not a twenty-first-century innovation—the consolidation and documentation of the collections started earlier, during the early 1930s, when objects were to be sold for much-needed cash. Recent decades have only added new formatting options through the implementation of an online registry. It remains to be seen how the move away from cardboard file folders—sometimes with dimensions no larger than a business card—changes the collective knowledge of museum employees. Databases are a space within a space. They are designed to bring immediacy and transparency where the accumulation of items had brought opacity and secrecy.

If new venues have been designed to spread out the pieces so that they do not obscure one another, the most notable transformation has been ushered in by the information infrastructure of the museum. As documented in chapter 2, the museum moved to computers in an effort to decouple the knowledge of the collections from the act of gazing on the collection in person, so that keepers could be knowledgeable without being present at the site of their treasured pieces. While pieces not present in the basement or other storage space of the main premises may be housed in a distant building, this digital technology brings them to the keeper's workstation.

This is possible for all keepers in the Hermitage, so the question arises as to why it is not so for all interested keepers worldwide. This new approach, clearly less obsessed with the constitutive media form of the museum premised on presence and face-to-face encounter, breaks down the collections into attributes that have the virtue of being fungible. As opposed to the presence and exclusive spatiality of the items in the collection, only worth collecting and buying because they are not blessed with the gift of ubiquity, attributes can be read and considered at any time and from anywhere—and have a different relation to space than the cherished pieces themselves.

ATTRIBUTES AS REPLACEMENTS FOR PIECES

In addition to freeing objects from the exhibition form of spatiality, information infrastructures now allow us to query the database for pieces, that is to say, pieces in bulk.[1] Any attribute used by the keepers can become a keyword used to search the collections: perhaps one wishes to search for a specific collection of items, for example, a gift from the "Andropov estate." However, this is only one attribute among many attached to each piece in the collection; others include color, material, date of release or production, and so forth. The list of attributes is conceivably infinite. What happens when attributes replace collections as the mode of description for an ensemble of things? The "traditional" collection celebrated ensembles on the basis of a series of attributes that were explicit and marked its boundaries. The Shushkhin collection is an example of this phenomenon: the collection may be formed on the basis of a very strict criterion—namely, whether Shushkhin was at some point the owner of the paintings—but as a collection it contains a variety of pieces. And this variety can challenge the mundane and insufficient knowledge of a collector, especially when collections grow quickly. As Shushkhin began to collect, he both acquired paintings and lost sight of them. While he may have kept some trace of each and every item of the collection in a large acquisition ledger,

he would have listed only a set of attributes. Attributes are ways of simplifying the description of objects that could each merit infinite stories, told in juicy or highbrow detail by art historians. In stories of objects, details can be told in ways that turn them into pivots of cultural transformation. In contrast, the limited ranges of attributes are meant to allow management of these objects at a distance—one need not even move them around, let alone move around them. They are memory tools, as theorized by Geoffrey Bowker (2006) in his comparative study of three different regimes of memory across the nineteenth and twentieth centuries, that allow for the mobilization of a distant object through time. But scientific collections are of a different nature than artistic collections. They are meant to document laws of nature and monstrosities of nature. If specimens are kept, it is for a variety of reasons, first among them the possibility that their descriptions are incomplete and will need to be revisited at a future date. In the keeping of scientific specimens, presence for the sake of presence is not celebrated. No magic of presence replaces the rational description of specimens, and it is these descriptions that find a natural site of endurance in big books, whether atlases or other forms, which stand in for the specimen. The revolution of modern science, as has been noted repeatedly (Long 2001), is to rid the magic of presence from accounts of the world. From a modern scientific point of view, attributes are all one needs to know about a specimen. Yet-to-be-discovered attributes may join the list, but this list is not a degraded version of the specimen kept in a scientific collection; on the contrary, it is all there is to know in a rational manner as of the time of description. Cultural databases, on the other hand, cultivate a different relationship to their unique pieces of art.

THE MEMORIES OF ACCUMULATION

Art collections entertain complicated relations to the process of accumulation. Unlike other collections that require less maintenance by way of regular inspection, old artwork must be kept

carefully, so that the items are not solely reduced to their attributes. Large numbers of objects require large and appropriate sites. The yearly tour that keepers take of their collections is that moment in time when the unique item regains its consistency and reminds the keeper that attributes in their clean and eternal classificatory function hide things in a process of decay. The idea that information technologies would gradually offer a new and exhaustive—albeit less direct—view of the items in the collection stands in opposition to the history of the Hermitage during the twentieth century, which reminds us that the very notion of "collection"—or "fund" or any other term used to characterize the museum's full complement of assets—is itself in question. Preceding the phase at which one entertained the idea of an electronic record attached to each and every object, the entire post-1917 history of fast and unruly accumulation speaks to the flow rather than to the stock nature of the collection. The Hermitage was equally blessed and cursed by too many pieces that were wildly and quickly acquired, and the inert building could not keep pace. Here again, space features centrally in the life of the museum—but this time, when combined with the specific nature of accumulation, it generates a form of forgetfulness. Each new acquisition—and, more to the point, each new element—having joined the collection hastily, does not end up on an infinite shelf of treasures. Rather, the object simply adds itself to a place that is, by default, not yet organized along the neat classificatory principles that prepare the description of artwork by attributes. The word "collection" may misleadingly summon the image of a list, but that particular technology of memory is a rare feat in the case of most collections. Before lending themselves to the pleasure of manipulation of index cards and structured tables, elements accumulated are parts of clumps. This natural collocation is the opposite of a classification effort.

When the museum collects objects, they are owned and stored, but at the same time they are being forgotten. The forgetfulness of collections comes as a surprise to the extent that we picture collections as lists or window displays; either way, they are technologies

of representation that make transparent the infrastructure of conservation and make visible the things collected. Notably, this process occurs for all the items and all at once. Lists have characterized the modern sciences and, before that, the process of rationalization, as documented by Jack Goody (1977, 1986) in his well-known studies of lists and table-making practices. Long before museums grew large and accumulated massive collections, natural historians and philosophers drew up long lists. Here again, we see that specimens of natural wonders had to be sorted, and finding them afterward was not always an easy task. Yet the list did not (necessarily) come into being in the wake of man-made accumulation: cloud formations are many and hard to distinguish, but they are not produced by the dozens of objects in a workshop, and they are not brought together in one site for close inspection. What set the museum lists apart as crucial devices of collective memory was precisely that combination of features: numerousness and collocation.

When good reasons not to classify add up, accumulation drifts further away from memorialization. In the case of the Hermitage, the problem of spaces of classification is a complicated one because it was never just a technical one. Keeping art in a box was not meant merely to protect it from the threat of bad weather, changing humidity, and vicious winds along the Neva. Boxing up and fencing off was a way of protecting the artwork against more diffuse threats formulated from the outside against some of the collected treasures. The admonitions and warnings given to the museum's directors throughout the twentieth century also functioned as subtle reminders that the collection was off limits for many of the Party cadres, who privately praised the foreign collections but were outwardly critical of their presentation to a public that needed, instead, to be trained in the glories of socialist realism. One should add to these domestic threats the other more distant threats of previous owners who could level claims against the illegal appropriation of paintings during and after the Russian Revolution and World War II. More or less explicitly formulated, these threats exacerbated the sense of protection afforded by the

building itself: it was a shell that stood for a people proud of its treasures and traditions.

Internal theories at the Hermitage relating to visitors and tourists offer a fairly straightforward topography, with a linear gradient of intellectual proximity quite homologous to the spatial gradient of distance to the building. If Hermitagers are accorded special status in Saint Petersburg, they in turn feel close to those they see as the "real" amateur art lovers: the locals who sign up for the presentations in the museum auditoriums. Among these respected visitors, schoolchildren feature as a priority both because of their age and due to the museum's declared focus on pedagogy. Visiting frequently and often enrolled in the early art-education program, children are less threatening visitors and are fervently celebrated by the Hermitagers. From this point in the gradient on, visitors are perceived as individuals who have lost a true focus on the exhibitions and collections and devolve into tourism: the attribution of this perceptual loss and hence distance from the objects moves from other Russians to Europeans (with the German, Dutch, and French visitors receiving special consideration for their proximity to the arts). Moving further away still, visitors are equated to tourists, and their roaming into the museum corridors is felt as an intrusion.

A visit to the museum's back offices, preserved from the rowdy circulation of tourists and visitors, reveals a series of home-like spaces, where coffee and tea are served on a continuous basis. The absence of official retirement for employees of the Hermitage, a policy enforced since the early 1990s, created an incentive for older employees to stay longer. These incentives are not exclusively and not even primarily monetary in nature, as the salaries earned at the Hermitage are low and pensions not much better. Instead, the building is experienced as a shelter, a place of prestige filled with excitements. This positive sense of the workplace does not, however, preclude internal tensions between scholars over funds. In fact, the very existence of these feuds could be considered as evidence of attachment to the place—a place that should be protected from outside gazes, with "outside" starting as near as the keeper next

door. In many ways, the building is not just a large and majestic box but, as we have seen in earlier chapters, can be likened to a series of small boxes, both highly porous and insulated from one another.

MEMORIES AND SURPRISES IN AN ENCLAVE

With the space of the museum folded and convoluted, and with most of its areas beyond public access, let alone visible to visitors, the knowledge of the treasure contained therein is now somewhere else: it is always stored, at times even hidden. Moving away from the site of the visible—the here and now of direct contact that celebrates the presence of the work of art in the museum's collections—the space of the museum becomes a cavernous thing—and a treasure well hidden therein can lead to a treasure hunt. The transformations that come with cavernous space are not to be ignored or downplayed. The relative size of the collection and the consequent invisibility of most of the items to the keepers working in the museum create a two-fold sense of responsibility and curiosity. The difference established between the categories of invisible-to-the-public and accessible-to-the-keepers (and to authorized personnel) builds proximity to this invisible collection. A duty is born of this threshold, and a privilege is bestowed upon employees who are privy to the secrets of the treasure. Yet at the same time, the new invisibility of the collections in the practical conditions of storage give them a sense of exotic distance. "Bounty hunter" may be the description most useful in appreciating the keepers' relations to the invisible. This stance, mixing curiosity and expectation, is reaffirmed now and then when a masterpiece "turns up" from the storage rooms. The website of VTB, a leading Russian bank, addresses with caution this expectation with a text by the art historian Kira Dolinina:

> One of the myths in the museum is that there are a lot of undiscovered masterpieces in the Hermitage storage. Unfortunately, this is not true. It is rare to find something new. But sometimes it happens.

In the 1960s, Dutch art historian Herbert Haverkamp-Begemann vis-
ited his Leningrad colleagues at the Hermitage. Talking with them
over a cup of tea, he happened to notice under the cupboard the edge
of a huge sheet. It turned out to be an unthinkably large drawing
(228 × 170 cm): *Venus, Cupid, Bacchus, and Ceres*, by the Dutch mannerist
Hendrik Goltzius. Mannerism is a frivolous, esoteric, narcissistic, art
of bodies and their interweaving—of course it was not appreciated in
the Soviet hierarchy of genres, but even then everybody understood
that it was a masterpiece. From that time, finding something like that
has been the impossible dream of every keeper.[2]

There it had been ignored for decades, possibly centuries, a situa-
tion that may have been the result of various circumstances. The
most common reason for items being "lost" is the fact that museum
storage has itself become a series of black boxes, hermetically
protecting what is inside from challenges that might come from
outside. Remoteness and the absence of transparency have degener-
ated into a lack of structure. And, either by chance or because of a
particular item's essential aversion to easy categorization, a long-
lost (or long-forgotten) gem can be rediscovered or even discovered
for the first time. This situation may give us a deeper appreciation
of the word *treasure* which appears in the title of so many publica-
tions about the Hermitage, for treasures are both what need to be
protected and what need to be discovered. In the long history of
public museums, treasures were often pursued in foreign lands and
brought back to be displayed as emblems of military grandeur and
enlightenment. After all—so the rationale of the time claimed—
distant cultures had not been shattered by these incursions, just dis-
placed and maintained for eternity. At the Hermitage, these initial
episodes of collecting and seizing all took place the same way they
did at the British Museum or the Louvre, as a combination of royal
treasure hunting and looting by nation-states. But these museums'
stories of discovery did not end with the initial accumulation. Once
items were inside the museum, in storage boxes filled in haste, a sec-
ond treasure hunt began, one where the new rules of the game were

created by the peculiar envelope the building supplied—protecting the treasure so well that it hid it again. This is the holy grail of treasure: sought after everywhere, with all hope lost along the way, the grail turns up in the basement of a regular building. And it is this hope, this surprise, that gives a new allure to the storage area and to the generally neglected part of the collections that are not on permanent display: out of the limelight, left in the dark and remote corridors of the building, these minor items might indeed conceal real treasures. All of a sudden, treading the space of these private areas becomes much more than maintaining back offices and looking after known pieces. The back stage can resurface as the front stage: the wrapped-up, rolled-up canvas long thought to be the work of a minor painter and never closely examined can instantly be promoted to the roster of the museum's masterpieces. A keeper from the West European Painting Department remembers:

> The Hermitage collection had formed long ago, and the best things were bought long ago. And nothing of the kind that Catherine II bought could be bought now. However, later, there was a big shake-up—and the Hermitage spilled out a lot. On the other hand, a lot was acquired—through the nationalization of other museums and private collections. Lots of things were brought in from other palaces. Hundreds of things were brought and piled up, receiving only sketchy descriptions. There was a lot of junk as well as unrecognized things. So the best way to expand the Hermitage exposition is to work with its own holdings. As I say, if the Hermitage lacks something, one should just seek properly. Because even now the most sensational discoveries are possible. Fund B has just entered the new depository at Staraya Derevnya. Before, these paintings were kept on multilevel trestles, with very limited access for any examination on the third floor in the Winter Palace. These are hundreds and hundreds of paintings that haven't received specialists' attention for decades, since their arrival, when they were looked at and received their descriptions as part of the group. A lot of things are [still] to

be discovered. Recently—it's embarrassing to tell this to our foreign peers—a previously unknown five-meter-high altarpiece by Rubens was found in the Hermitage. It was brought from Alexander Nevsky Lavra in the 1930s; Catherine II purchased it in the eighteenth century. Well, it's at least two [different] centuries that a new five-meter high Rubens has appeared on the horizon. . . . I think [even] our director hasn't understood that this was Catherine's little gift from the other world to celebrate our jubilee. There is no way you can get such a thing today.

This space, now riddled with uncertainty and surprise—most of it positive, as demotions or deattributions of official museum treasure rarely originate from unexpected findings but rather from the (flawed) material structure of the pieces under scrutiny—is the world of the scholars working in the Hermitage. The opaque nature of the space and the promises of its still-anonymous objects give the building an aura that was the primary theme of the Hermitagers who spoke with us. One may wonder whether the myth of the long-hidden gem and its resurfacing deserves so much attention. After all, organizations all cultivate their own myths. But this one is of particular interest to us because it tells the story of the fashioning of the memory of the museum—and also of its forgetfulness.

At the Hermitage, there was never a *stock*, if one understands the term to mean a set of well-delineated and well-defined properties. Rather than a stock, there were two other modalities of existence. One was the *flow*, which primarily brought pieces into the museum and rarely took them out, even if the loss of objects is amplified in the collective memory as traumatic events. After the opening of the borders, and the rapid surge of loans to other museums abroad, the sense of flow and the threat that it entailed for the stock was revived among the museum cadres closer to the collections. Moving collections out, even temporarily, jeopardized the integrity of the treasures and lent itself to the accelerated decay that the museum fended off in the first place. But there was another modality of

existence, albeit one that did not lend itself to the same criticism as the flow. This mode of being is not even easy to name simply because it is an in-between phenomenon, a state of limbo. Not lost, not hidden, not quite present, still, or moving, this limbo with regard to the collections is not only important for the uncertainty it creates around purely factual, accounting-related questions. Beyond the perimeter of the collection, the limbo of the museum adds a dimension to the otherwise finite space of the museum: pieces in this state are yet to be discovered.

Museums cultivate a complex relation to secrecy and visibility. They are technologies of visibility, not unlike microscopes for natural and life scientists. At first, they take away and create distance between the specimen and the curious individual. Walls of museums, their gates and the sophisticated protections against breaches of all kinds with which they have increasingly been equipped, stand in the way of a direct and easy contact with and access to the collections. Without proper vetting of the visitor—ticket or pass paid, body searched, and bags checked in—collections are not accessible. They are kept secret, so that what museums do is as much to hide as to make visible. A selective disclosure is what happens in the museum. Historian of science Hans-Jörg Rheinberger (1997) alerted us to the element of surprise and uncertainty that seemingly mechanical, factory-style laboratories accommodate. Labs are populated by instruments and standards and constitute factories that reserve the possibility of surprise. This is the seemingly counterintuitive dimension of laboratories. They have created a space entirely controlled *and* designed to allow for the recording of novelty—not just any kind of novelty, given the stringent rules that animate the lives of laboratories, but novelty nonetheless. Steven Shapin and Simon Schaffer (Shapin and Schaffer 1985; Shapin 1995) pointed to the epochal invention of laboratories in a series of papers and books that documented the interplay of the unique experimental sociality of science and its radical consequences on the refashioning of truth as a category to be reckoned with. The Hermitage should be read as a similar institution: from a distance, it looks like

the ultimate stage of standardized methods. Like all museums with the three imperatives of science, display, and conservation, it proposes a dual architecture of representation: for employees, the use of acquisition and circulation databases and the documentation of any listed item in the museum, and for visitors, the actual items, presented with the greatest possible clarity. Everywhere we look, an almost laboratory-like environment seems to enact the dreadful promise of disenchanted worlds, where even the most different and distant artifacts are all aligned and ready for display. This is the nightmare of museum critics. But as the laboratory digs further its holes of museums as machines—with museums seeming to offer up the same artificial and confined products as machines, served to a public mostly unaware of the particulars of the pieces on display—it also invents its own drama, reenchanting the uncertainty of their boundaries and the possibilities of surprise. The mechanism underlying this possibility is a derivation of the spirit of the laboratory as formulated by Rheinberger. It is produced by the encounter of two series of events. First is the rapid expansion of the museum's collections and the unique and complicated history of their accumulation during short periods of time following the Revolution of 1917 and World War II. Second is the series of threats experienced by the museum and its employees, marked by the hardships of the Siege of Leningrad (1941-1944) and the aesthetic policies of the new communist regime, gradually enforced from the 1930s onward. These two series of events have met in the Hermitage—or, more precisely, around the envelope of the building. Although we may observe the imperial, Soviet, and post-Soviet eras as unique episodes—as circumscribed or regional cases—the continuity of these events tell us much about the violence of art predation in the wake of armed conflicts and the occupation of foreign territories. A story beautifully told by Bénédicte Savoy (2003) looks at the case of another turbulent era, the early nineteenth century and the looting expeditions of Napoleon, which included the carrying off of Russian treasures. The history of the Soviet Union and New Russia exacerbated a genetic feature of museums: they confine artifacts. In a way, the history

of the Hermitage offers a magnified glimpse of the way museums work worldwide. But in the case of the Hermitage, the museum confined more than just the artifacts: for a few decades, museum caretakers were similarly confined due to the continuing lack of circulation between the USSR and the rest of the world, at least the capitalist world.

CONCLUSION

Secreting Memories

My first encounter with the Hermitage and its people was a puzzling one, and it came in the form of a document. Known as a *prikaz* (in Russian, literally an order), it was jointly signed by the director of the museum and by the rector of the European University at Saint Petersburg, setting the terms of an agreement between the two individuals and their respective institutions. It declared in plain terms that the university, represented by myself, would conduct a study of the museum. As such, it contained little information that should have been concealed from third parties. Instead, it formalized a dance that started in 2012 and lasted for a few years, up until the manuscript of this book was finally discussed with Hermitagers. This document turned out to be both precious and physically elusive. The copy signed by the director of the museum and the rector of the university was the only signed version of the document, and it was closely guarded by the museum. Any request for interviews would require a presentation of the *prikaz* as proof that the team of university investigators was not intruding in the museum without a clear research mandate. I repeatedly contacted museum departments by phone to request

interviews, and after a few minutes of exchanges the issue of the *prikaz* would be raised: in compliance with orders from above, it was only upon presentation of the signed agreement that Hermitagers would agree to talk to me. The document was all-powerful and often difficult to track among the offices of the museum. It was one of many quasisecret documents I kept discovering as I traveled through the institution, and, far from being an exception, it stood as an exemplar of the relations between the integrity of the organization and the documentation of its knowledge.

The claim of this book is that the Hermitage is at once a place in which the museum explores its own collections and protects its own culture. It is a site of exploration because, from the beginning, the museum has slowly been discovering what it contains and what it can do with its holdings. As an organization, it has been the site of a series of accidental experiments: it was in charge of extraterritorial collections at a time when anything extraterritorial was considered dubious and, more recently, it left the Cold War behind to join the fray of generalist, world-class museums. The self-exploration is ongoing as of 2019, with the mission of the museum frequently discussed by its administration at both high and low levels. Since World War II, this exploration has been shaped by the evolving organizational ethos of the museum: strict and formal, on the one hand, and free and open, on the other. The great volume of resources accumulated and the lack of established scholarship in the wake of the war opened up new possibilities for investigation and discovery. Exploration was initially left to the initiative of individuals, at a time when the collections were not yet properly sorted out and the treasures were still in crates and boxes following their hasty accumulation. More recently, the organization of keepership has also put individuals in charge of the museum's collections, with legal stewardship of artworks held by keepers, to the possible exclusion of others.

Protection has been the other topos of the narrative conveyed by Hermitagers, with the outside world portrayed as not always welcome in the exploration of the treasure. Throughout our interviews, inside and outside the museum, one image kept being invoked:

the perception of the museum as a family, organized around oral communications—Who would write down messages between family members?—and maintaining a solid wall of separation around its premises. The policy of not forcing retirement, set in place by Mikhail Borisovich Piotrovsky, the current director of the museum, has reinforced the idea of the museum as a haven, a notion cultivated by all Hermitagers. Exploration and self-protection do not coexist well if the form of exploration in question does not "stay" in the museum—that is, if it engages outside communities of art historians and museum specialists. Given the size of the museum and its collections, however, this attachment to the internal at multiple levels (the department, the museum, the nation) could never happen without interaction with the outside world. At times forced, at other times voluntary (as with the embrace of the exhibition circuit after 1991), communication with the outside world has most often leaned toward oral forms of knowledge, still tentative and uncertain, experimental and loose. It is a mode of communication not yet ready or willing to be taken into the general public.

This initial tension between exploration and self-protection translates into a second one, between appropriation and credit, which mirrors the initial tension of the collective experience of working in a commune-like organization protecting itself from the perils of the outside world. Appropriation of collections is the local form of the division of labor, at times pushed to its extreme: collections became the property of the keepers fortunate to have been put in charge of their maintenance and use. *Credit* is the recognition bestowed upon Hermitagers by their peers within and from outside the institution. Reputation, in manifestations ranging from rumors of a great eye ("Izergina and her sharp, 'diamond' eye") to volumes published abroad, is the marker of credit garnered by keepers as they display expertise. But "expertise" is a problematic term here, one that casts the museum as something anomalous. One of the contentions of all keepers we interviewed was that the art expertise that mattered was one cultivated in the proximity of artworks, not one learned in abstracto from books or other modes of viewing at a

distance. This contention has always been a line demarcating claims made by museums' employees and those put forward by university-based art historians, for whom considerable effort was sometimes required in order to access museums, and who could never take for granted a private display room. Insisting, as all Hermitagers would, on the virtues of proximity to and bodily experience of the pieces would exclude non-Hermitagers from their version of scholarship, a form of systematic study premised on appropriation more than generalized credit. Appropriation and credit are the two ends of a spectrum. On one end is the privatization of the museum piece by an individual within the institution; on the other end is the "public" release of information about the artworks. One remembers immediately how, in the case of the Hermitage, this making-public has assumed a variety of forms, ranging from quasiprivate oral communications between colleagues, who respect each other for their deep expertise but might not ordinarily agree to share their knowledge even with other members of the museum, to the publication of catalogs or articles, accessible to anyone. This spectrum tends to run parallel with an oral-written gradient, with the most public gestures being enacted by the museum's written documents. Once caught in the written mode, knowledge may escape the control of its producer. To produce a record that is both written and private requires a dedicated attention to its (lack of) circulation (Galison 2004). So documentation takes knowledge to the public, but many of its instantiations remain private and are part of the museum routines or modes of activity. The *prikaz* was not just a quasisacred manifestation of the director's handwriting to be kept in a safe; instead, it seemed to align with the nature of all documents in this organization. Invoking the magical properties that Claude Lévi-Strauss ([1955] 1976) famously observed in the appropriation of writing in *Tristes Tropiques*, these documents were ways of keeping knowledge private and of bending the organization to the writer's advantage.[1]

Organizations always police their boundaries, and maintenance is never accomplished once and for all; rather, it is a relentless activity meant to maintain the inside and the outside of the organization

as distinct and nonconflicting domains. These policing activities are *rapidly* supported by documents. "Rapidly" is used here to capture the fact that for large organizations studied by social scientists, intimate, word-of-mouth communications do not work quickly or efficiently enough. As soon as organizations exceed their "Mom-and-Pop" dimensions and involve a large number of people who are not otherwise related, they begin to depend on documents.[2] Organizations cannot be understood or even treated as objects of inquiry for social scientists without reference to the documents that compose them. Documents, far from being mere contextual elements that spice up otherwise dry descriptions of organizations, are the very backbones of those organizations. Remove them from organizations and they soon collapse. Their role in organizations is nothing less than giving them stability and longevity and making possible their expansion. They also keep organizations integral—that is, true to their mission—by making explicit their (limited) goals. In a nutshell, without documents animating organizations they would explode or implode, but, one way or another, they would lose sight of their perimeter. One should note that the description of documents-enabled organizations does not distinguish between corporations and public administrations. It is even a well-documented characteristic of public administrations that they are documents based and that states would not have the monopoly of violence if it were not for their ability to centralize and control their population. This is even a relatively consensual theory of the state, one that spans Weberian and Foucauldian approaches while avoiding the radical formulation of Lévi-Strauss.

Organizations get stabilized by their documentary production; their boundaries are set, and the regime of routines sets in. With this regime in place, organizations lose the ability to differ from one another and to deviate from the paths carved out by documentation. One argument made by the organization theorists who have paid the closest attention to the interaction between time and "organizing" as a process (Jones, McLean, and Quattrone 2004) is that one should not conceive of time as an outside dimension, à la Kant, a

dynamic beyond the control of managers. Mobilizing process phi-losophy and the work of philosopher Henri Bergson, they suggest instead that time is a by-product of organizations. Organizations are only "good" to the extent that they manage to fend off uncertainty and to define the timing of input and output, thereby domesticating the ecology around their territory. A successful organization is one that manages to keep at bay the temporalities that animate com-peting organizations. In addition to making time a central concern, process-organization theorists point to organizations as achieve-ments. Fragile and unstable, they are patchwork assemblages whose momentum is preserved by the ballast of documents. Tangible, vis-ible, and conspicuous documents are the material behind all lofty theories of organizations.

Organizations are the product of protoforms of capitalization, established before the developments of the nineteenth century well documented by economic historian Alfred Chandler ([1977] 1993) in his saga of the transformation of the farm/household-based economy to the large corporation, with its distinction between owners/shareholders and managers. This transformation has meant a change in the visibility of operations and products: with clients identified and a need for standard delivery recognized, production is written up in such a way that documents can stand in for what used to be, nearly exclusively, a process of expertise or knowledge passed down from one worker to another. This represents a trans-formation from the tacit to the explicit, facilitated by documents. The advent of these documentation processes immediately made the corporation a public object by virtue of its circulation of scripts and directions, even before the legal invention of the publicly traded company. Later on, the division of property and management within organizations exacerbated the documentation of operations that were now distant from their owners and under the direct control of managers. Whether we look at corporations from within (attending to the rules of the organization) or from the outside (from the van-tage of reports made to owners or to clients), we see documents pro-liferate as means of maintaining the proper choreography between

employees and products and between managers and profits. In a growing organization, documents are the crucial tools for the control of the new, dense environment made up of first dozens, then hundreds, and soon thousands of employees and as many clients and owners. From family businesses to large corporations, the most striking feature of the rise of large organizations is the "chorus," that is, the new set of voices that all need to be corralled so that business does not become chaos. Documentation provides that safeguard.

One study of the English East India Company points to another use of documents. In *Indian Ink*, geographer Miles Ogborn (2007) takes us down a related, if somewhat different, path, no longer that of the dense and chaos-prone hive of the large corporation—with its divisions and overlapping prerogatives in need of a clear set of rules to keep everyone on his own course—but rather that of the distant and discrete interactions between the Crown and its newly established colonies. In this case, documents act as means for controlling distance, rather than density. *Indian Ink* is a brilliant application of the creed (encompassing science and technology studies and actor-network theory) laid out by Bruno Latour (1983) in his studies of scientific laboratories, in particular the documents that produce the generality of scientific statements. Revisiting the values that are said to animate the scientific communities after Merton's pronouncements (1942, 1957, 1988), Latour turns to universality (the U of the Mertonian KUDOS) as a subject for close scrutiny, not as an intellectual resource that could be taken for granted. Scientific findings do not gain universality through any magical "eureka" moment, let alone through a moment that would enlighten the entire scientific collective at once. Instead, making a statement universal requires a form of rhetoric that takes the empirical world and turns it into a fact—fixed, accepted, and deployable. The phenomenon of documentation is crucial here precisely as that which solidifies the chain of reference leading a piece of the world to become a fact. In Latour's work, labs are the ultimate producers of generality, as their problem is to stabilize statements, starting from within their vicinity and moving outward. They are designed to solve the

problem of universality, that is, to talk about and to the universe from the site and in the language of a document. Documentation is a tool used to turn the "here and now" of scientific practices into scientific statements.

For organizations, laying out ways of doing is good so long as these guidelines do not fall into the wrong hands, that is, those of competitors who are all too happy to use them for their own benefit. The imperative is to protect the business of organizations from becoming too public too rapidly. Some ways of doing need to be kept from leaking out to the public or the competition, for fear of losing the formulae or recipes that make the organization profitable. How does an organization prevent documentation from becoming its Achilles' heel? As we have seen, documents have the dual and contradictory ability to strengthen collectives and to undo them. They yield both consistency and deconstruction. This brings secrecy back into the equation of organizations: when documents are produced in order to organize, they must also circulate and inform. As vectors of communication and as scripts for the coordination of employees, their very nature is to emerge from within the organization and gain some form of publicity. Agents of fluidity, they deprive employees of their sphere of professional privacy. Media scholars have been busy looking at the ways in which technologies of documentation make things public, but they have done so without remembering the lesson of Simmel (1906): each public has its ghosts, and documents exclude as much as they include.

The secret societies of the Hermitage are as many publics, made possible and activated by the hundreds of *prikazy* produced every year in the museum. Documenting and keeping secrets while talking to its public: that was the puzzle documents presented in a museum surrounded with enemies, both real and imagined. The art history produced at the Hermitage has exacerbated an old tension animating art history scholarship. Premised on the presence of an artwork in a specific site (usually a museum) and on the experience following an encounter with a sensible subject, art history cultivates a complicated and contentious relation to the cultural accumulation

produced by museums. The Hermitage had not only accumulated on a massive scale, it had also done so on such a wide range that the Soviet period and its mottos of proletarian art expressions and the consequent proper narratives of art forms found itself challenged by the Hermitage and hesitating as to the proper treatment to be reserved to its Hermitagers. This unique historical configuration led to the private celebration of an art history cultivated between the walls of a building experienced as a shelter. How do Hermitagers look back at the Soviet era and the constraints it imposed on their scholarship? In his memoirs, Boris Borisevich Piotrovsky comments on the pieces he wrote in besieged Leningrad: "I can say that the academic articles I wrote in Leningrad during the winter of 1941–1942 satisfy me more than some of the works written in peacetime, which is understandable—at that time you could write nothing at all or you could write with enthusiasm, [there was] no middle ground" (Piotrovsky 1995). But was there ever peacetime for Hermitagers?

ACKNOWLEDGMENTS

I n the preface I made mention of the quasi-experimental nature of this book. One dimension of this experiment needs to be emphasized further, as it conditioned every other. This book is the product of an experiment by the European University at Saint Petersburg (EUSP) and its rector at the time, Oleg Kharkhordin. Much larger and more multidimensional than that of this book, the EUSP's experiment has produced a body of scholarship in conversation with Western traditions that has earned it the laurels of academic rankings in Russia. A relatively recent arrival on the Russian academic landscape, the EUSP is at once a research center and the leading private, higher-degree-granting institution for the social sciences in Russia, ranking every year among the top five of all Russian universities. The Skolkovo Foundation provided initial funding for STS@EUSP, the center which hosted this work, and the university subsequently lent its assistance in every possible way. Many individuals were crucial in the completion of this project. Ilya Utekhin, Oleg Pachenkov, Natalia Voinova, and Anastasia Karkacheva helped its progress continuously. I enjoyed nearly constant conversations with Ilya from the moment I first imagined the project. He, like

many natives of Saint Petersburg, knew the museum inside and out; he had gone there as a child and had taken his children there. Oleg Pachenkov devised a study of the surrounding areas of the museum and of its footprint in the city, and we had some fruitful conversations about the measure of culture. First Natalia Voinova and then Anastasia Karkacheva helped with the organization of a project for which no fewer than twelve students were counted on to conduct interviews and collect data. Kirill Bikov was a smooth go-between, helpfully grasping academics' and museum employees' sharply contrasting senses of time. He was a great diplomat and an even better smoking companion outside the EUSP.

Beyond the university, many others listened to my ideas for the book and were kind enough to read some of its sections. The head of the museum made this project possible, generously inviting me to the institution and accepting with even greater generosity the timing of the project's execution. Geraldine Norman was generous enough to discuss with me her extensive knowledge of the museum while writing her second history of the post-1991 period. Martin Giraudeau and Ksenia Tatarshenko kindly consulted with me on a previous version of this book and provided much-needed advice. In addition to being staunch supporters of the project, which they followed from its inception in the fall of 2012, the insights they contributed later made this book better. Similarly, Beatrice Lewin Dumin, Santiago Arragon, Franck Cochoy, and Amah Edoh read a final version of the book and contributed sharp comments on the architecture of its chapters. In Paris, SciencesPo supported the completion of the book through its generous teaching and sabbatical policies. Throughout the project, Médialab was the perfect institution at which to conduct my work whenever I was in Paris. Michel Gardette and Bruno Latour were understanding enough to let me finish the project in Saint Petersburg while holding a teaching position in Paris.

The book would not have seen the light of day without the contributions of a number of students who joined two seminars designed to help build a research group at the intersection of media studies,

museum studies, and social theory in 2013 and 2014. They have all been superb ethnographers of the museum's public spaces, even engaging at times in daring "breaching experiments" with the guards in the exhibition spaces to illustrate and understand Garfinkel's notions of social order. They have been incredibly patient with the foreign (and at times outlandish) mores of both the author of this book and the interlocuters we were advised to consult at the museum. A few of these students have been central to the project: Olga Kaukhchan, Andrei Vozyanov, Nikita Balagurov, Evgeny Manzhurin, and Ekaterina Dyachenko led the interviews that had to be conducted in Russian. Afterward, they accepted the rules of collective reading of interviews they had led by sharing them with another student, who would code the transcript and then turn this code back to the interviewer to check whether the experience of the face-to-face interview carried meanings that a straight coding of text could not convey. This discipline, initially made necessary by the significant number of Hermitage employees we interviewed and by my imperfect command of Russian, turned out to be a successful research experiment and a quasi-open laboratory, where we worked collectively to understand the much larger and more confined Hermitage experiment. Finally, this book is a present for Mario Biagioli, Diana Kurkovski, and Olga Sezneva for their warm presence and sharp conversation, offered since we started work on Russia for another project, one concerning Russian programmers. Italian coffee and pasta in the Moika 51 commune helped us all make it through the harsh winters of Saint Petersburg.

NOTES

INTRODUCTION

1. "Hermitager" in Russian is эрмитажники. It is the name that employees who feel dedicated to the museum adopt for themselves. As with all such categories, the question of who qualifies as a Hermitager is contested.
2. In a way, the Russian Museum, which stands just a few yards away, is much more representative of Russian culture(s). However, it does not enjoy the same prestige as the Hermitage in the collective representation and implicit ranking of museums.
3. I use the term "keeper" throughout the text, and in chapter 3 I will clarify the different types of keepers working in the museum. What matters at this stage is the conflation of keeping and researching, that is to say, the fact that scholars who produce research are legally in charge of their own "funds" or "collections" of works.
4. Levinson-Lessing is the most apt example of an extremely knowledgeable, highly respected legend whose written output was meager. In the polite terms of the anonymous author of his obituary published in the *Burlington Magazine*, "Levinson-Lessing suffered all his life from a deep unwillingness to commit himself to paper. He loved research for its own sake and although his vast erudition earned him an international reputation, he has left to posterity a comparatively small heritage of published works" (Anonymous 1974, 44).

5. This box is very different from the white cube theorized in the late 1970s by Brian O'Doherty (1986) in his discussion of the modernist gallery. As we will see, our box has a complex topography and comes closer to a labyrinth than a hollow white cube.

6. David Holloway (1996) makes a similar case for another population of experts living in an enclave, the nuclear physicists who worked on the atomic bomb. Douglas Weiner (1999) goes further in his revisionist take on what is widely accepted as Stalinist-era political apathy by documenting actual political engagements beyond the safe confines of laboratories. One of the main differences between his proto-environmentalists and our keepers has to do with the objects of care in question. Hermitagers were around and above their treasure, always close by, and always in a mode of preservation. Weiner's scientists were immediately drawn to making bigger claims, though they were working on local cases.

7. The Pushkin museum, located in Moscow, has a much smaller collection and hosts nothing to rival the Hermitage's trove of royal presents and foreign pieces, acquired by the Soviet state from 1917 to 1945. More important for our purposes, the Pushkin museum's location has made it both a lesser urban attraction and a closer reflection of Soviet taste. Unlike the Pushkin museum, the Hermitage found itself relegated to the margins of Soviet political intrigues by virtue of its location in Leningrad. Indeed, this was an advantage of sorts because the controlling arm of the Communist Party was weaker at such a distance from the capital. The Pushkin museum was closer to the decision makers, and its keepers were both under stricter control and enjoyed a more favorable discourse with the Party.

1. MOVING OBJECTS

1. Federal Law of May 26, 1996, N 54-FZ, "On the Museum Fund of the Russian Federation and Museums in the Russian Federation" [in Russian], http://base.garant.ru/123168/3/#ixzz3EmzSqY00http://base.garant .ru/123168/3/—ixzz3EmzSqY00.

2. This is according to official data from the museum's website: https:// www.hermitagemuseum.org/wps/portal/hermitage/what-s-on/temp _exh/2014/New+Acquisitions/.

3. This distinction may soon lose its significance, as nature as we knew it may soon become an artifact of the past, and "extinct" and "endangered" may themselves become the natural descriptors for the specimens of nature.

4. The late Vladimir Matveev, deputy director at the Hermitage, set to document the footprint of the collection exhibitions. The result of this

enterprise takes up two volumes, the first dedicated to the domestic exhibitions (Matveev 2011), the second to the foreign exhibitions (where Hermitage pieces travel) and to the Hermitage exhibitions hosting foreign museums' pieces (Matveev 2012). The graphs presented in figure 1.1 draw on these accounts with a granularity of country. Beyond the sheer number of pieces, no other information about the nature of the items circulated—either those lent to foreign museums or those hosted at the Hermitage—is available in either volume. Olga Olkheft helped turn long tables into a usable database.

5. The literature on organization studies has paid more attention to filmmaking as the site of temporary projects (Bechky 2006; DeFillippi and Arthur 1998; Stjerne and Svejenova 2016; Storper 1989) than to museums and their hybrid mix of permanent and temporary activities.

2. DOCUMENTING THE MUSEUM

1. This statistic was cited in a website that is no longer available: http://itravel .by/stories/id_1599/muzei/ermitazh—chtoby-osmotret-vse-eksponaty -muzeya-ponadobitsya-8-let*/.

2. The work was entitled *Catalogues des Tableaux qui se trouvent dans les galeries et dans les cabinets du Palais Impérial de Saint-Pétersbourg.*

3. Christine Hine (2006) writes about the role of databases in communicating research in the life sciences. In these fields, the issues are both very different and strikingly similar to the museum sciences. The sheer quantity of results produced by teams located in laboratories across the world would overwhelm any team trying to keep up with all the pertinent research. Knowing what is out there is problematic—not unlike the puzzle of a museum figuring out what is "in there." The discrepancy between recording and describing—the interstice of creativity for Hermitage keepers—exists in the case studied by Hine, but it is not found where the contribution of biologists will be most noticed. Recording and describing are nearly one and the same gesture there, so that the conventions formulated by the database structure are of utmost importance to capture properly the objects under study.

4. See "User Collections" at the State Hermitage Museum website, http:// testmain.hermitagemuseum.org/wps/portal/hermitage/explore /collections/user-collections/.

5. Interpreters of Tarde's economic anthropology (Latour and Lépinay 2009) acknowledge passion as a substantial force behind production: passionate interests define what is quantifiable; and passions shape capitalism.

The latter observation is a variation on the opposition, set forward most clearly by Albert Hirschman (1977), between interests and passions in the rise of capitalism.

3. ART HISTORY FROM THE COLLECTIONS UP

1. We will observe this in detail when we meet the guides who articulate the art history practices of keepers, "methodologists," and the public.
2. There are exceptions to this rule, but outside curators who do visit the museum often come for exhibitions that sit at the margins of the core of Hermitage collections. One such exhibition was "Manifesta 10," presented in 2014; Kasper König was its head curator.
3. While this claim has some validity, similar systems exist in a number of the larger museums in Moscow and Saint Petersburg as well as in many provincial museums.

INTERLUDE 2: MOBILITY AT HERMITAGE

This chapter owes much to the insights of Jean Philippe Cointet. Andrey Vozyanov helped convince the Hermitage HR department to share this precious material.

1. Such was the case of Vladimir Yuryevich Matveev, the deputy director in charge of exhibitions and development, who passed away in 2015. He started his career as an intern in the General Service Department. He had no formal training in art history but was exposed daily to the practical questions raised by exhibitions. He was subsequently appointed to the History of Russian Culture Department. He was promoted to head of that department in 1990, and in 1995 he took charge of the exhibitions and other activities of the Hermitage's Dutch and Italian satellites.

4. THE NOSTALGIC MODESTY OF HERMITAGE RESTORERS

1. "There is an urgent need for those university faculties whose graduates may seek curatorial positions to offer a basic course in 'conservation for curators' and for museums to require such training as a fundamental curatorial qualification" (Resolution of the Fourteenth General Conference of the ICOM, Buenos Aires, Argentina, 1986).

2. "Russia's first restoration departments were established in secondary colleges, the first in 1965 at the 1905 Arts College in Moscow, and another a year later at the Vladimir Serov Arts College in Saint Petersburg. Shortly afterwards, two higher-level educational institutes began to provide training for restorers. These were the Stroganov Institute of Industrial Art in Moscow and the Ilya Repin Institute of Painting, Sculpture and Architecture in Saint Petersburg" (Klokova 1994).

3. The professionalization of restorers by university faculties is a recent development for both the Soviet Union and for other countries. In many countries, restorers were once educated in restoration laboratories within museums, as they were in the USSR. This was the situation, for example, in British museums. In a famous article, Garry Thomson (1970) complained of the lack of basic professional training in the conservation sphere.

4. Following the meeting of two ICOM committees, the International Committee on Museum Laboratories and the International Commission on the Care of Paintings, held at Hermitage Museum in 1963, Philip Hendy (1965) wrote: "We were given striking proof that the Deputy Director, Professor Levinson-Lessing, had a grasp of the problems of conservation and of the scientific techniques involved in their solution which is rare even among museum directors of a much younger generation. We also saw abundant evidence of excellent current practice, including such perfect examples of cleaning as Rubens's early *Ecce Homo*, now looking as if it had come straight from the painter's easel. It is indeed true that in the Hermitage one can see the art of Boucher, for instance, as one can see it in quantity nowhere else, superb in quality and pristine, as if his pictures had never been harshly lined and had never borne any of those surface-coatings which so quickly discolour and distort." (580)

5. On the Museum of New Western Art, see the coda of chapter 1.

5. GUIDES: TAKING SCIENCE DOWN THE GALLERIES

1. Guides are overwhelmingly female; we had only one interaction with an (elderly) male guide. All interviews were conducted with female guides.

2. The list of these presentations is revealed at the beginning of the season, in September, and the stars of the museum have their appearances booked within a few hours of tickets going on sale.

3. The peak season runs from May to September.

4. On the experiment of world's fairs, see the work of Alfred Heller in *World's Fairs and the End of Progress: An Insider's View* (1999).

5. Benjamin writes his famous essay "The Work of Art in the Age of Mechanical Reproduction" with the concern of an observer of political regimes adept at exploiting images. He was both excited by the prospect of a democratization of the experience of art opened up by images reproducing otherwise exclusive pieces and worried that such images could mobilize the visceral impulses of an entire population when edited for propaganda purposes. The "aura," the central character of the Benjaminian drama of art pieces seized by the culture of reproduction, is also the central figure of the museum as a medium. Visitors come for the unique experience of the flesh-and-blood encounter with the piece, but their experience keeps being mediated: the building, the guide books, and the museum guides all stand in the way of the "pure experience."

6. Guidentour is another main provider of outside guides to the Hermitage. A younger institution than Intourist, it has fewer connections to the tourist agencies of Saint Petersburg.

7. The exception to this usual state of affairs is the group of friends who book a customized tour and carry into the excursions all the routines—as well as the frustrations—of previously formed relationships.

8. Sophie Houdart (2013) has offered a compelling ethnography of the management of the international crowds during the Universal Exhibition in Nagoya, Japan, in 2005. She pays particular attention to the devices used to both sustain the attention of the crowds and maintain order and peace on-site.

9. It is worth noting that the use of this communication device is now spreading beyond museums. A Swiss agency has its own micro-earpiece and uses it for all visits—their clients wear the earpieces as they land and remove them upon taking off.

6. SPACES AND SURPRISES: TECHNOLOGIES OF VISION FOR A LONG WINTER

1. Still, these infrastructures are constrained by other forms of spatiality. Standards can be exclusive to a department or to the museum, or they can aim at a more open-source approach so as to reach the largest possible audience. A piece's attributes may enjoy a virtual ubiquity, until the infrastructures supporting their deployment across networks fail, at which point the piece regains its arrogant aura and reasserts its exclusive spatiality.

2. Среди бродячих музейных мифов есть и такой: в фондах Эрмитажа хранится множество еще не опубликованных шедевров. Увы, это не так. Но иногда из музейного небытия что-то вдруг возникает.

Так, в 1960-е годы почтенный голландский искусствовед Херберт Хаверкамп-Бегеманн навестил своих ленинградских коллег в Эрмитаже. И там, беседуя за чашкой чая, вдруг заметил за шкафом край огромного листа. Это оказался немыслимо большой (228 на 170 см) рисунок «Вакх, Церера, Венера и Купидон» главного голландского маньериста Хендрика Голциуса. Маньеризм, искусство легкомысленное, эзотерическое, самовлюбленное, искусство тел и их переплетений, в советской табели о рангах, понятное дело, было чуть выше плинтуса. Но то, что это безусловный шедевр, было всем понятно и тогда. С тех пор найти что-либо подобное в запасниках музея остается пусть несбыточной, но мечтой каждого нового хранителя (http://vtbrussia.ru/culture/hermitazh /koty-shedevry-privideniya).

CONCLUSION

1. Lévi-Strauss ([1955] 1976) writes:

 To establish a correlation between the emergence of writing and certain characteristic features of civilization, we must look in a quite different direction. The only phenomenon with which writing has always been concomitant is the creation of cities and empires, that is, the integration of large numbers of individuals into a political system, and their grading into castes or classes. Such, at any rate, is the typical pattern of development observed from Egypt to China, at the time when [writing] first emerged: it seems to have favored the exploitation of human beings rather than their enlightenment. This exploitation, which made it possible to assemble thousands of workers and force them to carry out exhausting tasks, is a much more likely explanation for the birth of architecture than the direct link referred to above. My hypothesis, if correct, would oblige us to recognize the fact that the primary function of written communication is to facilitate slavery. (391)

2. An interesting and possibly growing set of (sometimes criminal) organizations avoid resorting to documentation, preferring to keep all efforts at coordination and coexistence fully oral so as to not leave traces. They have not been part of the present study.

REFERENCES

Alberti, Samuel J. M. M. 2005. "Objects and the Museum." *Isis* 96, no. 4 (December): 559–571.

Aleshin, Andrey B. 1985. *Ryestavratsiya Stankovoy Maslyanoy Zhivopisi v Rossii. Razvitiye Printsipov i Myetodov* [Restauration of Easel Painting in Russia. Development of principles and methods]. Saint Petersburg: Artist RSFSR.

——. 2006. "Pryelyoodiya k ryekviyemoo po natsional'noy shkolye ryestavratsii" [Prelude to a Requiem for the National School of Conservation-Restoration]. *Relikvia* 15. Accessible at http://art-con.ru/node/4583.

Alpers, Svetlana. 1984. *The Art of Describing: Dutch Art in the Seventeenth Century.* Chicago: University of Chicago Press.

Anonymous. 1974. "Vladimir Franzevich Levinson-Lessing." *Burlington Magazine* 116, no. 850: 44.

Appadurai, Arjun, ed. 1986. *The Social Life of Things: Commodities in Cultural Perspective.* Cambridge, UK: Cambridge University Press.

Baxandall, Michael. 1972. *Painting and Experience in Fifteenth-Century Italy: A Primer in the Social History of Pictorial Style.* Oxford: Oxford University Press.

Bechky, Beth A. 2006. "Gaffers, Gofers, and Grips: Role-Based Coordination in Temporary Organizations." *Organization Science* 17, no. 1 (January–February): 3–21.

Beck, James, and Michael Daley. 1996. *Art Restoration: The Culture, the Business and the Scandal.* New York: Norton.

Benjamin, Walter. (1935) 1969. *The Work of Art in the Age of Mechanical Reproduction*. Trans. Harry Zohn. New York: Schocken.

——. 1986. *Moscow Diary*. Trans. Richard Sieburth. Cambridge, Mass.: Harvard University Press.

Benois, Alexandre. 1980. *Moi Vospominanija* [My memories]. Moscow: Nauka.

Biriukova, Nina. 2009. *The Hermitage Through the Eyes of a Hermitager: The Recent Past*. Saint Petersburg: State Hermitage Museum.

Bloor, David. 1973. "Wittgenstein and Mannheim on the Sociology of Mathematics." *Studies in the History and Philosophy of Science* 4, no. 2: 173–191.

——. 1983. *Wittgenstein: A Social Theory of Knowledge*. London: Macmillan.

——. 1992. "Left and Right Wittgensteinians." In *Science as Practice and Culture*, ed. Andrew Pickering, 266–282. Chicago: University of Chicago Press.

Borgman, Christine L. 2009. "The Digital Future Is Now: A Call to Action for the Humanities." *Digital Humanities Quarterly* 3, no. 4.

Bowker, Geoffrey C. 2006. *Memory Practices in the Sciences*. Cambridge, Mass.: MIT Press.

Brainerd, Andrew W. 2007. *On Connoisseurship and Reason in the Authentication of Art*. Chicago: Prologue.

Brown, Jonathan. 1995. *Kings and Connoisseurs: Collecting Art in Seventeenth-Century Europe*. Princeton, N.J.: Princeton University Press.

Brown, Kate. 2013. *Plutopia: Nuclear Families, Atom Cities, and the Great Soviet and American Plutonium Disasters*. Oxford: Oxford University Press.

Burrus, Christina. 1994. *The Art Collectors of Russia: Private Treasurers Revealed*. Trans. Ros Schwartz and Sue Rose. London: Tauris Parke.

Chakovskaia, Lidiia. 2013. "Conversations with Evsei Rotenberg." *Iskusstvoznanie* 3-4: 492–524.

Chandler, Alfred D. (1977) 1993. *The Visible Hand. The Managerial Revolution in American Business*. Cambridge, Mass.: Harvard University Press.

DeFillippi, Robert J., and Michael B. Arthur. 1998. "Paradox in Project-Based Enterprise: The Case of Film Making." *California Management Review* 40, no. 2 (Winter): 125–139.

DiMaggio, Paul. 1978. "Elitists and Populists: Politics for Art's Sake." *Working Papers for a New Society* 6: 23–31.

——. 1982. "Cultural Entrepreneurship in Nineteenth-Century Boston." *Media, Culture and Society* 4: 303–322.

——. 1983. "The American Art Museum Director as Professional: Results of a Survey." *Bullet* 24: 5–9.

Doyle, Richard M. 1998. "Emergent Power: Vitality and Theology in Artificial Life." In *Inscribing Science: Scientific Texts and the Materiality of Communication*, ed. Timothy Lenoir, 304–327. Stanford, Calif.: Stanford University Press.

Ernst, Wolfgang. 2012. *Digital Memory and the Archive*. Minneapolis: University of Minnesota Press.

Faibisovitch, Viktor. 2010. "Dari Gnyezda Orlovih" [Gifts of the Orlov family nest]. 95: 2.

Felch, Jason, and Ralph Frammolino. 2011. *Chasing Aphrodite: The Hunt for Looted Antiquities at the World's Richest Museum*. Boston: Houghton Mifflin Harcourt.

Fleck, Ludwik. (1935) 1981. *Genesis and Development of a Scientific Fact*. Trans. Frederick Bradley and Thaddeus J. Trenn. Chicago: University of Chicago Press.

Foucault, Michel. 2002. *The Order of Things: An Archaeology of the Human Sciences*. Psychology Press.

Friedlander, Max J. 2008. *On Art and Connoisseurship*. London: Lowrie Press.

Galison, Peter. 2004. "Removing Knowledge." *Critical Inquiry* 31, no. 1 (Autumn): 229–243.

Gilburd, Eleonory. 2014. "The Revival of Soviet Internationalism in the Mid to Late 1950s." In *The Thaw: Soviet Society and Culture During the 1950s and 1960s*, ed. Denis Kozlov and Eleonory Gilburd, 362–401. Toronto: University of Toronto Press.

Gitelman, Lisa. 2014. *Paper Knowledge: Toward a Media History of Documents*. Durham, N.C.: Duke University Press.

Gombrich, E. H. 1960. *Art and Illusion: A Study in the Psychology of Pictorial Representation*. Princeton, N.J.: Princeton University Press.

Goody, Jack. 1977. *The Domestication of the Savage Mind*. Cambridge, UK: Cambridge University Press.

——. 1986. *The Logic of Writing and the Organization of Society*. Cambridge, UK: Cambridge University Press.

Grimsted, Patricia Kennedy, F. J. Hoogewoud, and F. C. J. Ketelaar, eds. 2007. *Returned from Russia: Nazi Archival Plunder in Western Europe and Recent Restitution Issues*. Builth Wells, UK: Institute of Art and Law.

Guichard, Charlotte. 2014. *Graffitis: Inscrire son nom à Rome*. Paris: Seuil.

Hannavy, John, ed. 2008. *Encyclopedia of Nineteenth-Century Photography*. London: Routledge.

Heinich, Nathalie, and Michael Pollak. 1989. "Du conservateur de musée à l'auteur d'exposition: l'invention d'une position singulière." *Sociologie du travail* 1: 29–49.

Heller, Alfred. 1999. *World's Fairs and the End of Progress: An Insider's View*. Corte Madera, Calif.: World's Fair, Inc.

Hendy, Philip. 1965. "Condition of the Hermitage Pictures." *Burlington Magazine* 107, no. 752 (November): 580.

Hennion, Antoine. 2015. *The Passion for Music: A Sociology of Mediation*. Trans. Margaret Rigaud. London: Routledge.

Hine, Christine. 2006. "Databases as Scientific Instruments and Their Role in the Ordering of Scientific Work." *Social Studies of Science* 36, no. 2: 269–298.

Hirschman, Albert O. 1977. *The Passions and the Interests: Political Arguments for Capitalism Before Its Triumph*. Princeton, N.J.: Princeton University Press.

Holloway, David. 1996. *Stalin and the Bomb: The Soviet Union and Atomic Energy, 1939–1956*. New Haven, Conn.: Yale University Press.

Houdart, Sophie. 2013. *L'universel à vue d'œil*. Paris: Petra.

Innis, Harold A. (1950) 2007. *Empire and Communications*. New York: Rowman and Littlefield.

——. 1995. *Staples, Markets, and Cultural Change: Selected Essays*. Montreal: McGill-Queen's University Press.

Izergina, Antonina. 2009. *Vospominaniâ, pis'ma, vystupleniâ*. [Memories, Letters, Talks—the State Hermitage Museum.] Saint Petersburg: State Hermitage Press.

Jenkins, Tiffany. 2016. *Keeping Their Marbles: How the Treasures of the Past Ended Up in Museums—and Why They Should Stay There*. Oxford: Oxford University Press.

Jones, George, Christine McLean, and Paolo Quattrone. 2004. Introduction to "Spacing and Timing." Special issue, *Organization* 11, no. 6: 723–741.

Josephson, Paul. 1997. *New Atlantis Revisited: Akademgorodok, the Siberian City of Science*. Princeton, N.J.: Princeton University Press.

Kafka, Ben. 2012. *The Demon of Writing: Powers and Failures of Paperwork*. New York: Zone.

Kagane, Ludmila, and Albert Kostyenevich, 2008. *Ispanskaya zhivopis' XV - nachala XX vyeka* [Spanish painting 15th-early 20th centuries]. Saint Petersburg: State Hermitage Museum.

Kinmonth, Margy. 2014. *Hermitage Revealed*. Documentary. London: Foxtrot.

Kittler, Friedrich. 2009. *Optical Media*. Cambridge, UK: Polity.

——. 2014. *The Truth of the Technological World: Essays on the Genealogy of Presence*. Stanford, Calif.: Stanford University Press.

Klokova, Galina. 1994. "Training Restorers in Russia." *Museum International* 46, no. 4 (January–December): 51–53.

Kopylova, Rozaliia. 2008. *The Lessons of Archaists: The Green Hall—an Anthology*. Saint Petersburg: Institute of Art History.

Kopytoff, Igor. 1986. "The Cultural Biography of Things: Commoditization as Process." In *The Social Life of Things: Commodities in Cultural Perspective*, ed. Arjun Appadurai, 64–91. Cambridge, UK: Cambridge University Press.

Kozlov, Denis, and Eleonory Gilburd, eds. 2014. *The Thaw: Soviet Society and Culture During the 1950s and 1960s*. Toronto: University of Toronto Press.

Labenski, Ksaverij Ksaverievič. 1805. *Galerie de l'Ermitage, gravée au trait d'après les plus beaux tableaux qui la composent, avec la description historique, par Camille, de Genève*. Saint Petersburg: Alici. Available at https://gallica.bnf.fr /ark:/12148/bpt6k64601250.

Latour, Bruno. 1983. "Give Me a Lab and I Will Raise the World." In *Science Observed: Perspectives on the Social Study of Science*, ed. Karin D. Knorr-Catina and Michael Mulkay, 141–170. Beverly Hills, Calif.: Sage.

Latour, Bruno, and Vincent Antonin Lépinay. 2009. *The Science of Passionate Interests: An Introduction to Gabriel Tarde's Economic Anthropology*. Chicago: Prickly Paradigm.

Latour, Bruno, and Steve Woolgar. 1979. *Laboratory Life: The Construction of Scientific Facts*. Beverly Hills, Calif.: Sage.

Levinson, Mark. 2010. *The Box: How the Shipping Container Made the World Smaller and the World Economy Bigger*. Princeton, N.J.: Princeton University Press.

Levinson-Lessing, Vladimir. 1985. *Istoria kartinnoy Galerei Hermitaga*. [History of the Hermitage Picture Gallery] Leningrad: Iscusstvo.

Lévi-Strauss, Claude. (1955) 1976. *Triste Tropiques*. Harmondsworth, UK: Penguin.

Long, Pamela O. 2001. *Openness, Secrecy, Authorship: Technical Arts and the Culture of Knowledge from Antiquity to the Renaissance*. Baltimore: Johns Hopkins University Press.

Lynch, Michael. 1985. *Art and Artifact in Laboratory Science: A Study of Shop Work and Shop Talk in a Research Laboratory*. London: Routledge.

Maddox, Steven. 2014. *Saving Stalin's Imperial City: Historic Preservation in Leningrad, 1930–1950*. Bloomington: Indiana University Press.

Matveev Vladimir. 2012. *Ermitazh "vsyemirniy," ili Planyeta Ermitazh: Vistavochnaya dyeyatyel'nost' moozyeya za roobyezhom i proizvyedyeniya iz zaroobyezhnih sobraniy na vistavkah v Gosoodarstvyennom Ermitazhye* [Hermitage "World," or the Planet Hermitage: Exhibition activities of the museum abroad and works from foreign collections on exhibitions at the State Hermitage Museum]. Saint Petersburg: Slaviya.

——. 2011. *Ermitazh "provintsial'niy" ili Impyeriya Ermitazh: vistavochnaya dyeyatyel'nost' moozyeya v ryegionah SSSR i Rossiyskoy Fyedyeratsii* [Hermitage "provincial" or the Empire Hermitage: Exhibition activities of the museum in the regions of the USSR and the Russian Federation]. Saint Petersburg: Slaviya.

McLuhan, Marshall. (1962) 2011. *The Gutenberg Galaxy: The Making of Typographic Man*. Toronto: University of Toronto Press.

——. 1964. *Understanding Media: The Extensions of Man*. New York: McGraw-Hill.

Merton, Robert K. (1942) 1996. The ethos of science. In *On Social Structure and Science*, ed. P. Sztompka, 267–276. Chicago: University of Chicago Press, 1996.

——. (1957) 1996. The reward system of science. In *On Social Structure and Science*, ed. P. Sztompka, 286–304. Chicago: University of Chicago Press, 1996.

——. (1988) 1996. The Matthew Effect, II. In *On Social Structure and Science*, ed. P. Sztompka, 318–336. Chicago: University of Chicago Press, 1996.

Munnich, Joan. 1773. *Catalogues des Tableaux qui se trouvent dans les galeries et dans les cabinets du Palais Impérial de Saint-Pétersbourg*. Saint Petersburg.

Muñoz Viñas, Salvador. 2012. *Contemporary Theory of Conservation*. New York: Routledge.

Nekrylova, Anna. 2012. *The Russian Institute of Art History—a Concise Activity Report*. Saint Petersburg: Institute of Art History.

Nemchinova, Larissa. 2014. *Ryestavratsiya v Ermitazhye: Vzglyad skvoz' prizmoo vryemyen* [Conservation in the Hermitage. Through the Prism of Time]. Saint Petersburg: State Hermitage Museum.

Nikulin, Nikolay. 2010. *Vospominaniya o Voyne* [War Memories]. Saint Petersburg: State Hermitage Museum.

Nikulin, Nikolay, and Gleb Pavlov. 1998. *The Department of Art Theory and Art History, 1937-1997. Part 1*. Saint Petersburg: Saint Petersburg State Institute of Painting, Sculpture, and Architecture.

Norman, Geraldine. 1998. *The Hermitage: The Biography of a Great Museum*. New York: Fromm.

——. 2006. "Mystery of the Missing Treasures." *Telegraph*, December 5, 2006. http://www.telegraph.co.uk/culture/art/3656932/My story-of-the-missing -treasures.html.

O'Doherty, Brian. 1986. *Inside the White Cube: The Ideology of the Gallery Space*. Berkeley: University of California Press.

Odom, Anne, and Wendy R. Salmond, eds. 2009. *Treasures into Tractors: The Selling of Russia's Cultural Heritage, 1918-1938*. Washington, D.C.: Hillwood Museum.

Ogborn, Miles. 2007. *Indian Ink: Script and Print in the Making of the English East India Company*. Chicago: University of Chicago Press.

Pearce, Susan. 1994. *Museums, Objects, and Collections*. Washington, D.C.: Smithsonian.

Philibert, Nicolas. 1990. *La Ville Louvre*. Documentary. Paris: Films d'Ici.

Piotrovsky, Boris Borisovitch. 1995. *Stranitsy moej zhizni* [Pages of my life]. Saint Petersburg: State Hermitage Museum.

Plenderleith, Harold James. 1956. *The Conservation of Antiquities and Works of Art: Treatment, Repair and Restoration*. London: Oxford University Press.

Polanyi, Michael. (1958) 1974. *Personal Knowledge: Towards a Post-Critical Philosophy*. Chicago: University of Chicago Press.

——. (1966) 2009. *The Tacit Dimension*. Chicago: University of Chicago Press.

Pomian, Krzysztof. 1990. *Collectors and Curiosities: Paris and Venice, 1500-1800*. Cambridge: Polity.

Potin, Vladimir Mikhailovich, and Elena Shchukin. 1990. Ermitazh. Istoriya i sovryemyennost'. Hermitage. History and modernity. Moscow: Art.

Price, Sally. 1991. *Of Artists and Connoisseurs: Cultural Authority in Cross-Cultural Contexts*. Berlin: Arabische Buch.

Rheinberger, Hans-Jörg. 1997. *Toward a History of Epistemic Things: Synthesizing Proteins in the Test Tube*. Stanford, Calif.: Stanford University Press.

Riles, Annelise, ed. 2006. *Documents: Artifacts of Modern Knowledge*. Ann Arbor: University of Michigan Press.

Savoy, Bénédicte. 2003. *Patrimoine Annexé: Les biens culturels saisis par la France en Allemagne autour de 1800*. Paris: Maison des Sciences de l'Homme.

Schöch, Christof. 2013. "Big? Smart? Clean? Messy? Data in the Humanities." *Journal of Digital Humanities* 2, no. 3: 2–13.

Semenova, Natalia, and Nicholas Iljine. 2000. *Prodanniy Sokrovishta Russiiy* [The sale of Russia's treasures]. Moscow: Russkiy Avantgard.

Serapina, Natalia. 1999. "Ermitazh kotoriy miy poteryali" [The Hermitage which we lost]. *Neva* 3: 135–157.

Shapin, Steven. 1995. *A Social History of Truth: Civility and Science in Seventeenth-Century England*. Chicago: University of Chicago Press.

Shapin, Steven, and Simon Schaffer. 1985. *Leviathan and the Air-Pump: Hobbes, Boyle, and the Experimental Life*. Princeton, N.J.: Princeton University Press.

Sher, Jakob A. 1978. "The Use of Computers in Museums: Present Situation and Problems." *Museum International* 30, no. 3–4 (January–December): 132–138.

Simmel, George. 1906. "The Sociology of Secrecy and of Secret Societies." *American Journal of Sociology* 11, no. 4: 441–498.

Spassky, Ivan. 2013. *Roosskoye zoloto. Sbornik izbrannih statyey* [Russian Gold: Selected Articles]. Saint Petersburg: State Hermitage Museum.

Star, Susan Leigh, and James R. Griesemer. 1989. "Institutional Ecology, 'Translations' and Boundary Objects: Amateurs and Professionals in Berkeley's Museum of Vertebrate Zoology, 1907–39." *Social Studies of Science* 19, no. 3: 387–420.

State Hermitage. 2016. *Gosoodarstvyenniy Ermitazh. Moozyeyniye rasprodazhi. 1930-1931. Arhivniye dokoomyenti* [State Hermitage. Museum sales. 1930-1931. Archival documents]. Saint Petersburg: State Hermitage Museum.

Stjerne, Iben Sandal, and Silviya Svejenova. 2016. "Connecting Temporary and Permanent Organizing: Tensions and Boundary Work in Sequential Film Projects." *Organization Studies* 37, no. 12: 1771–1792.

Storper, Michael. 1989. "The Transition to Flexible Specialisation in the U.S. Film Industry: External Economies, the Division of Labour, and the Crossing of Industrial Divides." *Cambridge Journal of Economics* 13, no. 2 (June): 273–305.

Thomson, Garry. 1970. "Conservation in the Museums of the United Kingdom." *Museum* 23, no. 2: 134–139.

Thomson, Garry. 1978. *The Museum Environment*. London: Butterworth-Heinemann.

Turnbull, Paul, and Michael Pickering, eds. 2010. *The Long Way Home: The Meaning and Values of Repatriation.* New York: Berghahn.

USSR Ministry of Culture. 1985. *On the Approval of Instruction in Accounting and Storage of Museum Property Located in the State Museums of the USSR.*

Walden, Sarah. 2005. "Cash? Who Needs It!" *Guardian,* January 22, 2005. https://www.theguardian.com/artanddesign/2005/jan/22/heritage.artsfunding.

Weiner, Douglas R. 1999. *A Little Corner of Freedom: Russian Nature Protection from Stalin to Gorbachev.* Berkeley: University of California Press.

Williamson, Oliver E. 1981. "The Economics of Organization: The Transaction Cost Approach." *American Journal of Sociology* 87, no. 3: 548–577.

Wiseman, Frederick. 2015. *The National Gallery.* Documentary. Cambridge: Zepora.

Yefimova, Irina. 2009. "Iz Istorii Izdaniya Moozyeynih Spravochnikov. (Na Primyerye Izdatyel'skoy Dyeyatyel'nosti Ermitazha Do 1921 G)." [From the History of the Publishing Museum Reference Books. (The Example of the Publishing Activity of the Hermitage Before 1921)]. *News of Higher Education Institutions* (3): 80–84.